250 Brief, Creative & Practical

Art Therapy Techniques

. .

A Guide for Clinicians & Clients

Susan I. Buchalter, ATR-BC, CGP, LPC

250 Brief, Creative & Practical Art Therapy Techniques © copyright 2017 by Susan I. Buchalter

Published by:
PESI Publishing & Media
PESI, Inc.
3839 White Ave.
Eau Claire, WI 54703

Cover Design: Amy Rubenzer
Editing By: Marietta Whittlesey
Layout: Amy Rubenzer & Bookmasters

Printed in the United States of America
ISBN: 9781683730958

PESI
Publishing
& Media
www.pesipublishing.com

Dedication

Dedicated to my beloved father, Martin George Buchalter, a very creative and artistic man, and a powerful figure and inspiration.

And, thank you to Dr. Alan H. Katz for his superb technical support.

Author Bio

Susan I. Buchalter, ATR-BC, CGP, LPC is a senior clinical therapist and art therapist at The University Medical Center at Princeton, where she introduced art therapy to doctors and staff members in the 1980s. She is a board certified art therapist, licensed professional counselor, and certified group psychotherapist, and has spent over 30 years leading art therapy and psychotherapy groups. She is co-creator of the Garden State Art Therapy Association; now known as The New Jersey Art Therapy Association. She was an adjunct professor at Trenton State College (The College of New Jersey).

Susan is the author of *A Practical Art Therapy, Art Therapy Techniques and Applications, Art Therapy and Creative Coping Techniques for Older Adults, Mandala Symbolism and Techniques: Innovative Approaches for Professionals,* and *Raising Self-Esteem in Adults: An Eclectic Approach with Art Therapy, CBT and DBT-Based Techniques.* She has a private practice in Lawrenceville, New Jersey.

Table of Contents

Introduction

When a client walks into a therapy room, he may not know what to expect. He might be anxious, unsure, and fearful. He doesn't know what his role will be and he may fear others won't accept him or think he is unintelligent or unworthy. It takes time for individuals to get used to therapy, whether it is group or individual therapy. Rushing right into deep discussion may create undue stress, and support unhealthy behaviors such as withdrawing, talking too much, acting silly or sarcastic, or leaving the room to alleviate anxiety.

A group that begins with introductions and then a brief warm-up provides a gradual and calming transition into more intensive therapy. Providing the client with a safe and welcoming environment helps him better acclimate to the group environment, other group members, and the therapist who is leading the session. Clients want to know they can fit in and interact appropriately.

Beginning a group gradually using creative warm-ups allows individuals to introduce and express themselves, and experience therapy in a non-threatening and welcoming manner. Warm-up exercises provide a way to test the waters. The client can get a feel for his role in the group, how it is run, its norms and structure, and how individuals tend to interact with each other. He begins making connections almost immediately by sharing the work created during the warm-up exercise. The warm-ups can also be used as effectively in individual sessions, and with people who want to enhance their self-awareness and expand upon their creativity.

Warm-ups can be considered "mental stretching." They are usually five to ten minutes in length and help clients become familiar with drawing, self-expression and communicating with others. The warm-ups are relatively simple and provide an almost guaranteed successful outcome, which increases self-esteem and makes it more likely that the client will feel comfortable and share issues and concerns. A sense of mastery is gained since it is almost impossible to "fail." Very little is required or expected, and the participant is reassured that he is in charge; there is no right or wrong way to approach the warm-up. The warm-ups are never judged; the results are explored and the client decides when, how, and with whom he will share his artwork. These creative exercises provide those mini successes so necessary for motivation and full engagement in therapy. Individuals gain self-esteem by taking tiny steps forward.

Clients often take a lighthearted approach to the warm-ups. Sometimes simply because they are called *warm-ups*, and participants know they will not be judged or coerced to do or say something that is too stressful. It is just this relaxed approach and attitude that makes warm-ups so powerful. When clients are not worried about how their work looks or how they come across to others, they frequently let their guard down and share more issues and feelings than they might do otherwise.

If a client discounts his work during the warm-up, it is common for other group members to support him and encourage him to continue working, and not worry about the end product. This interaction becomes the client's first bonding experience with the group. In one recent session, a client named Bob wanted to throw his work out; he thought it was ugly and messy. When he started crumpling it up and walking towards the garbage can, a few veteran clients pleaded with him to keep it. They told him his work was valuable and all that counted was self-expression. They knew drawing ability was not mandatory. The appearance of the work is unimportant; one does not need to be an artist or have drawing ability to

engage in these warm-ups. In addition, if writing is included in an exercise the client doesn't need to know how to spell or use grammar correctly. His penmanship does not have to be neat or even legible; almost anything goes during these exercises.

Sometimes there is a client who does happen to have great ability. He is usually admired by his peers and complimented for his talent. This support enhances the client's self-esteem and abilities, and creates a positive relationship with group members from the get-go. Straightaway, he finds his niche within the group.

Warm-ups help create cohesiveness within the group because of the relaxed nature of the brief exercises. Clients are given time to settle down, relax, catch their breath, socialize and meet and greet each other. Warm-ups afford clients a time to unwind while energizing their minds and enhancing their thinking skills. Warm-ups are similar in many ways to that daily cup of coffee so many people enjoy before starting the workday. The exercises, like the coffee, wake people up and clear the mind; ideas begin to percolate and flow. Clients experiment with shape, design, color and self-expression, and often ask questions and make comments relating to artwork, technique, style and others' results. In this way they form connections with peers.

Another benefit of the warm-up is that latecomers can enter the group room, make themselves comfortable, and begin the exercise without feeling stressed or left out because the exercises are flexible and easy to complete. If the warm-up is left unfinished, the client has the choice to continue it another time or leave it as it is. There are no expectations about the outcome. The latecomers will not be too much of a disruption because, although significant, the warm-up does not carry the same importance as the central group therapy, which is more structured and more intensive. Interrupting a warm-up, although undesirable, is not as disturbing as interrupting a process group. By the time the warm-up has ended and the process group begins, latecomers are settled and ready to work on their issues.

HOW TO USE THIS BOOK

This book will focus on using brief warm-up exercises to facilitate communication, connection and creative expression among a wide variety of clients, as well as all individuals who want to gain greater creativity, introspection and self-awareness. These brief techniques will pave the way for clients to become involved and focused on longer, more introspective art therapy and psychotherapy groups. The goal is to use the exercises as "mental stretching," to help individuals learn to think in the abstract and become comfortable with self- expression and self-exploration. Participants soon realize that the focus is on the process and not the final product. Quick, imaginative exercises often prove helpful in facilitating group interaction and growth. The warm-ups may relate to the theme of the group therapy, which follows the warm-up, but this is not a necessity. It depends on the needs of the clients and the therapist's view of what the goals and theme of the session will be.

Drawing, painting, collage work, and creative expression, which are the main methods of expression during these warm-ups, have a multitude of benefits including:

- Creative expression of ideas, feelings, problems and concerns
- Decreased stress and anxiety
- Increased feelings of calm and well-being
- Increased self-esteem, self-awareness and mindfulness

Creative expression provides the opportunity to document one's thoughts and refer back to them as needed. In this way, the individual has the opportunity to view patterns of growth and change.

Engaging in creative endeavors strengthens the immune system, and may be connected to overall better health and longevity.

This book will present warm-ups that provide various benefits to diverse individuals and populations. All of the exercises have general benefits, such as self-expression and creative thinking, but some of them will promote additional desired behaviors, actions and activity. For example, if a client is withdrawn, a project that elicits more sharing and active participation, like collage work, might be preferable to a sketching exercise.

To make it easier for therapists, teachers, psychologists, counselors, and individuals interested in continued self-exploration, the exercises will be categorized according to general theme and whether or not they are stimulating, calming, thought-provoking, etc. This will help suggest which exercises would be most beneficial for specific individuals and groups. The multimedia exercises promote decision-making and increased activity levels, and the self-reflective exercises promote increased self-awareness. The CBT-based chapter will include some cognitive behavioral therapy and dialectical behavioral techniques.

The therapist needs to decide which exercises are appropriate for her clients and for the type of group she leads. For example, mindfulness may be therapeutic for a group of recovering addicts, but not for a group of people challenged with schizophrenia. It is not uncommon for the person with schizophrenia to have a difficult time sitting still, being introspective and following guided imagery for more than a few minutes. Mindfulness might make that person anxious, especially if he hallucinates or has high anxiety.

Projects will be explained in an easy and clear manner, and examples of patient work and/or their reactions/comments will be included. The artwork has either been copied and re-drawn with permission of the participants, or designed to serve as an example solely for this publication.

MATERIALS FOR WARM-UPS

You will need paper, markers, oil pastels, crayons, and/or colored pencils for most exercises. Additional materials will be noted, if needed.

1
Chapter
Mindfulness

Mindfulness helps people experience peace and serenity. Mindfulness has origins in Eastern philosophy and Buddhism, but individuals do not need to be religious or even spiritual to practice it. According to Jon Kabat-Zinn: "Mindfulness means paying attention in a particular way; on purpose, in the present moment, and non-judgmentally."[1] "Mindfulness is about observation without criticism; being compassionate with yourself. In essence, mindfulness allows you to catch negative thought patterns before they tip you into a downward spiral. It begins the process of putting you back in control of your life."[2] "Mindfulness is a way of observing our experience, in the present moment, without judgement. Mindfulness helps us 'defuse' - to distance ourselves from unhelpful thoughts, reactions and sensations."[3]

When an individual is mindful he is fully aware of his senses and experiences. The client is encouraged to accept his thoughts, feelings and behaviors and not to judge them. He doesn't dwell on the past or on feelings of guilt. Individuals are encouraged to focus their full attention on what they are currently experiencing and to let their incoming thoughts gently flow away. Attention, or awareness, is the central feature of mindfulness. "Mindfulness is a skill that allows us to be less reactive to what is happening in the moment. It is a way of relating to all experience—positive, negative and neutral—such that our overall suffering is reduced and our sense of well-being increases."[4]

Core features of mindfulness include observing, describing, participating fully and being non-judgmental and concentrating on one thing at a time.

Mindfulness can include techniques such as deep breathing, focusing on one's breath, observing one's thoughts, and creative techniques such as mandala design, drawing a flower in detail or listening to music. It might incorporate methods such as staring at an object to view it fully. It might comprise being aware of all one's senses at one time. Mindfulness practice is about learning to control one's own mind, rather than being at the mercy of it, which may result in rumination and extreme stress.

Mindfulness improves both mental and physical health. It reduces anxiety and helps individuals find pleasure in life. It lessens worries and regrets, and helps people enjoy relationships and activities. Self-esteem increases as worry and concern about what others think diminishes and control over one's life increases. Pain and obsessive thoughts often seem to decrease.

Focusing on the moment generates energy, clear-headedness and might help individuals develop new habits that help to weaken negative patterns of thinking and behavior.

Over time, mindfulness brings about long-term changes in mood and levels of happiness and well-being.

Art therapy works well with mindfulness because being engaged in creative endeavors helps the individual focus on the artwork, which becomes his center of consciousness. He is in the moment, aware only of color, line, image and design. He is not judging his work, but allowing his art to flow from within.

EXPLORING THE SENSES 1

PROCEDURE: Clients close their eyes, take a deep breath, and draw what they see, hear, feel, touch or smell.

QUESTIONS FOR EXPLORATION:

1. What was your experience like?

2. What did you represent on the paper?

3. Which of your senses is most significant to you?

4. Which sense are you focusing on right now?

5. How can you use your senses to reduce stress and be in the moment?

CLIENT RESPONSES:

Devin, a woman in her fifties, challenged with anxiety and depression, drew an exotic island as her "escape." She stated she visualized an island in the Caribbean, complete with pineapple trees, a bright sun, sparkling clear blue water, and majestic trees towering over a stretch of warm, welcoming sand. Mountains were situated in the background. Devin remarked that observing the scene created calmness within her, and she wanted to stay with the feeling as long as possible. She remarked she could almost feel a slight breeze while inhaling the fragrance of wildflowers and clean, fresh air.

Maggie, a young woman in her twenties, also challenged with depression and anxiety, drew a tropical jungle scene with lots of greenery. She shared that she felt like she was in the middle of a plush jungle enjoying its sights and sounds as well as the "moist, pleasant air and warm temperature." She stated she felt welcomed and safe, as if the greenery was protecting her from any danger that might come her way. Maggie remarked that she felt "stupid" for drawing a jungle scene, but that was the first thing that came to mind. She was reassured that her visualization was valid and important, and could be used to reduce stress and as a reminder to be mindful.

MINI MANDALA

PROCEDURE: Outline a circle from the top rim of a large paper cup and color it in from the inside out.

QUESTIONS FOR EXPLORATION:

1. What type of image or design was formed?

2. Did you choose to stay within the circle or did you venture out of the circle? What does that say about your personality?

3. Can you think of a title for the mandala?

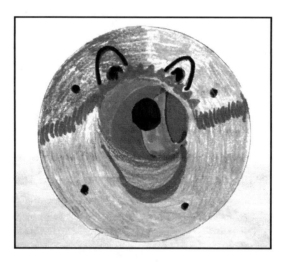

This warm up is useful for most populations because it is quick, easy and helps individuals focus and express their ideas. It provides structure, but participants can also choose to draw outside of the circle if they desire. Many clients like to design at least two or three mandalas if possible.[5]

CLIENT RESPONSE:

A 44-year-old client named Sid, diagnosed with bipolar disorder, designed this creative mandala. It began as a light pencil drawing of a face, and then he added color and more design in order to transform the face into a planet. Sid called the mandala, "a planet with a face." He decided to continue adding to the planet, while sharing that "it was important to expand upon this idea." He created a Saturn-like planet in the solar system, which he titled "HTRAE." This is earth spelled backwards.

Sid emphasized the importance of thinking outside of the box and he emphasized how it helps but also hurts him to be an innovative thinker. He gave the example of a recent incident in group. A peer asked Sid what he had in his lunch bag and he replied, "A bomb." He was joking and thought it was funny, but the staff at the short-term psychiatric facility was not amused. He was strongly confronted and told never to refer to the subject of weapons or bombs again. Sid understood the seriousness of his actions but stated that there are too many limits on what we say and do in this "anal society."

DRAWING BLIND

PROCEDURE: Draw with your eyes closed. Create any type of design or image. It may be abstract or realistic.

QUESTIONS FOR EXPLORATION:

1. How challenging was this exercise?

2. What are the benefits of doing artwork in this manner?

3. Did you find you were more or less mindful while drawing?

CLIENT RESPONSE:

Madeline, a 60-year-old woman challenged with alcohol and opiate addiction, drew the profile of her son Jack, whom she hasn't seen for nearly a year. When she viewed her sketch, she shared, "the sketch doesn't look like much of anything, but it represents my son in many ways." She said she often thinks of her son and misses him greatly. "He lives in another state and chooses not to see me because he's angry at me." Madeline shared that her son has been disappointed repeatedly by her erratic and selfish behavior. She sighed, "He doesn't trust anything I say or do."

According to Madeline, he still carries a grudge because Madeline was an irresponsible parent, who frequently left Jack alone at a young age. Madeline said she knew Jack was envious of his friends' mothers who were helping with homework, showing love and devotion, and "doing motherly things like cleaning the house, baking cookies for school functions, and making dinner." Madeline stated she knows she has been terribly irresponsible, but she wants to change now. She also acknowledged that she has to be patient and prove to Jack that she will maintain her sobriety. Madeline was cognizant of the fact that earning trust would take a very long time.

MINDFUL SPIRAL

PROCEDURE: Draw a spiral design, focusing on being spontaneous and in the moment. A spiral looks like a curl, coil or corkscrew, and often radiates out or winds inward, closer to a central point.

QUESTIONS FOR EXPLORATION:

1. What does the spiral look like? Does it remind you of anything in particular?

2. Is it simple or complicated?

3. Did you begin from the middle spreading outwards or from the top down (inwards)?

4. How could the presentation of the spiral reflect personality traits and mood?

5. What feelings or images are elicited by it?

6. Do you ever feel like you are spiraling in some way?

CLIENT RESPONSE:

Leah, a woman in her mid-sixties, drew a large, colorful spiral that almost seemed to bounce off the page. Leah remarked that the spiral reminded her of herself because she had been overindulging in food, shopping, spending and "anything else you can imagine," due to her bipolar disorder spiraling out of control. Leah shared that she stopped taking her medicine a few weeks before because she felt wonderful and full of energy; she didn't want "to come down off my high."

Her husband flipped, according to Leah, when he received a bill from a department store for three thousand dollars. He told Leah she had no choice but to get help immediately. Leah reluctantly agreed, knowing her frivolous and careless behavior would eventually ruin her marriage and her finances. In addition, she wasn't sleeping and she was over-eating. She gained over 10 pounds in two weeks, which she knew would eventually cause her to feel depressed and stressed.

MINI MANDALOODLE

PROCEDURE: Provide the outline of a small circle (about 3 -4 inches in diameter). Participants color it in with a doodle design, allowing the shapes and lines to interconnect in any way they desire, preferably using black marker or colors if desired.

A Mandaloodle is a mandala doodle. The circle is filled in with doodles of all sorts.

QUESTIONS FOR EXPLORATION:

1. How does it feel to "let your thoughts roll" and not worry about the outcome of the design?

2. How does designing the Mandaloodle create a feeling of calm and being in the moment?

CLIENT RESPONSE:

Anita, a 21-year-old woman challenged with bipolar disorder, drew a squiggle mandala below to represent her anxiety and "mixed-up thinking." She shared that she enjoyed this exercise because, although her thoughts were scattered, she was able to contain them in the circle, which provided her with a temporary sense of well-being. Anita shared she enjoyed not having to worry about the outcome of the design, and she was pleasantly surprised when it turned out "so well." She remarked she would try to create Mandaloodles whenever she felt anxious.

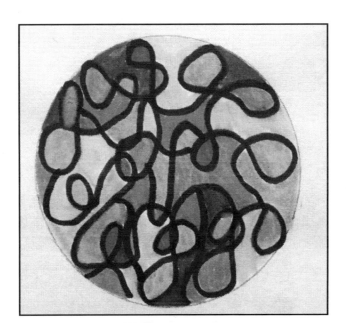

FEELING THE BEAT

ADDITIONAL MATERIALS: A CD, iPod or radio.

PROCEDURE: Draw as you listen to one song (soft or upbeat).

QUESTIONS FOR EXPLORATION:

1. How did the music make you feel?

2. How did your sketch reflect the meaning, beat and/or feeling of the music or song?

3. How can listening and/or drawing to music help you relax and be more mindful?

CLIENT RESPONSES:

Emma, a young woman in her twenties, diagnosed with depression and bipolar disorder, drew her reactions to a Beach Boys song, "Good Vibrations," below. Emma first painted to the beat of the music, and then used black marker to continue expressing feelings evoked by the music. She stated the song made her feel more energetic and improved her mood. She remarked she felt like dancing, but would have been embarrassed to do so in front of group members. When asked, Emma mentioned that the song reminded her of summers at the beach and having fun with friends. She said she has not seen her friends for weeks and knows she needs to socialize more often. Emma remarked the little squiggles she included in the artwork represented anxiety, "which is lessening but still there." The squiggles also symbolized her "occasionally drifting off and focusing on worries instead of focusing on the music." Emma shared that she had fun with the exercise and forgot how much she enjoyed "listening to oldies."

Lisa, a 35-year-old woman, overcoming anxiety and OCD, drew this eye-catching design on the next page while listening to the music of The Beatles and Bob Dylan. She shared that she began the drawing by allowing her hands to just move to the music. Then she started using shapes and color to represent feelings associated to the music.

To Lisa's surprise the shapes turned into what she called "a strange fish looking after a baby octopus." Lisa explained, "The fish has a palm tree growing out of the side of its head. It also has a tiny blue baby fish in its belly." When asked, Lisa shared the picture may symbolize her guilt about leaving her two young children with neighbors while she attends the psychiatric program. She sadly remarked that her daughter was crying when she left the house that morning at 8:00AM. "It made me so upset." Lisa stated she feels like a bad mother, but knows she has to help herself in order to be there for her children.

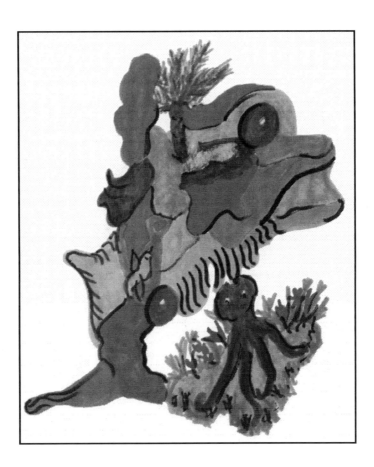

PEACE AND SERENITY

PROCEDURE: Draw a design representing peace and serenity.

QUESTIONS FOR EXPLORATION:

1. How can you attain the serenity depicted in the design?

2. When was the last time you felt peaceful?

3. What does peace feel like and look like? What are the colors, shapes, lines and images like?

CLIENT RESPONSE:

A 59-year-old man named Craig sketched a scene of two figures sitting in a small boat, fishing on a tranquil blue lake. Craig shared that the figures symbolized his son and himself. He remarked that his son is now married and living in another state, but they have always been very close, and over the years spent much time sharing interests, such as fishing, baseball and football.

Craig mentioned that when he thinks of those wonderful times, he feels peaceful and full of love for his son. He asserted that although his best friend Jim isn't as good of company as his son, Jim is now his substitute fishing buddy, and they both have a great time engaging in their favorite sport.

FOCUS WITHIN

PROCEDURE: Draw your "center." Think about your body as well as your spiritual center.

QUESTIONS FOR EXPLORATION:

 1. Where is your center?

 2. What do you like to focus your attention on?

 3. When was the last time you felt centered?

 4. How did it feel?

CLIENT RESPONSE:

Xavier, a 47-year-old man challenged with bipolar disorder, drew Mickey Mouse below. He shared that Mickey Mouse is a beloved iconic character that he and his family have loved for years. He said he smiles and always feels better when he looks at the cartoon figure. Xavier remarked that some of his happiest experiences were when he took his two young sons to Disney World about 10 years ago. He reminisced, sharing that they went on the rides, stayed at a Hawaiian-themed hotel, ate breakfast with Mickey, and experienced all that Disney had to offer. He chuckled, "It sounds funny for Mickey Mouse to be my center, but Mickey Mouse lifts my spirits." He mentioned he owns expensive Disney artwork, sculptures and other unique items. At the time of this exercise, Xavier was wearing a Disney teeshirt and Mickey Mouse socks, which group members found very amusing.

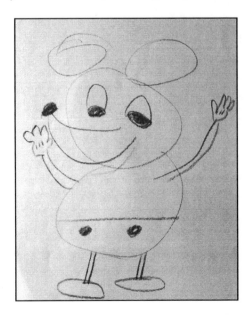

SWAYING IN THE BREEZE

PROCEDURE: Create an image that you find relaxing (e.g., clouds floating by, ocean waves, flowers or trees swaying in the breeze).

QUESTIONS FOR EXPLORATION:

1. How can imagery create a sense of calmness and reduce stress?

2. When would it be helpful to visualize this imagery?

3. When was the last time you engaged in an activity that made you feel tranquil?

CLIENT RESPONSE:

Lorna, a 37-year-old woman overcoming a deep depression, remarked, "I can't draw," so she chose to create a collage of items she found relaxing. She shared that she was beginning to "become my old self," and able to engage in relaxing activities, while focusing on positive thoughts. She added photos, which included a puppy, an artist's palette, a woman in a yoga pose, a smiling face, and a watch. Lorna commented that she worries about the passing of time, and decided she would not gaze at the clock so much during the day. She pledged she would begin exercising again and attempt to live in the moment. She remarked that she was thinking about getting a dog because she loves animals.

Lorna commented that a pet would give her pleasure, a purpose, motivate her to exercise, and provide great companionship. She also added the word "art " along with a picture of an ink pen, stating she used to paint and promised she would begin painting again, deciding to set up an art area in her apartment as soon as possible.

EXPLORING THE SENSES II

PROCEDURE: Draw one thing you see, one thing you hear, one thing you feel and one thing you smell.

QUESTIONS FOR EXPLORATION:

1. How does mindfulness of your surroundings help you relax?

2. How can your environment affect your stress level?

3. What type of environment do you find most therapeutic?

CLIENT RESPONSE:

A 58-year-old woman named Antonia, who had been having difficulty with her grown son, drew a dark cloud to represent what she sees (actually the sun was shining and there were no clouds in the sky). She drew a sketchy dark green line to symbolize the humming of "annoying" background voices emanating from another room; she created a brick to represent the feel of the art table in front of her, and she drew a dark circle of sinewy smoke to represent what she smells.

In reality, there was only the faint scent of hand wash in the air, but Antonia felt so miserable and angry that her senses "were distorted." She also added a small figure (herself) being hammered by a large mallet (her son). She remarked that the previous day her son and she had had a heated argument and he had said many hateful and bitter things to her. His last words were that he never wanted to see her again. Antonia felt devastated.

LIVING IN THE MOMENT

ADDITIONAL MATERIALS: Cut paper, acrylics, magazine photos.

PROCEDURE: Ponder this affirmation for a few seconds: "Be happy for this moment is your life." (Omar Khayyam)

Next, draw your experience of *this moment*. You may add words, phrases and magazine photos if desired. Think about thoughts, feelings, emotions, attitude, motivation, behavior, and environment.

QUESTIONS FOR EXPLORATION:

1. How did you represent this moment? Did you tend to be more positive, negative or neutral?

2. Is there anything to be joyful about now?

3. How does the way you view this moment represent how you tend to live your life?

4. How can a focus on finding happiness in the moment affect your mood, outlook, energy level, work, life satisfaction and relationships?

CLIENT RESPONSES:

Oliver, a man in his late sixties, wrote a variety of words in various sizes and colors on the paper, creating an attractive type of word art. He shared that the words reflected his current feelings, and he laughed as he remarked that he was experiencing "so much at one time." Some of the words he included were, "humor, kindness, low self-esteem, disrespect, fear, emotional pain, sadness, depression, dread, physical pain, sunshine and forgiving." Oliver commented that his desire was to find more of a balance in his mood and behavior. He stated that he felt well at the time of this exercise, but he knew he might feel stressed and very anxious at home.

Doris, a 52-year-old woman, created an abstract design with a few words intermingled within the colorful shapes. She shared that "in this moment" she felt sunny, energized, bright and enthusiastic. Doris remarked that although it was almost 3:30PM, and she had felt tired earlier, the warmth and kindness of the group members made her feel upbeat and energized. She shared she wanted her design to represent her joyful mood so she attempted to make the shapes connect with one another to symbolize the positive connection she felt toward group members.

RESTING MIND

PROCEDURES: Symbolize your mind at rest. In your drawing, depict the calmness and peacefulness associated with being mindful.

QUESTIONS FOR EXPLORATION:

1. What types of shapes, images and colors were used to portray your mind?

2. Describe the way your mind usually works (e.g., calm, chaotic, swirling thoughts, negative thoughts, positive thoughts, confused, focused, etc.).

3. How can being mindful contribute to a calmer and happier life?

4. What does mindfulness mean to you?

5. What part of your life/lifestyle would benefit most from being mindful?

CLIENT RESPONSE:

Heather, a 28-year-old woman with depression, drew a lightly colored amorphous shape "sitting on a cloud." Heather shared that it was rare that her mind was at rest, but when she was able to relax she felt at peace and sometimes like she was "floating on a cloud." She commented that smoking marijuana used to make her feel serene, but eventually the marijuana "turned on her" and made her feel depressed and a little paranoid. She shared she is trying to reduce stress by exercising at the gym, journaling, sketching, listening to guided imagery and calming music, and taking more walks in the park.

LOVING BREATH

PROCEDURE: Listen to the soothing music and slowly breathe in through your nose and out through your mouth while imagining you are being bathed in love, peace and warmth. Imagine yourself breathing in beauty and calmness and breathing out anxiety and stress.

Next, draw yourself being embraced by someone or something you love (you may write in addition to or instead of drawing).

QUESTIONS FOR EXPLORATION:

1. Who or what is embracing you? How are you feeling?

2. When was the last time you felt supported?

3. How can you support/embrace yourself?

4. What can you do today to show yourself self-compassion?

CLIENT RESPONSE:

A woman in her mid-fifties named Gina drew herself being embraced by her mother who recently died of a heart attack at age 92. She shared that her mother was a kind, loving woman who was always supportive of her, even throughout her addiction, two divorces, and severe financial problems. She remarked that her mother taught her the art of forgiveness and seeing the big picture. Gina shared she was unsure who would support her now because she and her daughter had been estranged for years, and her friends were all addicts whom she had to avoid if she wanted to remain sober. Gina remarked, "I know I have to learn to be my own best friend, but that will be an ongoing process, and not an easy one."

EXPERIENCING THE "NOW"

PROCEDURE: Draw where you are in the moment.

QUESTIONS FOR EXPLORATION:

1. How did you portray yourself? Consider size, shape, color, expression, position on the paper, etc.

2. Think about where you are physically and/or emotionally (e.g. Are you focused on what is happening now, or are you dwelling on past or future events?).

3. Are you where you want to be right now? Think about where you are emotionally and what your environment and relationships are like at this point in your life.

4. Would you like to change? If so, how can you begin to transform yourself and your life?

CLIENT RESPONSE:

Sharon, a 59-year-old woman with anxiety issues, drew herself with other family members, below, in a hospital room watching her sleeping father, who was trying to recover from a severe illness. She shared that she was seated on the right next to her mother, who was speaking to her sister-in-law. Sharon stated that she felt stressed and worried; she was daydreaming about happier times. She wished things could be different and imagined her and her family enjoying a delicious meal at a favorite restaurant instead of gathering at the hospital. When asked, she explained that she coped by taking one day at a time.

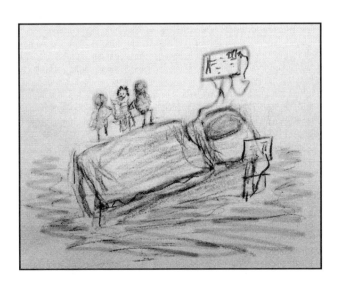

MOMENT X 1

PROCEDURE: Think about the phrase "Moment x 1" (it means take one moment at a time)[6]. Draw something you presently need to take one moment at a time or had to take one moment at a time in the past.

QUESTIONS FOR EXPLORATION:

1. How can taking something one moment at a time be helpful?

2. When have you had to handle a problem, issue or loss in this manner?

3. What can you share about the present moment (e.g., is it stressful, relaxing, boring, etc.)?

CLIENT RESPONSE:

A 26-year-old woman named Sloane drew a figure sitting on top of a colorful setting sun. She remarked the figure represented her boyfriend whom she had just broken up with because he didn't want to commit to a long-term relationship. The sunset symbolized the end of a "beautiful period of time." Sloane stated she was heartbroken, but that she and her boyfriend had very different life goals. She shared that she is old fashioned and wants a family and a house in New Jersey, while he wants to live in a large city like Chicago or Los Angeles and enjoy a fast-paced life.

In addition, he recently announced he wanted an open relationship, which Sloane found extremely repugnant and upsetting. Sloane mentioned she had to accept her new life and put one foot in front of the other, taking each day moment by moment in order to cope with her distressing situation.

PAST, PRESENT, FUTURE

PROCEDURE: Think about this affirmation: "The past is a lesson. The present is a gift. The future is your motivation."

Next, draw a symbol related to a lesson you learned in the past, a gift you have in the present and a goal for the future.

QUESTIONS FOR EXPLORATION:

1. What lesson/s have you learned that have affected how you lead your life now?

2. In what way do you see the present as a gift? What is your greatest gift?

3. What goal/s do you have for the future? Are you determined to push forward or are you having difficulty with motivation?

CLIENT RESPONSE:

A 34-year-old man named Richard drew a bottle of whiskey to represent the past, a group of people sitting around a table to represent the present, and a family of four people to represent the future. Richard shared that he has been drinking and taking drugs since high school, and has been completely selfish and irresponsible. He stated he used to blame his wild behavior on his illness (bipolar disorder), but acknowledged he used his illness as an excuse to do whatever he wanted. He shared that he is currently attending AA and NA, as well as a variety of therapy groups in order to stay clean and sober.

Richard remarked he is hoping to go back to school and eventually get a job as a computer technician. He mentioned he would like to settle down in future years and have a wife, two children and a nice home in the suburbs.

AFFIRMATION PASS

ADDITIONAL MATERIALS: Printed out affirmations cut out and ready to distribute, glue, scissors, and an 11x17 or larger sheet of drawing paper. The group leader should have about three times as many affirmations as there are group members.

Affirmation examples included:

"I am the master of my thoughts."

"I am enough."

"I choose to make the rest of my life the best of my life." (Louise Hay)[7]

PROCEDURE: Clients are asked to look through the affirmations and choose one that resonates with them. Then the paper is passed around the room and each person takes a turn gluing his affirmation onto the page, anywhere he likes. The one sheet goes around the room until all the chosen affirmations have been glued on to it and an affirmation collage has been created.

One group participant is asked to read all of the affirmations or each person reads the affirmation he or she originally selected.

QUESTIONS FOR EXPLORATION:

1. Did your original affirmation convey a significant message?

2. Which collage affirmation affected you most?

3. Which affirmation would you choose to lessen stress? To be more mindful? To lessen depression?

4. How can affirmations help change your way of thinking?

5. Group participants may want to vote for the most meaningful affirmation.

CLIENT RESPONSE:

There was a lot of discussion and socialization occurring during this exercise. Group members appeared pleased with the outcome of the collage.

Out of the eight affirmations the most popular one was:

"Happiness is a choice. Not a result. Nothing will make you happy until you choose to be happy." (Ralph Marston)[8]

One individual wrote, "Asking myself to help myself."

2
Chapter
Self-Awareness

With our busy schedules, it might be difficult to think about who we are, our strengths and weaknesses, our drives and personalities, our habits and values. Many people just aren't inclined to spend too much time on self-reflection. Even when personal feedback is presented to us, we're not always open to it.

Self-awareness is important for many reasons. It can improve one's judgment and help identify opportunities for personal growth and professional development. Self-awareness builds self-esteem and confidence. It helps individuals decide which direction their life should be following and what their needs and desires are.

Being self-aware includes acknowledging and understanding:
- Wishes and desires
- Strengths
- Weaknesses
- Motivation or health and happiness
- Challenges
- Relationships with others
- Barriers to achieving wishes
- Beliefs and values
- Self-esteem

The following exercises help clients broaden their outlook and examine their identity, lifestyle, goals, relationships, purpose, and overall life satisfaction. In order for a person to change negative thought patterns, unhealthy behaviors and low self-esteem, he must first become aware of any barriers to happiness and success.

Transformation entails self-awareness. An individual needs to be aware of his desires, fears, dreams, and goals. If a person is unhappy or indecisive, it is important to have a plan and understand what has to be completed in order to head in the right direction. Until an individual recognizes his purpose, thinking patterns, and life path, he will have difficulty forging ahead and overcoming obstacles. Participation in self-awareness activities helps create a pathway for further exploration and reflection.

ENHANCING THIS DAY

PROCEDURE: Create a quick sketch of what you need "today."

QUESTIONS FOR EXPLORATION:

1. What do you need in order to feel fulfilled?

2. What are your immediate needs and what are your long-term needs?

3. How do you handle your emotions when your needs are not met?

4. How can you increase the likelihood of satisfying your desires?

CLIENT RESPONSE:

Cindy, a 35-year-old woman with depression and anxiety, took a somewhat lighthearted approach to the exercise. She drew an ice-cream sundae topped with chocolate syrup, colorful sprinkles, walnuts, almonds, chocolate bits, and a cherry. Cindy shared that she has been trying to diet due to a 15-pound weight gain over the past few months. She stated her medication is making her retain fluid and causing her to feel ravenous all the time. She remarked that she's hungry from the moment she wakes up in the morning to the moment she goes to sleep at night. She stated she's trying to stay away from sweets, fast food and fried food, but this is a very difficult endeavor. Cindy shared that she would be ecstatic if she could eat ice cream right now.

Many group members smiled and completely agreed with her. One man jokingly offered to take all eight participants to a local ice-cream parlor. *This exercise took place at 9:35AM, not long after Cindy ate her rather large breakfast of oatmeal, wheat toast and eggs.*

IMMEDIATE THOUGHTS

PROCEDURE: Sketch the first thing you thought of when you woke up this morning.

QUESTIONS FOR EXPLORATION:

1. How does your image reflect your morning mood?

2. How can your thoughts affect your motivation to wake up, shower, and begin the day?

CLIENT RESPONSES:

Terrence, a 35-year-old man with bipolar disorder, drew a smiling face. He shared that this was the first day in a very long time he actually felt better. He stated that his head was clearer, he was more focused, and he felt motivated. He shared that in the past he had great difficulty waking up and would usually believe the day would be terrible. The medicine made him so tired that functioning was a huge chore.

☙☙

Brad, a young man in his mid-twenties, challenged with addiction issues, drew a large plate of pancakes smothered with syrup. Brad, who likes to be the group comedian, shared that he woke up ravenous and wanted to eat a big, delicious breakfast. He remarked that he hopped out of bed, took a quick shower, and made sure to find the time to stop at a fast food restaurant on the way to the program. He stated that he "absolutely had to have a huge breakfast." He described in detail what he ate and how good it was, while group members began to salivate. Brad laughed, clearly enjoying all the positive reactions, and said that he was actually beginning to feel hungry again. He then started sharing his possible lunch menu.

Brad's humor created a relaxed atmosphere and a warm feeling among group members. They became united in their laughter and enjoyment of Brad's attitude and detailed breakfast description.

SELF-REPRESENTATIVE MAZE

PROCEDURE: Draw a maze and place yourself in it.

QUESTIONS FOR EXPLORATION:

1. What type of maze did you draw (easy, difficult, complicated, etc.)?

2. Where did you place yourself in the maze?

3. Are you satisfied with the placement?

4. How long have you been in the maze?

5. If you are within the maze, do you see an end in sight?

6. Are you ready to find a way out?

7. Are you alone or are others in the maze with you?

CLIENT RESPONSE:

Bernard, a disorganized 30-year-old man with bipolar disorder, placed himself at the very beginning of the maze. He drew himself as a tiny stick figure surrounded by a very large and detailed maze. His figure appears precariously balanced; it looked like it would tumble over very easily. Bernard shared that the maze (his life) seems overwhelming right now and he is having difficulty even entering the maze. He feared that upon entering the maze he would become lost and never find his way out of it. He shared that he was trying to stop drinking and smoking marijuana. Bernard stated that drinking and marijuana were his lifelines, "they are the only things that keep me sane and allow me to relax."

Bernard shared that he has been all alone at the entrance to the maze since about 16 years of age. Bernard did say that he was willing to accept help from others, and would definitely require assistance to manipulate the maze. "There are some pretty scary things in there." He was referring to responsibility, getting sober, getting a job and possibly going back to college. He said he would begin by trying to wash his own clothes and cook for himself. He was supported to take tiny steps forward.

WINDING ROAD

PROCEDURE: Draw a winding road and place yourself on it.

QUESTIONS FOR EXPLORATION:

1. Where are you on the road?
2. How do you feel about your placement?
3. What types of experiences have you had on the road?
4. Are there obstacles of any kind on the road?
5. How long have you been traveling the road?

CLIENT RESPONSE:

Danielle, a 55-year-old woman with bipolar disorder, drew herself halfway down a bumpy road. She shared that she has overcome many hurdles but she still has a long way to go in order to feel "normal." She drew herself as a large stick figure that appeared uncertain. She noted that her uncertainty might be attributed to her rocky relationship with her husband of 34 years. Danielle remarked that he is very controlling and keeps her from engaging in hobbies such as painting and collage art, and social activities with friends. Instead of making a mess with art materials he wants her to keep the house spotless and be cleaning and cooking in her spare time.

In addition to husband problems, Danielle has a controlling and overbearing mother-in-law who apparently controls her husband "like a puppet." She butts into their private life and even involves herself in marital disputes. Danielle stated she has to get off the road she is presently on because it is unhealthy and destructive.

WHO AM I?

PROCEDURE: Draw one symbol to represent yourself.

QUESTIONS FOR EXPLORATION:

1. How would you relate the symbol to your personality characteristics and behavior?
2. What is your reaction to the symbol? (e.g., is it positive; is it something to be proud of? Does it represent a strength or achievement?)

CLIENT RESPONSE:

Alexander, a man in his forties diagnosed with depression and anxiety, drew an artist's palette. He shared that he is an artist and has sold his paintings for hundreds of dollars in various galleries in New Jersey and New York City. He stated that art helps him cope with life's stressors, and believes he would have committed suicide a long time ago if it wasn't for the joy he derives from painting, and the distraction that art provides for him. He commented that when he paints he forgets some of his issues and becomes immersed in what he's doing. He remarked that he becomes happier and temporarily forgets how terrible his life has become. He shared that he even forgets his loneliness and disappointment with close friends and family.

VIM AND VIGOR

PROCEDURE: Think about your motivation, vitality and strength. Consider the size, shape and color of your energy. Is there a specific image or design representative of your energy? Draw your energy.

QUESTIONS FOR EXPLORATION:

 1. Describe the amount and intensity of energy you possess.

 2. How would you rate your energy?

 3. How can you achieve and maintain energy throughout the day?

CLIENT RESPONSE:

An 18-year-old woman named Alyssa drew a small green turtle to represent her energy. She shared that she has virtually no energy now, but is plodding along slowly and steadily. The tale of the tortoise and the hare came to mind as she spoke about feeling left out and that her friends and other people her age were where she "should be right now." She complained that she should be in college and living in an apartment, away from home. She believed she should be more independent. Alyssa felt she was way behind her peers and would have difficulty catching up. She was asked to be aware of every time she said, "should." *Should is a word to avoid; it promotes low self-esteem and guilt.*

LINED UP

PROCEDURE: Draw a picture using only straight lines.

QUESTIONS FOR EXPLORATION:

 1. How challenging was this task?

 2. What did you create and what does it represent?

 3. Do you tend to stay on the "straight and narrow" path or do you tend to deviate to the right or left?

CLIENT RESPONSE:

Renee, a 46-year-old woman with bipolar disorder, drew a house that was falling apart. Renee remarked that the house used to be a mansion but after years of neglect, it had become very rundown and was falling apart. When asked, Renee mentioned that the house could represent her. She stated she feels tired and run down all the time. She complained that she doesn't like her old clothes and she lost too much weight. "I'm too skinny." Renee continued to berate her appearance, even criticizing her straight hair and nails, which she stated she hates because they are short and unpolished. When asked, Renee remarked she tends to worry what others think, tries to please everyone, and always does what is expected of her. In addition, she stated that almost any type of change makes her extremely anxious.

DESIGNING DOTS

PROCEDURE: Draw a picture using only dots. You may want to examine the work of Georges Seurat, who created amazing masterpieces using pointillism. This type of exercise is fun, easy and an effective mindfulness exercise, which aids in increased relaxation and focus.

QUESTIONS FOR EXPLORATION:

1. How did you organize the dots in order to create a piece of art?

2. This type of drawing requires a focus on details; are you usually focused and organized or less structured in your life?

CLIENT RESPONSE:

Marie, a woman in her sixties dealing with depression and anxiety, drew a dot flower below. It took up most of the page and was very attractive. She used red, pink and green colors to design it. Marie shared that she enjoyed creating the art because it helped her focus and it was soothing. She liked the ease of placing the dots on the paper and observing what would result from the placement. She shared that she loves flowers and her husband often surprises her with her favorite red roses even when it is not a special occasion. Marie remarked, "Flowers brighten my day and help with my depressed mood, at least temporarily."

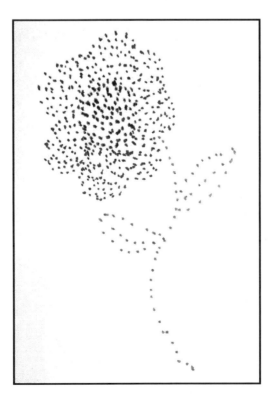

GLASS OF OPTIMISM

PROCEDURE: Draw a glass and fill it with your level of happiness today.

QUESTIONS FOR EXPLORATION:

1. How filled up is the glass?
2. Is your glass frequently on the fuller side (optimistic) or emptier side (pessimistic)?
3. What affects the fullness of your glass (e.g., relationships, hobbies, rest, etc.)?

CLIENT RESPONSE:

Alan, a young man in his twenties overcoming anxiety and addiction issues, drew a glass that was three-quarters full and designed with colorful swirls. Alan shared that he had learned many coping techniques while participating in an outpatient psychiatric program, and he was getting along better with his father, who had often berated him in the past. His father viewed him as a failure and a disappointment because of his lying, stealing and drug abuse. His father had high expectations for him, wanting him to complete school and become an attorney. Alan shared that the swirls represented his hope to move out of his parents' home and return to school or get a job. They also symbolized his anxiety about making a dramatic change in his life. He did emphasize, when asked by a peer, that his glass was half full and not half empty. He was determined to be more positive in his outlook.

REMINISCENCES OF HOME

PROCEDURE: Draw one item you remember in your first bedroom.

QUESTIONS FOR EXPLORATION:

1. What do you remember most about the item?
2. Why was it significant? Did it make you feel special, cheerful, sad, etc.?
3. What was life like for you during that period of time?

CLIENT RESPONSE:

John, a 28-year-old man with addiction issues and bipolar disorder, drew a model of Frankenstein. John shared that he and his father had created the model together when he was about 10 years old. He remarked that they had spent many weekends working on the model, even painting it together. John sighed, sharing that his father was so proud of him during those earlier years. "But now my father shows much disappointment and anger with me. He tells me I am a loser and will amount to nothing. He used to think so highly of me; we were best friends." John remarked that he wishes his father would try to learn more about addiction and mental illness, and try to understand what he is experiencing. John stated he believes his father doesn't even want to understand. "He only wants me to be normal." He complained that his father constantly compared him to his older brother who was in medical school and excelling. "That hurts," John said. "It is tough to try to live up to the accomplishments of my brother." One group member suggested John not compare himself to his brother, try not to worry so much, and focus on his sobriety.

TREASURED POSSESSION

PROCEDURE: Draw your favorite item in your house.

QUESTIONS FOR EXPLORATION:

1. What is the significance of the item?

2. How does it make you feel?

3. Is it a person or thing?

4. Is it new or old? Did you buy it for yourself or was it given to you?

CLIENT RESPONSE:

Marvin, a 48-year-old man with bipolar disorder, shared that his guitar was his favorite item. He stated he loves playing the guitar. "It relaxes me and makes me happy." Marvin went on to say that when he plays the guitar he is in a different world. He is not thinking about his problems or his stressful job and "horrible boss." He remarked that he feels pleased with himself every time he learns to play a new song, especially one that had been difficult to learn.

Marvin laughed, commenting to group members that when he was younger he wanted to be a rock star. He visualized himself headlining concerts with his band, surrounded by fans swooning and screaming for him to play more tunes.

SELF-AWARENESS
AND TRANSFORMATION

PROCEDURE: Fold a piece of paper in half. On one side, represent one thing you like about yourself and on the other side draw one thing you would like to change.

QUESTIONS FOR EXPLORATION:

1. What do you like about yourself and what do you want to change?

2. Which side of the paper is emphasized?

3. How can you begin changing undesirable actions, lifestyles, relationships and/or traits?

CLIENT RESPONSE:

Jill, a 32-year-old nurse with anxiety and addiction issues, drew a smiling woman on one side of the page and "a bottle of booze" on the other side of the page. Jill shared that the smiling woman represented her desire to help people and her love of nursing. She continued to share that she is on a forced leave from work because she was caught taking care of a patient, with alcohol on her breath. She was mandated to attend an addictions program or else be fired from her job. The bottle of alcohol represented her anger at herself for not having the control to stop drinking, and for imbibing on the job.

She stated that she knows she has an illness, but still feels guilty about her dangerous binge drinking and despicable behavior. Jill shared that she wished she could take back all the lying and damage she has done, but knows she has to forget the past and begin anew.

BRAIN WAVES

PROCEDURE: Draw your brain waves. Think about your thought patterns, and the way your brain appears to function, for example: Are your thoughts chaotic or calm? Are you able to control your thoughts or do they run rampant? Do they tend to be positive or negative? Do you tend to think clearly or are you forgetful and disorganized? Do you often act impulsively or do you take time to process first and then act?

QUESTIONS FOR EXPLORATION:

1. What do your brain waves look like? For instance, are they wavy, smooth, bright or dull?

2. How do the waves reflect your thoughts and/or personality?

3. Have the waves changed recently?

CLIENT RESPONSE:

Carol Anne, a woman in her late thirties, drew a series of multi-colored squiggly lines covering the page. She shared that her brain waves are erratic right now and that she is having difficulty concentrating and focusing. She explained that she hears what is being said to her but doesn't take it in. "I will forget what you said 10 minutes later, because I am hearing but not really listening." She remarked that her depression makes it difficult for her to read more than a paragraph of a book or magazine, and she also has problems engaging in conversations and staying on topic. Ironically, she was able to engage fully in this exercise, follow directions well, and share appropriately.

DREAM IMAGERY

PROCEDURE: Draw one symbol from a dream (recent or in the past).

QUESTIONS FOR EXPLORATION:

1. What does the symbol represent to you?

2. Is it a novel symbol, or repetitive?

3. Do you usually remember your dreams?

4. What type of dreams do you often have; are there recurring themes?

5. How do your dreams reflect your state of mind and/or daily experiences?

CLIENT RESPONSE:

Wendy, a 55-year-old woman suffering with extreme anxiety, sketched a picture of a prehistoric animal. "It looked somewhat like a Tyrannosaurus rex, and it was chasing me," she said. Wendy remarked that she was terrified in her dream, and just when the dinosaur was about to pounce on her, she woke up in a sweat. When asked, Wendy commented that the dinosaur might represent her mounting financial issues. She noted that she owes a lot of money on her credit cards and her mortgage is past due. She complained that she stays up nights worrying that the bank will take her house and she will have nowhere to live. She shared that she often has nightmares but this was the first time she feared for her life in a dream.

REFLECTIONS OF MYSELF

PROCEDURE: Draw a self-representative shape. Reflect on your personality characteristics, self-worth, interests, concerns, life style, and your core beliefs. For example, someone with very low self-esteem may draw themselves as a tiny, lightly sketched stick figure, while someone with healthy self-esteem may create a large robust figure taking up much of the page.

QUESTIONS FOR EXPLORATION:

1. How is the shape reflective of your personality and traits?
2. Is it on the larger or smaller side?
3. Is it colorful, bright, detailed or duller and simplistic?
4. Would you have drawn a similar shape in the past, and do you think your shape will be similar or different if you are asked to draw another in the future?

CLIENT RESPONSE:

Minnie, a woman in her seventies with depression and anxiety, drew a block to represent herself. She shared that until recently she had been very strong and handled all of her problems and life's obstacles well. She remarked she even accepted the death of her husband after a long illness with cancer. The death of her best friend Marge was "the straw that broke the camel's back." Minnie stated that she had been friends with Marge since childhood, and she was actually closer with Marge than she had been with her husband of 40 years. Minnie stated she felt lost and feared her "strength block would turn into a weak, little pebble." She did smile a bit when group members supported her, telling her she was still strong, and smart for seeking help.

THE COLOR OF PAIN

PROCEDURE: Draw your pain using color and shapes.

QUESTIONS FOR EXPLORATION:

1. What does your pain look like? What does it feel like?
2. Is it large or small, steadfast or wavering?
3. Where is your pain focused?
4. How long has it been with you?
5. How do you deal with it?
6. How can you minimize or eliminate it?

CLIENT RESPONSE:

Mark, a 55-year-old man diagnosed with bipolar disorder, drew his pain as one large red spiral. He stated that when he worked as a builder 5 years ago, he had a severe accident, which put him out of commission for months. A steel girder fell on his back and knocked him unconscious; he was in a comma for 3 weeks. Mark shared that although he sees a pain management doctor, he is always in discomfort and has difficulty sitting still for more than 10 to 15 minutes at a time. Sleep is also a huge issue for him because he can't get into a comfortable position. He did say that drawing seemed to be a welcome distraction and lessened his pain, albeit for a short while.

EMOTIONS IN THE SKY

PROCEDURE: Draw a sun, cloud and star. The sun will represent optimism; the cloud will represent depression or pessimism; and the star will represent hope and enthusiasm for a brighter future.

QUESTIONS FOR EXPLORATION:

1. How did you represent the symbols? Which ones are emphasized and which symbols are minimized?

2. How does your sketch relate to your current mood and motivation?

3. What are you doing to improve your outlook?

CLIENT RESPONSE:

A 26-year-old woman named Ava drew a small sun to represent a tiny glimmer of hope that eventually she would heal from a recent sorrow. She added a large dark cloud to represent her despair and shock regarding her boyfriend who recently left her for another woman. She stated he had just spoken about getting married and having children the previous week. Ava remarked he told her he loved her more than anyone he had ever met and wanted to be with her for eternity. She remarked she was heartbroken but also extremely angry for being deceived in such a cruel manner.

Ava placed a silver star near the sun and shared that she believes in fate and thinks there is still a man somewhere who will love her and accept her for who she is. She remarked that in the future she would be more alert towards warning signs that her relationship might not be going as well as she thinks. She stated she would take things slowly and be very careful about whom she chooses to date.

SYMBOLIC TREE

PROCEDURE: Draw a tree in any way you please.

QUESTIONS FOR EXPLORATION:

1. What type of tree did you draw?

2. Is it tall or short? Strong or weak?

3. Is it young or old?

4. Has it weathered many storms?

5. Has it lost branches or has it grown new ones?

6. What is the root system like?

7. What does it need to grow and thrive?

8. In what ways does it reflect "you"?

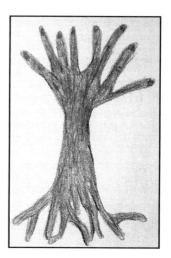

CLIENT RESPONSES:

Gail, a 32-year-old woman with bipolar disorder, drew a surreal looking tree, above, with its hand and fingers (branches) reaching upwards. Gail shared that she feels pulled in many directions, and feels as if she is being pulled "by the roots." She remarked that her tree looks like it is "anxious, antsy and unstable." She shared she feels that way most of the time. When asked, Gail stated the tree needs some stability and a strong, stable root system to survive.

Bill, a depressed man in his early thirties, drew a dead tree. The tree was small and frail, with a cracked brownish/black trunk; there were no leaves on the few scanty branches. The tree seemed to be turning downward, much like an elderly person suffering from a degenerative back disease. Bill complained that Sara, his girlfriend of five years, had just left him without an explanation. He shared they had been arguing about getting married, but she gave no indication that she felt so strongly about the matter. She had not given him an ultimatum, even though he thought this would occur eventually. Bill admitted he really did not want to get married, ("too much responsibility,") but he certainly wanted to remain with Sara. He felt in a bind, lost, and terribly depressed because of her departure. When asked what the tree (Bill) needed to recover, Bill replied, "a kiss from Sara."

PRIZED POSSESSION

PROCEDURE: Draw one of your favorite possessions.

QUESTIONS FOR EXPLORATION:

1. What possession did you draw?

2. Why is it important to you?

3. Are there memories associated with it?

4. How long have you had it?

5. How does it help you?

6. Did you find it, buy it, or was it a gift?

7. Does it help you cope with adversity?

CLIENT RESPONSE:

Beverly, a woman in her forties with depression and addiction issues, drew her cat, Pudding. She shared that Pudding was helping her through her depression and was the only thing in the world she loved. Pudding gave her a reason to wake up, shower, and dress in the morning. Beverly knew she had to feed and take care of her beloved cat. She also knew the cat could sense how she felt; Pudding seemed to empathize with her and copy her actions.

Beverly mentioned that when she felt depressed, Pudding would also act depressed, eating less, looking sad, and sleeping more. Beverly did not want to be responsible for "a mentally ill cat," so she tried to function. She stated Pudding was a blessing because she was able to say anything to Pudding and Pudding would still love her unconditionally and certainly not judge her. Beverly found that very comforting, especially when she was faced with tremendous disappointment and adversity.

JUST FOR TODAY

PROCEDURE: Draw yourself a present – something you need today.

QUESTIONS FOR EXPLORATION:

 1. What do you need today?

 2. How important is the item/concept to you?

 3. How would it help you?

 4. How would it affect your mood or behavior?

 5. Is it a realistic present?

 6. What can you do to achieve it/ buy it/ acquire it for yourself?

CLIENT RESPONSE:

Madeline, a 50-year-old woman with bipolar disorder, decided to take the suggestion one step further. She chose to add photos of what she wants to do "as soon as possible." She quickly designed this collage, below, that focused on her desire to visit China. She shared that a trip to China would be an amazing present; "It's on my bucket list." She included The Great Wall, which she has wanted to visit for years. On the bottom right of the page she included the phrase "indulge all 5 senses." Madeline related the phrase to her pledge to live life to its fullest and enjoy many great experiences and new adventures. She remarked she hates to be bored, and always needs to be moving, going places, and meeting new people.

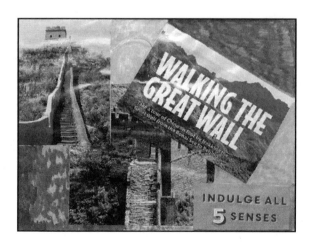

GROUP MOOD

PROCEDURE: Draw what you perceive to be the mood of the group members. This exercise can also be effective with family members and friends. Observe body language, facial expressions, interactions, and what is and isn't being verbalized.

QUESTIONS FOR EXPLORATION:

1. What colors, shapes and/or images did you use to represent the group mood?
2. How does the mood of the group affect your mood?
3. What factors play a role in the mood of the group?
4. How do you feel about being part of the group?
5. What is your role in the group?
6. What can you do to change the mood of the group when group members seem low-spirited?

CLIENT RESPONSE:

On a sunny Monday morning, a young man named Dane drew a very serene scene to describe the mood of the group. He stated his work, which was drawn with pale crayon colors, represented a sunrise over a beautiful meadow. He shared that group participants appeared tired, but calm and friendly. He liked that they welcomed him warmly as they introduced themselves during the warm-up exercise. When asked, Dane shared that he liked the peaceful mood of the group and felt relaxed and motivated to work.

LINE DIALOGUE

PROCEDURE: Create a dialogue (connection/relationship) between two or more lines.

QUESTIONS FOR EXPLORATION:

1. What type of dialogue is represented?
2. How do the lines connect with one another?
3. How does the line dialogue reflect your own inner dialogue?

CLIENT RESPONSE:

DJ, an 18-year-old challenged with addiction issues, drew two lines on opposite ends of the paper, and one squiggly line in the middle of the paper. DJ remarked that the squiggly line represented him and the other lines represent his parents, who are constantly arguing with each other. He stated he is always caught in the middle of their arguments and they use him to hurt each other. He complained that he feels like a pawn in his parents' dysfunctional relationship. DJ mentioned that he drinks and smokes marijuana as a way to disengage from his parents and relax. He stated he was looking forward to next year when he would begin college and live on campus, "far away from my parents, thank goodness."

LUCKY CHARM

PROCEDURE: Draw your lucky charm.

QUESTIONS FOR EXPLORATION:

1. What type of lucky charm did you create?

2. Is the charm a person, item or concept?

3. Do you believe in lucky charms?

4. How can they help you or possibly undermine you?

5. How can you make your own luck?

6. Who is the luckiest person you know?

7. What makes him or her lucky?

8. Who is the unluckiest person you know?

9. What makes him or her unlucky?

10. What role does making healthy choices play in being lucky?

CLIENT RESPONSE:

A 56-year-old man named Hal drew a silver keychain that was representative of the one his wife gave him on their fifth anniversary, when he was hospitalized with sepsis and pneumonia. His name was engraved on it along with a heart that said, "Love Always." He remarked that he held on to the keychain throughout his hospital stay, even when he was weak and frail, and in extremely critical condition. Hal shared that his health eventually improved and he and his wife were able to celebrate their anniversary a few months later. Hal said he believed his wife's love and support helped him survive. He viewed the keychain as a symbol of that love and support and always kept it in his wallet. Hal believed it had helped him through other serious incidents such as a car accident in Princeton, New Jersey, a fall from a ladder, and a near-miss with a deer on a recent car ride home.

SELF-REPRESENTATIVE ANIMAL

PROCEDURE: Draw (in a realistic or abstract manner) the animal you relate to the most. The group leader may hand out photos of various animals so participants will be able to copy the pictures if desired.

QUESTIONS FOR EXPLORATION:

1. Which animal did you choose and why?

2. What characteristics do you and the animal have in common?

3. What about the animal's life do you find appealing?

4. How is its life different from yours (e.g., environment, relationships with other animals of the same species, amount of freedom, strengths and abilities, etc.)?

CLIENT RESPONSE:

Mason, a man in his forties, drew a large, gray shark. He shared that he is tired of being "Mr. Nice Guy," and letting people take advantage of him. He stated he does favors for all of his friends and family, and it is rare for anyone to return a favor or even thank him. Mason remarked that people in his life are so used to his kindness and willingness that they just assume he will do whatever they ask of him. He shared a recent experience where his friend George called him at 11:30pm on a weeknight, begging him to drive him to the airport to pick up his son who was arriving from San Diego. George told him his car wasn't working well and he was afraid it would break down on the road. Mason was half asleep but he got dressed and reluctantly drove his friend to the airport. The plane was an hour late and Carl, his friend's son, had to wait 45 minutes at the baggage claim to retrieve his suitcase.

On the way home, Carl complained that he was hungry and had to use the restroom, so they stopped at a fast food restaurant. George and Carl decided to order a hamburger and fries; they asked Mason what he wanted and then walked into the restaurant. Mason was not hungry but he decided to order fries and a large soda so he could stay awake while driving. Mason waited in the car straining to keep his eyes open, which was very difficult because he felt exhausted. When George brought the food back to the car, he looked at Mason and said, "Oh, it was $3.25." Mason was outraged. "I can't believe the nerve of my friend to charge for the food after I did such a big favor, not to mention paying for gas myself."

After relating this story Mason emphasized again that he wanted to be a shark so he would be respected and at the top of the food chain. "At least in the sea I would be the predator and not the meal."

HAND DRAWING II: PAST AND FUTURE

PROCEDURE: Outline both hands. In your right hand, draw what you were like (character traits, behavior, etc.), what you experienced, and/or what you achieved in the past.

In your left hand, draw goals and hopes for the future. You may add small magazine photos, words, affirmations and phrases.

QUESTIONS FOR EXPLORATION:

1. How has the past shaped who you are today?

2. What events from the past are most significant to you?

3. If you had the ability to change an event from the past, would you? Why?

4. If you could relive something from the past what would it be?

5. Share goals for the future?

6. How hopeful are you about the future?

7. What have you learned in the past that might help make your future brighter?

CLIENT RESPONSE:

Marv, a pleasant man in his late thirties, outlined his hands and filled them in with words that represented his past and present characteristics. In the middle of the hands, appearing as if the hands were holding it up, he placed a photo of an athlete. He shared that he used to be strong and athletic, but because of a work accident he is disabled and not allowed to participate in sports of any kind.

On his right hand, he included traits such as: outgoing, soccer player, football player, eccentric, fun, and winner. On the left hand, he added: reserved, reader, sleeper, relaxer, eater, television watcher, movie watcher, and loner.

Marv stated the right hand represented his strengths and the left hand represented his current activities and abilities, "which are not good." He shared that he doesn't do much all day long and has few interests. He watches sports on television but misses actively playing. Marv complained that many of his friends, who are athletes, stopped visiting because as time went on they had less and less in common. When asked if he learned something from the past that could help him now, he said, "practice till you got it."

SURFING THE WAVE

PROCEDURE: Draw yourself riding a wave. In dialectical behavioral therapy, "Riding the wave" is a technique that allows individuals to deal with uncomfortable thoughts and feelings. The wave begins slowly, peaks, and then dissipates. The idea is to surf the wave (your discomfort) until it slowly disappears. You feel calm once again, the anxiety fades away, like the ebb and flow of the ocean.

QUESTIONS FOR EXPLORATION:

1. How are you riding the wave (e.g., surfboard, small boat, body surfing, etc.)?

2. How does it feel to surf the wave?

3. What are the advantages to riding it?

4. How can you relate riding the wave to controlling anxiety and stress?

CLIENT RESPONSE:

Alex, a 28-year-old man challenged with heroin addiction and anxiety, drew himself on a surfboard floating over a wave. He shared that when he is high he feels he can conquer anything, but when he is clean, he feels like a loser. He stated that it is very difficult for him to communicate with others and to function effectively sober. Heroin helped him relax and reduced any pain he was experiencing from an old sports injury to his shoulder. He didn't see the benefit of being clean, except that he didn't have to keep hiding his lifestyle and drugs from his parents, whom he said were "all over me all the time."

MOVEMENT WITH STICKS

PROCEDURE: Draw a stick figure engaged in an activity.

QUESTIONS FOR EXPLORATION:

1. What is the figure doing and how would the figure in the picture be feeling?
2. Can you relate to the figure?
3. What is your reaction to the size of the figure, and its placement on the page?

CLIENT RESPONSE:

Miranda, a woman in her forties, drew a stick figure running on a treadmill. She shared she needs to start going to the gym because she is out of shape and has gained ten pounds during the past few months. She remarked she is not motivated to exercise and will have to push herself to do so. When asked, she shared she would have rather drawn a person eating a delicious meal because that is what she'd rather do instead of any form of exercise.

THE FIGURE WITHIN

PROCEDURE: Draw yourself (represented by a stick figure or shape) in a body of water.

QUESTIONS FOR EXPLORATION:

1. What type of body of water did you choose? A stream, river, swimming pool, pond, ocean, etc.?
2. What are you doing in the water? Swimming, surfing, drowning, boating, water-skiing, rafting, etc.?
3. Are you feeling comfortable, neutral or troubled?
4. How did you portray yourself? Small, large, in control, out of control, confident, unsure, anxious, etc.?
5. How does the way you portrayed yourself relate to your current life circumstances?

CLIENT RESPONSE:

Jose, a man in his forties, with bipolar disorder and addiction issues, drew himself swimming with sharks alongside him. He explained that he is swimming for his life. He related his picture to his feelings of insecurity and fear that he will not be able to overcome his addiction and find his place in the world. He said he feels like the sharks (his addiction) will attack him and slowly kill him.

FLOWING OF SELF-AWARENESS

PROCEDURE: Draw what's flowing through you right now (e.g., love, anger, fears, etc.).

QUESTIONS FOR EXPLORATION:

1. What is flowing through you?

2. How does it feel?

3. How long has it been inside of you?

4. Does it help you or hurt you?

CLIENT RESPONSE:

Sal, a 22-year-old man addicted to cocaine and marijuana, used colored pencils to list various words that represented what he was feeling and thinking (his flow). The words became transformed into an eye-catching and unusual design. Sal added many adjectives and nouns, some more pronounced and some sort of fading into the artwork. A few of the words included were: humor, kindness, frustration, fear, emotional pain, sadness, depression, dread, physical pain, forgiveness, happiness, unhappiness, and disrespect.

Sal stated he gets overwhelmed when his thoughts become intertwined and chaotic. He stated that when his thoughts race he has difficulty sleeping and he can't focus long enough to browse through a magazine or surf the Internet. He shared that his wish was to relax, perhaps take a nap, and be able to concentrate long enough to read a book or have a meaningful discussion with a friend.

MOUNTAIN AND VALLEY 1

PROCEDURE: Draw a mountain (strengths) and a valley (weaknesses).

QUESTIONS FOR EXPLORATION:

1. How does the mountain compare to the valley?

2. Which one did you draw first?

3. How tall is the mountain and how deep is the valley?

4. Would you like to change the size/depth of the mountain or the valley, and how would you begin this endeavor?

CLIENT RESPONSE:

Jaclyn, a 45-year-old woman challenged with anxiety and depression, drew a mountain and valley under three gray clouds. She stated the mountain represented her husband, below, whom she viewed as strong and controlling. She remarked that the very small valley situated near the hill represented her "own meek self." Jaclyn commented that she has no self-worth and feels like a loser. The clouds represent her three children whom she felt "suffered" because of her depression and the constant arguments she had with her husband. She shared that her children always seem stressed, and that her teenage son has a drug problem, and has been missing school on a regular basis. Jaclyn noted that the blue background symbolized hope that she would learn skills needed to improve her mood and motivation. She stated one of her goals was to stand up to her husband, discipline her son, and not let her husband make all the house rules.

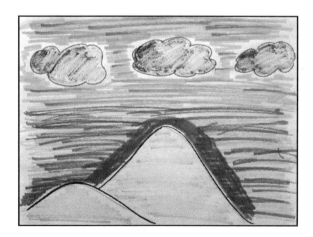

TRAIL OF LEISURE

ADDITIONAL MATERIALS: Magazines

PROCEDURE: Draw and/or use magazine photos to illustrate leisure activities you would like to pursue.

QUESTIONS FOR EXPLORATION:

1. What is your favorite leisure activity?
2. How often do you engage in the activity?
3. What activities would you like to pursue in the future?
4. Why is it important to structure your time with enjoyable pursuits that provide a sense of fulfillment?

CLIENT RESPONSE:

Sophie, a 25-year-old woman who recently quit her job as a store manager, drew an abstraction of a large woman in a yoga pose. She stated she would like to take yoga classes to help her relax and to lose weight. She shared that she wanted to improve her "terrible" body image. Sophie knows that she needs to be more active and stop sitting on her couch watching television and eating fattening food such as fries, chips, luncheon meats and ice-cream. She remarked she has been depressed for months, sleeping a lot and feeling sorry for herself. She stated that she tends to eat and sleep, and eat and sleep— "Which is an unhealthy and sick pattern of living." Sophie remarked she wants to get back out in the world and have a life.

MOOD SCULPTURE

ADDITIONAL MATERIALS: Self-hardening clay.

PROCEDURE: Participants create a shape, figure or sculpture to represent their mood using a small piece of clay.

QUESTIONS FOR EXPLORATION:

1. How does the sculpture reflect your mood?
2. What about it stands out the most?
3. What is your reaction to its size and shape?
4. What would you title the sculpture?

CLIENT RESPONSE:

Anne, a 32-year-old woman suffering from depression and anxiety, created an abstract sculpture of a pregnant woman. Anne shared she had been trying to get pregnant for over a year and was feeling depressed and frustrated about her inability to conceive. She stated that last year she had a miscarriage at 7 weeks of pregnancy and felt devastated at the time, even though her doctor told her miscarriages were common and didn't mean she couldn't have children in the future. Anne remarked she would probably try *in vitro* fertilization if she didn't become pregnant soon. She said she didn't know if her insurance would cover the procedure and her finances were very limited. Her financial problems and fear of the unknown was what worried her the most. She received a lot of support from group members, which seemed to help lift her mood and lessen some of her anxiety.

LIFE PATTERN

PROCEDURE: Draw your current life pattern. Think about your experiences, relationships, successes, failures and challenges. Use shape, color, images and lines to express whether your life pattern is smooth, bumpy, predictable or unpredictable.

QUESTIONS FOR EXPLORATION:

1. What is your reaction to the pattern?

2. How does it reflect your mood and feelings?

3. Is the pattern calm or chaotic?

4. How long as the pattern been the way it is right now?

5. Who or what is responsible for the pattern?

6. Are you satisfied with it or would you like to change it in some way?

CLIENT RESPONSE:

Irwin, a 40-year-old lawyer diagnosed with bipolar disorder, drew a rollercoaster and stated that his life pattern has had many highs and lows. He shared that his highs are very high and his lows are very low. He noted that his main problem is that his highs and lows come on suddenly and he could go from feeling like a king to feeling suicidal in a few minutes.

Irwin stated he is always trying to learn new coping skills to stop him from behaving erratically, but that a few months ago, he spent $4,000.00 on clothes, which he didn't need or want. He mentioned that he was completely out of control at the time and felt terrific while he was spending his money. Later, when he and his wife realized what he had done, he felt extremely remorseful. It was a lot of work finding all the receipts and returning the items, although some of the stores would not accept returns, and he lost about eight hundred dollars. He stated he prays for a medication that will work, putting an end to his frustrating and unstable life.

WALKING ON EGGSHELLS

PROCEDURE: Draw a personal egg filled with an image, color and/or a design. Write your name in the egg or under it.

QUESTIONS FOR EXPLORATION:

1. What is inside the egg?
2. How strong or fragile is it?
3. What happens if it cracks?
4. How likely is it to crack?
5. How can you relate to the egg?
6. Is the egg soft-boiled, hard-boiled, scrambled, poached, sunny side up, fried, etc.?
7. How does the specific type of egg relate to your personality characteristics?

CLIENT RESPONSES:

A 53-year-old woman named Delores, who was challenged with schizophrenia, but relatively high functioning, drew an egg composed of three colors: brown, purple and orange. The bottom of the egg was orange "because it is cooking." Delores remarked that the orange signified "a work in progress." She stated that her problems and her intense anxiety have interfered with her happiness and functioning. She was feeling stressed, depressed, and starting to hear voices when she tried to fall asleep. She complained that she had little control over the voices and their volume was becoming increasingly loud. They were starting to command her to harm herself.

Next, she added a layer of brown to the egg, which represented "the gook." The gook was the medicine and therapy that helped her work through her issues. This was a necessity, but according to Delores, it was extremely difficult and frustrating. "It was hard to acknowledge how sick I was and the voices were terrifying at times."

The brown shaded into purple, which Delores characterized as "grandeur, health, royalty, and functioning." She stated that she was feeling better and ready to go on vacation in a few days. She shared that she might need to return to the psychiatric program for a short while after she returned from vacation, but "that's okay."

⌥⌥

A man named Lee who had schizophrenia drew a "hardboiled egg man." The yellow egg man was sketched as a figure "cooking on the stove with a grin on his face." Lee laughed. "He is really cooking." Lee remarked that the egg man is happy because someone will enjoy eating him for breakfast. "He has a purpose." When asked, Lee mentioned the egg is fragile because his feelings have been hurt in the past. He related to the egg because he said he wanted people to like him and he enjoyed helping others.

A 57-year-old man named Donald, with bipolar disorder, drew a baby snake beginning to hatch out of the egg seen on the next page. Donald noted that the snake is a baby but deadly. "It is poisonous," he explained. "If it gets out of the egg it may attack and harm someone, even maim them or worse." When asked, Donald was not able to relate to the

snake, but he did compare the snake to his wife. He stated his wife is vicious, just like the snake. "She demeans me and is occasionally physically abusive." Donald shared that

once she threw a bottle at him and he needed 20 stitches in his head; he blacked out. He shared that he still loves her and knows there is good in her, and "most importantly she has all the money."

The red added to the bottom and sides of the snake represent the snake's anger and venom. Donald pointed out that there is no taming a snake and "even if you cut its head off it could still bite you." When asked how he could protect himself from the snake he answered, "I have to make sure it is fed and happy so it doesn't bite me."

PERSONAL BEATS

PROCEDURE: Draw your internal rhythm (e.g., is it harmonious? Is it out of sync? Is there a special pattern?). You may choose to focus on your heart rate, your anxiety and stress, or your coping patterns.

QUESTIONS FOR EXPLORATION:

1. How would you describe your internal rhythm?
2. How does it reflect your mood?
3. Has it changed over the last few years, months, weeks?

CLIENT RESPONSE:

Timothy, a young man in his early twenties, drew a chaotic, colorful design. He shared that he feels a lot of turbulence inside his mind. He has trouble concentrating, and his mind jumps from one thought to the next. Timothy mentioned that when he smoked marijuana he felt better, but he became addicted and unmotivated to do anything. He used to be a good student, usually getting A's, he noted, but the last two years have been difficult. Timothy commented that when he began college his mind started wandering. He found the work difficult and stressful, and he felt overwhelmed by the college atmosphere. Timothy stated that all the activities, noise and people made it very difficult to concentrate; "I couldn't even find a quiet place to work." He shared his hope that his mind would become calmer and he could get back to his "normal" self.

HOLDING ONTO INDIVIDUALITY

PROCEDURE: Choose your right or left hand to outline, and then draw an image, object, or shape in it that represents one aspect of your personality. You may also add something you like to do in your leisure time; for example; if you are a gardener, you may place a flower in your hand, while a cook may place a frying pan or a cake in his hand.

QUESTIONS FOR EXPLORATION:

1. In what way does the object drawn symbolize a leisure activity you enjoy or one aspect of your personality?

2. Is the item relevant to your current situation, mood, etc.?

3. Would you have drawn a similar image in the past?

CLIENT RESPONSE:

Heather, a woman in her thirties with bipolar disorder, created a colorful hand that included things she enjoys below. It is noteworthy that the design is well thought out and structured, in contrast to Heather's current restless and semi-disorganized state of being. Heather added words and phrases such as "parties, plays, good living, and attending barbecues." Her favorite part of the hand was the saying: "*You* have the power." She shared that the hand represented her personality because she is very friendly and likes to socialize and attend social gatherings. She admitted that lately she had been having some difficulty socializing, because she was becoming increasingly hyperactive, talking too much, not sleeping, acting "crazy" at times, and definitely eating too much. She admitted she needed to take her medication regularly to regain balance in her life.

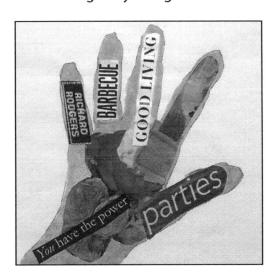

MOUNTAIN AND VALLEY II

PROCEDURE: Draw a mountain (to represent happiness) and draw a valley (to represent sadness).

QUESTIONS FOR EXPLORATION:

1. Which image appears stronger?

2. Which image do you identify with today?

3. Has the comparison you drew between the mountain and the valley always been about the same, or has it changed recently?

CLIENT RESPONSE:

Edith, a 57-year-old woman married to another woman for ten years, drew two mountains that were similar in size. Edith shared that her anxiety and depression were diminishing, and her energy and sense of humor were returning. She remarked that her wife tended to be controlling and demanding, and that she was always the one to give in to her wife's demands.

Edith shared that she had recently learned many coping skills, which taught her how to be more assertive, thereby getting many of her needs met. Her self-esteem increased, as she felt more in control of herself and her life. When asked, she stated she had been the valley for a long time, but now she was on par with the mountain. She laughed and quoted the television series, *Breaking Bad*: "I am the mountain."

MOOD RAINBOW

PROCEDURE: Draw a rainbow that reflects your mood, and add a wish at the end of it.

QUESTIONS FOR EXPLORATION:

1. How do the colors and size of the rainbow reflect your mood?

2. Does the wish affect your mood (e.g., feeling positive about the future, or unfulfilled and frustrated)?

3. Have you had the wish a long time or is it a more recent wish?

4. Is your wish doable or is it farfetched?

5. Are you taking measures to try to attain it, if it seems achievable?

CLIENT RESPONSE:

A 62-year-old woman named Miriam drew a darkly colored rainbow to represent the recent death of her beloved father below. She stated, "The entire rainbow isn't black, because I do have a good support system and a wonderful family." She mentioned she feels very sad, but that there are times during the day she becomes distracted, and for brief moments the sadness fades. "Until a jolt of despair hits my heart like a bolt of lightning."

Miriam said that her rainbow would have been drawn with bright colors just a few months earlier. She remarked that it is strange and terrifying how life can change in the blink of an eye. Her wish was for her daughter to have a second child who would be named after her father (represented by a fetus placed at the end of the rainbow). She declared that would be a wonderful tribute to him, especially since he was very concerned about his legacy. She shared, "I think that would make him happy, and it would make me feel better." She was already thinking of both girls' and boys' names, much to her daughter's chagrin.

LAYERS OF EMOTION

PROCEDURE: Draw a shape or image that is self-representative. Circle the image/shape (yourself) with layers of emotion. Place the emotions you experience most frequently closer to you and the emotions you feel less often farther away from you.

QUESTIONS FOR EXPLORATION:

1. How did you portray yourself?
2. Which emotions are closer to you?
3. Which emotions are farther away?
4. How do your emotions affect your behavior and attitude?
5. Which emotions would you like to change? Why?

CLIENT RESPONSE:

A 65-year-old woman named Debra added a few layers of orange, red and pink, to a semi-circle that partly surrounded a dainty looking stick figure. Debra shared that all the colors surrounding the figure were bright and cheerful because she felt well. She stated she was pleased about her newfound self-esteem, strength and motivation. She mentioned that she was ready to engage in social activities and go back to her volunteer position at the local hospital. Debra remarked she felt strong enough to deal with current life issues, which included a pending move, illness in her family and financial problems.

HAND DOODLE

PROCEDURE: Outline your hand and fill it in with doodles. Words and phrases may be added.

QUESTIONS FOR EXPLORATION:

1. In what way is the hand design reflective of some aspect of your personality? (Think about detail, images, shapes, etc.)
2. Does your design reveal current issues, ideology, etc.?

CLIENT RESPONSE:

Mel, a large, muscular man in his forties, added many curvy lines, shapes and small red hearts to his doodle. He also added words such as love, marriage, friendship, hope, future, fun, beach, and sweetheart. Mel shared he was planning to ask his girlfriend of two years to marry him, and felt somewhat stressed, but also excited. He expressed anxiety about the lifestyle change he would have to get used to, and his new role of breadwinner. This would be an important role because his girlfriend was disabled and unable to work outside the home.

Mel shared that he was pleased with the way his doodle turned out, deciding to cut it out, glue it on a black sheet of paper, and frame it. He would give it to his girlfriend after proposing to her, to further show her how much he adored her. Mel mentioned he didn't draw at home, but enjoyed working on the project and would want to participate in the creative group again. He commented that he never knew he could express so much through doodling.

MY FLAG

PROCEDURE: Sketch a flag (or a pre-drawn one may be distributed). Add symbols and/or words to represent your mood and/or character traits. You may use color, shapes, images, phrases, your name, etc.

QUESTIONS FOR EXPLORATION:

1. What might your flag and its symbolism convey about your attitude, emotions and resulting behavior?
2. To what extent do your personality characteristics affect your mood? For example, an optimist may handle adversity better than a pessimist.

CLIENT RESPONSE:

Tammy, a 28-year-old woman challenged with anxiety and depression, created a small flag with tiny words written all over it. Some of the words included: "Depressed, moody, failure, sad, worry, no hope, friendless, ugly, stupid, fat, gross, and stupid." She also added a few small sad faces to the flag. Tammy shared that she feels like she blends into the wall, as if she is a speck of dust. She stated it is difficult for her to do almost anything; even showering in the morning is a chore. "I only showered today because I had to attend the program, "she said. Tammy mentioned that she only eats to survive and sleeps most of the day. She told group members that sleeping is her escape. Tammy was encouraged to explore how her thoughts affect her mood and attitude. One group member suggested that she had more power than she believed, and encouraged her to volunteer or adopt a pet.

REINCARNATION

PROCEDURE: Draw a symbol relating to the animal you would most like to be if reincarnation exists (e.g., a banana representing a monkey or a trunk representing an elephant). *You may draw the entire animal if you desire.*

QUESTIONS FOR EXPLORATION:

1. What are your reasons for wanting to be this animal?
2. What are the animal's attributes and strengths?
3. How is your life similar or different from this animal?

CLIENT RESPONSE:

Rob, a 34-year-old man with schizophrenia, drew a bird and shared that he would like to be a bird so he could fly wherever he wanted. He thought he'd like to fly in a flock and be surrounded by "bird friends." When asked about the advantage of flying, he stated he wouldn't have to ask permission to go places and birds wouldn't judge him. He added that he wouldn't have to go to programs or see therapists.

MY WORLD (MINI MANDALA)

ADDITIONAL MATERIALS: Container

PROCEDURE: Outline a circle from the bottom of a coffee can or container (about 3-4 inches in diameter) and fill it in with various aspects of your "world." (E.g., Family, friends, hopes, dreams, fears, home/environment, vacations, hobbies, things you like and dislike, school, work, everyday life, etc.) You may write and/or draw your thoughts.

QUESTIONS FOR EXPLORATION:

1. What parts of the mandala do you especially like/dislike?

2. Did anything you added to it surprise you or cause you to think about something you may have not addressed in the past?

3. What do you feel about your world? (E.g., is it relaxing, stressful, fun, scary, full of changes, uncertain, fulfilling, etc.?)

4. How would you like to change your world?

5. On a scale of 1-10, where 10 is best and 1 is worst, what number would most accurately reflect your feeling about your life?

CLIENT RESPONSE:

A young woman in her twenties named Jessica, recently diagnosed with bipolar disorder, designed a chaotic looking mandala filled with many colors, swirling lines and shapes with jagged edges. Jessica shared that her world is blurry now. She complained that she is in a state of flux and has no idea what she will do next. She remarked that she wanted to add friends, family, interests and a job to the mandala, but currently she feels isolated from her friends and family, and she is unemployed, and taking a break from college.

Jessica shared that she was afraid that her life would stay stagnant, and she would become a total failure. When asked, she rated her life as a 2 on the 1-10 scale. Jessica mentioned that she used to do well in school and had many friends. She moaned, "I just don't know what happened to me."

HEARTFELT IMAGES

ADDITIONAL MATERIALS: Magazine photos and an optional heart outline.

PROCEDURE: Creatively answer this question: "If someone could see into your heart, what would they see?" You may draw, write and/or use any materials available. If desired you may use the heart outline, although it is not necessary to use a heart as the basis for your design.

QUESTIONS FOR EXPLORATION:

1. What would other people see within your heart? (E.g., Love, hate, concern, sadness, etc.?).

2. Would people close to you recognize what they see?

3. Do you have something in your heart that is hidden from one or more people?

4. Has your heart ever been broken? If so, how did you or how are you attempting to repair it?

CLIENT RESPONSE:

A 56-year-old woman named Margaret drew a face in the center of the heart and words to describe what's in her heart, "on the superior vena cava, right atria and aorta." On the bottom of the sketch, she wrote, "not my real face – a mask."

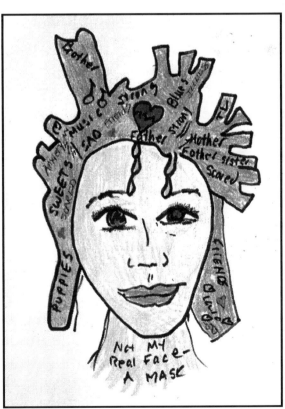

On the other parts of the heart she added the words: happy, sad, friends, scared, movies, father and mother (with tear drops near their names), strong, illness, brother, puppies (with hearts), kittens, fear, pain, chocolate, and she added music notes, zigzag lines near the word anxiety, and a small broken heart. Margaret shared there is a lot happening in her heart and sometimes it feels too full. "My heart has been broken" (represented by the small cracked heart) "and although it doesn't hurt as much, the pain always remains with me."

3

Self-Esteem &
Self-Compassion

Self-esteem develops from many sources including one's self-appraisal, achievements, parental support and approval, acceptance by friends and significant people in one's life, as well as handling challenges faced throughout the years. "Self-esteem is how we value ourselves; it is how we perceive our value to the world and how valuable we think we are to others."[9] In psychology, the term self-esteem is used to describe a person's overall sense of self-worth or personal value. According to Nathaniel Branden, PhD: "Self-esteem is the experience of being competent to cope with the basic challenges of life and of being worthy of happiness."[10] As adults, we are the judges of who we are and *we decide our self-worth*. For instance, someone who is nearly penniless and has a job he/she dislikes can have high self-esteem and someone who is financially secure with a loving family can have low self-esteem. It depends on *how we view* our environment, others, and ourselves. We decide if our lives are meaningful, if we want to change our life, and most importantly, if we are worthy individuals.

Our "core beliefs" often help determine our self-esteem. Awareness of these beliefs will enable us to increase our self-esteem while becoming more aware of our emotions, patterns of thinking and behavior.

Self-compassion, as defined by Kristin Neff in the academic literature, has three aspects: mindfulness, common humanity and kindness.[11] It entails being kind towards yourself and treating yourself the same way you would treat others. It involves self-understanding, self-respect and acknowledgment of one's feelings, thoughts and issues. Self-compassion entails patting oneself on the back for a job well done and accepting oneself regardless of problems, failures and perceived shortcomings. In essence the focus is on giving yourself a break. We are all human and everyone is just trying to get by the best they can. Berating ourselves and/or criticizing ourselves will often lead toward stagnation; we will not be motivated to do better. Self-compassion involves giving oneself permission to receive mental hugs, take healthy risks and accept that sometimes we will make mistakes and/or fail. It encourages us to work through issues and move on with our life. Studies have shown that people who show themselves self-compassion are more likely to be motivated to push themselves to work harder, and have higher standards.

The following exercises help individuals become more self-aware and introspective. They afford people the opportunity to examine healthy and unhealthy patterns of thinking, with the aim of increasing positive thinking and lessening or eliminating negative thinking and self-defeating behavior.

POSITIVE IMAGE

PROCEDURE: Draw a positive image. Think about people, places and things that lift your spirits and increase your self-esteem and feelings of well-being.

QUESTIONS FOR EXPLORATION:

1. What are the positive aspects of the image?

2. In which ways can you relate to the image?

3. How can you become more positive in your thinking?

CLIENT RESPONSES:

Corey, a 33-year-old man with bipolar disorder and addictions issues, drew his AA meeting as his happy place. He added a sketch of a group of people sitting around a long table. He stated that it is the only place where he can share feelings genuinely and no one "looks down on me; we are all the same." He remarked that the rooms were his safe haven. Going to meetings helps him stay sober and gives him a forum to vent his feelings and share his life story. He likes that, "no one criticizes you and everyone is in the same boat."

⚬⚬⚬

Dylan, a 20-year-old man diagnosed with bipolar disorder and attention deficit disorder, created a beach scene as his positive image. He stated that he likes to relax at the beach as often as possible. His stress dissipates as he bodysurfs and then basks in the sun. The beach reminded him of his childhood, which was a time when he felt carefree and ready to experiment and learn new things.

⚬⚬⚬

Karl, a 22-year-old man suffering from alcohol addiction and anxiety, drew a smiling clown to represent his happy place. He stated he was most happy when he was drinking. He remarked he felt calm, uplifted and self-assured when he was high; "I have never been happier than when drinking." Karl was able to listen to his peers who told him his happiness was "fake" and short-lived. In reality the alcohol was destroying his body, mind and soul. Karl knew that one of his primary goals was to find a new and healthy way to be joyful. He needed to explore activities that would substitute for the alcohol.

FIGURE IN ACTION

PROCEDURE: Draw a stick figure engaged in an activity. Name the figure.

QUESTIONS FOR EXPLORATION:

1. What is the figure doing?

2. What would his mood be like?

3. Can you relate to the figure?

4. How does the activity affect the figure's attitude and self-esteem?

5. What activities increase your sense of self-worth and happiness?

CLIENT RESPONSES:

Raphael, a young man in his twenties challenged with bipolar disorder, drew a figure in a sword fight with a zombie. He shared that the figure is skinny but strong. "You have to get the zombie in the brains to kill it." He continued, "You really need a gun, but I guess a sword will do."

When asked if he could relate to the figure, Raphael remarked that he would kill the zombie because he would defend his family. He characterized himself as a fighter, sharing that he had been in many street fights and won most of them. He told group members he has had a few broken ribs, one broken arm, and a few black eyes. He shared he felt "good" after the fights. Raphael shared that he also liked sports, and playing basketball made him feel "good too."

<center>⊙~ﾟ°ﾟ⊙</center>

Maura, a woman in her early thirties with anxiety and depression, drew a female figure dancing happily to Rock 'n' Roll music. Maura shared that she wishes she were able to dance and enjoy herself as she used to do. She mentioned she hasn't danced in at least two years because she hasn't had the energy or motivation to engage in any active pursuit. She remarked that her energy is depleted and complained, "All I want to do is sleep." In addition to lack of vitality, she shared that she isolates most of the time and hasn't seen her friends for months. She hoped that in the future she'd be able to enjoy dancing with friends once again.

EXPRESSING SELF-WORTH

PROCEDURE: Write your name and create a design around it.

QUESTIONS FOR EXPLORATION:

1. How does your design reflect your self-esteem?

2. How does your design reflect your personality?

CLIENT RESPONSE:

Lauren, a 19-year-old woman challenged with addiction issues, wrote her name boldly with blue marker, and added many hot pink hearts surrounding it. The one larger heart represented her boyfriend Ed. Lauren shared that Ed has been very supportive and accepts her unconditionally. She told group participants she felt very lucky to be in a relationship with such a wonderful person.

Lauren stated Ed intends to attend AA and NA meetings with her and will help keep her sober and drug-free. The rest of the hearts, according to Lauren, represented family members and friends who have helped her, and are still helping her to cope each day.

IMAGE OF STRENGTH

PROCEDURE: Draw strength. Think about your own strength. What are the colors, size, and shapes of strength?

QUESTIONS FOR EXPLORATION:

1. What is your signature strength?

2. How does this strength help you?

3. How did you acquire this strength?

4. Are there particular times when you use it or do you use it most of the time?

CLIENT RESPONSES:

Jack, a 38-year-old man with alcohol addiction, drew a large boulder to represent strength. He shared that he has always been the *rock* in his family and has kept everyone together through difficult times. He remarked that he helps family members physically (e.g., fixing the air conditioner and washing machine, moving heavy objects, etc.) and psychologically (e.g., solving problems, being the peacemaker and the family counselor).

Joan, a woman in her forties with bipolar disorder, drew a wide, smiling, red mouth. She stated that her strength is her sense of humor and her ability to make others laugh when they are anxious or sad. Joan shared that she is known as "The Helper" in her circle of friends, and enjoys the role. She remarked she feels better about herself when she changes someone's mood with a joke and/or her positive attitude. Joan stated although her illness is serious, she doesn't take herself too seriously. "And that makes all the difference in my mood, motivation and behavior." She added that she doesn't like labels and will not label herself or others.

Bryce, a young man in his twenties, drew a brain and stated his brain is his strength. He shared that he is using his brain to muster the strength and willpower he needs to stop drinking. He stated that he is working hard to learn the coping skills necessary to overcome his addiction. Bryce said that he is attempting to use exercise and distractions such as playing the guitar and cooking to stay sober, and shared that he hates AA but will attend meetings at least once a day until he feels more confident in his sobriety.

SELF-ESTEEM DOODLE

PROCEDURE: Create a doodle that reflects your current self-esteem. You may use straight or wavy lines that swirl, intersect and take their own unique form to express high, moderate or low self-worth. For example: colorful, dancing lines and shapes may represent high self-esteem while tiny cross hatched lines may symbolize low self-esteem.

QUESTIONS FOR EXPLORATION:

1. How does the doodle reflect your feelings of self-worth?

2. What specifically about the doodle do you like/dislike?

3. How does the size, movement and color of the doodle reflect your self-esteem?

4. Is there anything about the sketch you would like to change?

5. What would you title the doodle?

CLIENT RESPONSES:

Deena, a woman trying to overcome alcohol addiction, designed a complicated and colorful doodle she titled "All Roads Leading to Me." The doodle contains a heart (her love of her friends and family), a rainbow (hope), stars (brightness), a tiny green tree (new growth), and many wavy, red and orange lines representing her confusion and desire to stop drinking, ("But also my uncertainty whether this is feasible").

The outline of the doodle looks like the outline of the United States and the edge of it contains a smiling face (her goal). Deena mentioned that she wants to be free of her addiction and live her life in a healthier manner; she wants peace. She related the design to her recent increase in self-esteem. "It has been a small increase but still significant." Deena stated, "Ideally, I would like the sketch to appear calmer and less confused; it still makes me anxious when I look at it."

ᏗᢅᴼᐤᏨ

Paul, a 28-year-old man struggling with bipolar disorder and drug addiction, drew a doodle consisting of water and waves. The waves were of varying size and intensity. The outer layers of the waves appeared sharp, like razors emanating from the water. Paul named the doodle "I am Drowning." He shared that the doodle frightened him because it was very negative and symbolized his extremely low self-esteem. "My self-esteem is negative 90." He remarked that his self-esteem is the lowest layer of the waves, and it will be very difficult to raise his self-esteem because of his lying, cheating and deceptions. He stated he treated his family very poorly, even stealing money from them. He felt much remorse and he was overcome with guilt. Paul added a fierce-looking shark in the water and said, "Either I will kill the shark or it will eat me."

UNIQUE AMULET

PROCEDURE: Create a personal amulet or talisman. The amulet, which is usually an ornament, stone, or piece of jewelry, is meant to protect and provide a sense of safety. The Talisman also provides protection as well as good luck, e.g., a rabbit's foot, a horseshoe or a four-leaf clover.

QUESTIONS FOR EXPLORATION:

1. What is special about the amulet?

2. How can it protect or help you?

3. Is your amulet a person, item or concept?

4. Is it plain, fancy, detailed, precious, store-bought, from nature, etc.?

5. Can you carry it with you?

6. What other items, people, things, etc., serve as protection?

7. How can having an amulet (feeling protected) increase your self-esteem?

CLIENT RESPONSES:

A 55-year-old client named Audrey, overcoming anxiety and depression, drew an amulet necklace, which included four purple figures that represented her children. She shared she doesn't even need to wear the amulet. "Just knowing I have four wonderful children whom I love is enough to serve as a source of protection and self-esteem."

꩜

Ray, a 35-year-old man challenged with bipolar disorder, created a large, colorful spiral. He shared that the spiral represented a whirlwind that protected him from outside forces because he was safe within it. If anyone approached him the whirlwind would act as tornado and blow that person away "to the deepest part of hell." He shared that the whirlwind was very strong, impenetrable, and had been part of him for many years. He noted that it is with him always, even when he sleeps.

It is of interest to note that Ray has a very bad temper and scares people away by yelling and acting in an aggressive manner. Very few people confront him because they are afraid of his anger, his outbursts and his unpredictability. He seems to like scaring others and being in, what he thinks is, total control.

SLICE OF PERSONALITY

PROCEDURE: Create a slice of pizza that best represents your personality.

QUESTIONS FOR EXPLORATION:

1. What type of pizza did you draw?
2. How does the pizza reflect your traits (e.g., spicy, like a sausage and pepperoni pizza or plain and simple like a white slice)?
3. What is your favorite type of pizza?

CLIENT RESPONSE:

A 28-year-old accountant named Maria drew a simple white pie. Maria shared that she is plain like the pizza, dull and drab, often feeling like no one even notices her. Maria said she doesn't even like pizza, much to the chagrin of her family who own a pizzeria in a nearby town. She remarked that when she was in school she had no friends. "I wasn't even bullied, because no one noticed me." She shared that she spent much of her childhood watching television and playing with her dog and two cats. Maria complained that at work she spends much time alone in her office and rarely interacts with her co-workers. She remarked that her co-workers never ask her to join them for lunch or after-work activities, which makes her feel left out and depressed.

HEALING TOOLS

PROCEDURE: Draw one item, thing or person you need in order to heal.

QUESTIONS FOR EXPLORATION:

1. What do you need in order to heal?
2. How can the images depicted help you heal?
3. What steps do you need to take to begin to heal yourself?

CLIENT RESPONSE:

Bonnie, an attractive 41-year-old woman recovering from alcohol addiction and anxiety, drew a sketch of a handsome man to represent her need for a fulfilling, mature relationship. She shared that she longs for a romance that may lead to marriage. Bonnie mentioned that she "hibernated" all winter long, rarely stepping out, even to grocery shop or get the mail. She stated that something is getting in the way of her socializing and trying to find a man. She remarked that she decides to date and then she freezes at the last moment. She mentioned that in recent years she has tried dating a few times but the dates turned out to be disasters.

Bonnie stated that she immediately finds fault with whoever who is taking her out on a date. It might be his appearance, sense of humor or lack thereof, "stupidity," lack of manners, political affiliation, etc. With support from peers she promised to try to meet people in places like the library, coffee shops and bookstores. She decided that she would begin by spending at least 15 minutes, three times a week, at the local coffee shop, keeping alert for potential boyfriends and possibly girlfriends.

HANDFUL OF POSITIVITY

PROCEDURE: Outline your hand and fill your palm with loving images/thoughts.

QUESTIONS FOR EXPLORATION:

1. What images and positive thoughts did you place in your hand?
2. How does thinking positively affect mood and attitude?
3. Do you deserve to feel cheerful, admired and loved?

CLIENT RESPONSE:

Nancy, a widow at age 65, drew three pink flowers in the palm of her hand. She shared the flowers symbolized her grandchildren. Nancy emoted that her grandchildren were the loves of her life, "my pride and joy. " Nancy characterized them as smart, adorable and very funny. She stated that she laughs for hours when she's with them. She told group members, "my grandchildren are the best medicine for me, and *that* medicine is free." Nancy remarked she'd visit with them every day if she could, "but they live two hours away so visiting is sometimes difficult." She shared that she would love to live with her daughter and the children, but her son-in-law "would never go for that."

LOVING GIFT I

PROCEDURE: Draw a gift that you would like to give yourself.

QUESTIONS FOR EXPLORATION:

1. What type of gift did you give yourself?
2. Was it something that you have wanted for a long time?
3. What makes it special?
4. How would it help you and/or affect your well-being?

CLIENT RESPONSE:

A 27-year-old man name Eric, who was recently diagnosed with schizophrenia, created an abstract design representing his desire to be able to think clearly and pursue his love of mathematics in college. The small star-like shapes in the sketch were "mathematical symbols." The center shape represented the head of a man attached to a long neck. The head had bands around it to symbolize Eric's current problems with thinking clearly and realistically.

Eric shared that he was in his second year at an Ivy League school when he started feeling "peculiar at times," and having difficulty focusing on his coursework. He shared that he would experience severe panic attacks, believing he was about to die and that everyone in his class would die too. These attacks made it impossible for him to sit through classes and socialize with groups of people. Eric's goal was to get psychiatric help and become more stable on medications. He was hoping to feel well enough to go back to school within six months. Eric said the best gift for him would be to think clearly, stop having panic attacks, and gain control of his feelings and behavior. He said, "I just want to be me again."

LOVING GIFT II

ADDITIONAL MATERIALS: Magazine photos

PROCEDURE: Outline a large box and fill it in with one or more gifts you have given to others over the years. You may draw or use magazine photos and words.

Examples: Love, trust, humor, jewelry, clothing, support, help, empathy, a job, increased self-esteem, joy, freedom, independence, a pet, friendship, amusement, information, and guidance.

QUESTIONS FOR EXPLORATION:

1. What is one gift that you are grateful that you gave to someone else?

2. Which do you tend to enjoy more: receiving presents or giving presents?

3. How have you benefited from giving to others?

CLIENT RESPONSE:

It is noteworthy that the more rigid, concrete clients frequently shared that their special gifts were items such as a television set, jewelry, or a CD. Participants who tended to be more introspective would share concepts like love, hope, empathy and support.

Sadie, a 61-year-old woman challenged with depression and anxiety, used illustrations and a few magazine photos within a decorative box to represent some of the gifts she has given to her family throughout the years. She included her children (special gift for her husband), love to her family (symbolized by hearts), hope (represented by the rainbow), strength (represented by the mountains at the bottom right of the box), advice, food and parties for her children and husband.

Sadie remarked, when asked, that the best gift she ever gave to someone were her two girls, whom she adores. Her husband wanted two children and she felt proud that she was able to create, nurture, and be part of such an amazing family.

PERSONAL LOGO

PROCEDURE: Create a self-representative logo. Your logo may consist of a symbol, sign or image that represents your style, personality, life, interests, strengths, talents, etc. It reflects your brand (what is unique about you). An example of a logo would be the profile of a woman with long, wavy tresses to represent a company that may be titled Rapunzel wigs or a sketch of an exotic bird to represent a vacation resort.

QUESTIONS FOR EXPLORATION:

1. How does the logo represent your personality characteristics?

2. Does the logo reflect your strengths and achievements?

3. Are you satisfied with the logo, or would you prefer to change it in some way?

CLIENT RESPONSE:

Dante, an 18-year-old teenager, drew his tattoo, which consisted of a large, threatening-looking snake with the word "Fearless" winding around it. Dante shared that he *is* fearless and "has to be brave, *or act like it*," to survive on the streets. He stated that if he shows signs of weakness people will "destroy me."

Dante told group members that sometimes he doesn't feel so strong, and it is difficult to keep up the facade even though his life may depend on it. He admitted that he has even sold drugs, not because he wanted to, but because he was asked to by a gang leader who lived on his block. Dante emphasized that it is difficult to survive in his neighborhood, and he has to do whatever it takes to keep going. His stressful life was catching up with him, and he was glad he was accepted into a college in another state where "I can get away from the streets."

DIRECTING THE ARROW

PROCEDURE: Draw an arrow (think about the direction it is pointing).

QUESTIONS FOR EXPLORATION:

1. In which direction is the arrow pointing and what could that mean about your life direction and/or mood?

2. Is the arrow straight or curvy, facing upwards, downwards, diagonally, or to the side?

3. Where would you ideally like the arrow pointing?

CLIENT RESPONSES:

Jim, challenged with schizophrenia, shared that the arrow in his picture was moving up the hill, but it was not quite there yet. He remarked that it has been difficult moving forward, but he was hopeful he'd eventually arrive at his destination (a job and a relationship). Jack shared that auditory hallucinations, which scared and demeaned him, proved to be a formidable obstacle to overcome. Sometimes after taking many steps forward he was forced to take just as many steps backward. Jack shared the backward steps occurred because of "weeks wasted" being hospitalized due to his inability to cope with severe and uncomfortable symptoms. He stated that once he arrives at the top of the hill he will "feel good, but anxious with the thought that I might fall off of it." He remarked that he didn't know what was on the other side of the hill and uncertainty about the future frightened him.

☙◦❧

Gabby, a 40-year-old woman challenged with addiction issues, drew a variety of arrows, all pointing in different directions. She remarked that she is now a sober woman who doesn't know what twists and turns her life will take. She shared that she has to find a new job because her previous job was being a bartender, and she has to find new friends because all of her friends still drink and smoke marijuana. She stated she would take one day at a time and let her life evolve.

ARTFUL AFFIRMATIONS

PROCEDURE: Write a positive affirmation (e.g., I am enough, I am worthy, take one day at a time), and create a quick sketch to illustrate it. The group leader may print out a sheet of affirmations for participants to view and choose from if they desire.

QUESTIONS FOR EXPLORATION:

1. Why are affirmations helpful?

2. How does the illustration depict the mood and meaning of the affirmation?

3. What affirmation/s do you tend to repeat to yourself?

CLIENT RESPONSES:

A 57-year-old man named Calvin wrote, "I will take one day at a time." He drew the number one surrounded by many X's. He shared that he had been sober for two weeks and was very proud. Calvin stated that it had been a long, hard road and he had lost a lot in his life because of his drinking and drug abuse. He knew he had to stop drinking when he developed cirrhosis of the liver and heart disease, as well as Type 2 diabetes. His doctor told him if he keeps up his unhealthy lifestyle he will die within two years. Calvin said that hearing that pronouncement shocked him into taking action. He commented that he has intense cravings every day and sometimes he takes it "one minute at a time, because even one day at a time seems too overwhelming."

ᘓᘏᘐᘔᘑᘔᘐ

Daniela, a 29-year-old woman challenged with heroin addiction, and clean for two weeks, chose the affirmation, "what you allow is what will continue." She added brightly colored, rectangular shapes to represent a wide barrier between two figures. The full figure appears to be pushing the barrier, and the smaller figure is sitting on the ground, and almost looks like a small child or baby.

Daniela stated she is the child-like figure, trying to stay away from her ex-boyfriend Aaron, who is a heroin addict. She placed herself on the other side of the barrier, "far away from Aaron." She shared she needs to stay away from him because he won't stop using, and if she continues seeing him she will relapse. Daniela remarked she loves Aaron, but knows she has to keep her distance for her physical and mental health. In addition, her family threatened to stop giving her an allowance, and would force her to leave the house if she didn't stop dating Aaron. They insisted she attend an addictions program and focus on her recovery. She remarked she cries a lot, feels awful, and has been isolating from friends and family.

AWARD OF MERIT

PROCEDURE: Design an award for yourself.

QUESTIONS FOR EXPLORATION:

1. Why do you deserve the award?
2. What will you do with it? (e.g., display it, focus on it as way to keep positive, etc.)
3. What are your strengths and talents?
4. What awards have you achieved in the past? (Include physical and/or psychological rewards.)
5. How can the award motivate you to work towards your goals?
6. How can you reward yourself?

CLIENT RESPONSE:

A 29-year-old man named Max, who was challenged with alcohol addiction, drew a bottle of vodka with a star on top of it. He stated that the star represented his desire to stay clean and sober. He shared that he had been clean for three weeks and was proud of himself for abstaining and attending daily AA meetings. Max added that he was motivated to change, and believed he was on the right track with his life. His plan was to earn enough money to go back to school and get a degree in engineering.

COMFORT AND WELL-BEING

PROCEDURE: Draw someone or something you find comforting.

QUESTIONS FOR EXPLORATION:

1. What do you find comforting? Is it a person, place or thing?
2. How do your mood, attitude and behavior change when you feel comforted?
3. Do you ever try to self-soothe in order to find comfort?
4. What are the benefits of self-soothing?

CLIENT RESPONSE:

A 62-year-old woman named Pat drew her dog, a poodle named Snowy. Pat shared that her dog is a great companion and extremely smart. "He is my baby." Pat shared that as soon as she walks in the door Snowy runs to her, jumps on her, and licks her face in joy. "He accepts me just as I am." Pat commented that Snowy provides comfort for her and gives her a purpose. She stated that she takes very good care of him, sometimes even cooking him steak and hamburger for a treat. Pat shared that when she is alone at night Snowy makes her feel safe and often sleeps in bed with her. She bragged that he a good watchdog, and would bark loudly if anyone tried to enter the house. "He is my protector and confidant."

EMANATING WARMTH

PROCEDURE: Draw an image of someone or something that produces warmth. (e.g., sun, person you love, warm blanket, warm sand on a summer day, etc.)

QUESTIONS FOR EXPLORATION:

1. Why is warmth important to you?
2. What is your source of warmth?
3. When was the last time you felt warmth?
4. In what way(s), do you provide warmth to others?

CLIENT RESPONSES:

John, a 63-year-old man who was trying to overcome depression and alcoholism, drew his Siamese cats. He stated that when he is petting them, and looking into their big blue eyes, he is totally relaxed and happy. He remarked that his cats always greet him and love him unconditionally. "They don't demand I do this or that." He remarked that they provide warmth by cuddling up to him and sitting on his lap.

Hal, a 37-year-old man trying to overcome a variety of addictions, drew his motorcycle. He stated that when he gets stressed he either stays confined to the house all day or he takes off on his motorcycle. He shared that he loves the way the wind whistles, and the way the "air feels on my face" when he is speeding down country roads.

BEST/WORST

PROCEDURE: Draw a symbol or image to represent the "best" part of your personality and the "worst" part.

QUESTIONS FOR EXPLORATION:

1. What character trait/s do you like the best? The least?
2. How do your strengths help you and how do your perceived weaknesses harm you?
3. What can you do to continue to enhance your strengths?

CLIENT RESPONSE:

A 60-year-old woman named Grace drew a heart to represent the best part of her personality and a snail to represent the worst part. She shared that the heart symbolizes the love she gives to her family and friends. She stated she would do anything for the people she cares about.

The snail symbolizes her ADHD and her inability to organize and get things done on time. Grace remarked she was the queen of procrastination. She laughed and shared that she is always late, driving her husband and children crazy especially when they want to go to the movies and get good seats. Grace stated her husband always teases and says if she didn't have her head attached to her body, she would lose it.

WHO AM I?

ADDITIONAL MATERIALS: Magazine photos.

PROCEDURE: Create a quick sketch that answers the question, "Who am I?"

QUESTIONS FOR EXPLORATION:

1. How do you view yourself?

2. Has your view of yourself changed recently?

3. What are your strengths? Weaknesses?

4. What are some of your roles in life?

5. How do you think other people view you?

6. How would you ideally like to view yourself?

CLIENT RESPONSE:

A 63-year-old woman named Marcy drew a circular face staring straight ahead, and stated, "She is prettier and younger than me here". She also added self-representative magazine photos. Marcy included Jon Stewart along with his quote: "The best defense against bulls—is vigilance. So, if you smell something say something." Marcy related this quote to self-awareness – "That it is important to be aware of what is going on in one's environment." She added a dog and remarked that her dog is her best friend and gives her life meaning. She added ice-cream to represent her love of sweets. Alvin and the Chipmunks, and Lucy in a classroom symbolized her love of children. Marcy was a teacher before needing to take an early retirement due to physical illness. There is a small photo of a woman with her back turned away from the audience symbolizing Marcy's fear that she won't feel well again and will not get back "to my old self."

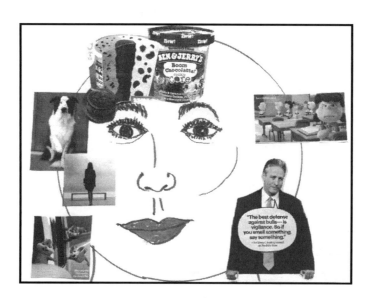

PERSONAL TAG

PROCEDURE: Draw a symbol that you would like others to associate with you. Examples may include: A lucky charm, a smiley face, a sun, heart, etc.

QUESTIONS FOR EXPLORATION:

1. What meaning does the symbol have for you?
2. How does it represent your personality characteristics?
3. Is it important that others view you in a specific manner?
4. Do you believe that others view you in a way similar to how you view yourself?

CLIENT RESPONSE:

Mario, a 21-year-old man with an addiction issue, drew a skull and cross bones as his personal tag. He shared that he lives in a "shithole" neighborhood where everyone has to act tough to survive. He explained that if a person comes across weak he will be pushed around, bullied, and most likely beat up and robbed; it wasn't uncommon to be stabbed for looking like an easy target. He shared that if he ever lets his guard down he can become a victim of a gang member or almost anyone with a chip on his shoulder. He smiled and then shared a few of his tattoos, which centered on the theme of strength and power. One of the designs included a large sword with a few drops of blood dripping off of it and onto a floating finger. When asked about it, Mario shared that he really isn't bad, just trying to survive. He remarked he is a big teddy bear, but only a select group of people ever find that out and know the truth about him.

SELF-ESTEEM BOUQUET

PROCEDURE: Draw a large flower with a circular center (or the group leader may provide an outline of a flower). The flower should have at least six thick petals. Draw a positive image or shape in the center of the flower and add positive images, words or statements in each of the petals.

QUESTIONS FOR EXPLORATION:

1. What was placed in the center of the flower?
2. What are your positive characteristics and strengths?
3. How do your unique characteristics affect your self-esteem and behavior?

CLIENT RESPONSE:

Rhonda, a 35-year-old woman trying to overcome heroin addiction, drew a large, striking flower filled with the names of people in her life whom she loves. A bright, red heart was placed in the center of the flower to represent Rhonda's strong bond and adoration of her family. On each of the petals she placed the name of a family member. She carefully added her husband's name and the name of her three sons and sister. Rhonda shared that her "greatest and *only* achievement" is her family. She stated that her sister is her best friend; they have been inseparable since they were babies. She mentioned that her husband is a saint and accepts her unconditionally. Rhonda remarked that there have been many things in her life she feels guilty and embarrassed about doing, but her family has always stood by her side and helped her in any way possible.

STRENGTH GARDEN

PROCEDURE: Draw a few strengths growing from the ground to create a garden.

QUESTIONS FOR EXPLORATION:

1. Which strengths are growing in the garden?
2. Is the garden full or sparse?
3. How long have the strengths been growing and how developed are they?
4. Which is your favorite strength?
5. Do you have the seeds to plant future strengths?

CLIENT RESPONSE:

A 25-year-old woman named Lisa used part of a magazine photo as the basis of her garden; the flowers, stems, leaves, grass and small shrubbery were drawn with markers as seen below. Lisa shared that her garden was blooming because it had been nurtured during the past year. She stated that she has nurtured it with positive self-talk, various self-help skills and mindfulness techniques. Her garden contained many of her strengths, some of which included: being hopeful, thoughtful, creative, kind, strong, smart, a loyal friend and humorous. Lisa remarked that her garden was lush and would continue to flourish as long as she continued to be patient while her medication was adjusted, and as long as she was open to learning and implementing new coping skills. She shared that her most valuable strength was her sense of humor because it helped her cope with problems and allowed her to laugh at herself. "Not always taking myself so seriously." She commented that her "new" strength was creativity. Lisa shared that she never considered herself creative, but acknowledged that her sketches were "pretty good."

POPSICLE STICK AFFIRMATIONS

ADDITIONAL MATERIALS: Large popsicle sticks or tongue depressors.

PROCEDURE: Write an affirmation on a popsicle stick and decorate, if desired. Once finished, place your stick in a container in the middle of the table and each person will select one and read it aloud. When everyone has shared, you may keep the affirmation stick you chose.

QUESTIONS FOR EXPLORATION:

1. What is your reaction to the affirmation you chose? Are you able to incorporate its message into your everyday life?
2. How does the affirmation relate to your thought processes, behavior, lifestyle and/or attitudes?
3. Do you have your own favorite affirmation? Which affirmation did you write on your original popsicle stick?
4. How can positive thoughts and statements help improve your mood, self-esteem and quality of life?

HOMEWORK: Periodically write more affirmations on popsicle sticks and place them in a jar or decorative cup. You may decorate a jar yourself using decoupage, permanent markers or glass paint. Eventually you will have a jar filled with affirmations that you can peruse when the mood strikes. You may even give the affirmations to friends and family members to lift their spirits and provide extra motivation.

CLIENT RESPONSE:

A group of eight people of varying backgrounds participated in this exercise. They agreed that they enjoyed the exercise very much and found it enlightening and pleasurable. They liked the idea of collecting affirmations in this manner, and they appreciated the new connections that were created.

One young woman named Hillary chose the affirmation: "Life is not about waiting for the storm to pass; it's about dancing in the rain." She remarked that she loved the saying and would refer back to it frequently. She shared that the affirmation's message is the opposite of how she often thinks and behaves. She said she usually denies herself all types of things until whatever has to be done is completed. For example, if she has a test in one week she will not go out with friends or watch movies or television shows, or browse the Internet until the test has been taken. If she is angry or sad, she will not do anything fun; she will sit and stay with the feeling until it goes away. She said that she is saving her money for a condo in the future, so she rarely buys herself anything and she rarely goes out with friends because food and drink are so expensive. Hillary remarked that she's aware she needs more of a balance in her life.

THOUGHT-PROVOKING
VISUALIZATIONS

ADDITIONAL MATERIALS: Template of a male and female profile.

PROCEDURE: Use a pre-made silhouette of a man or woman's profile and/or draw your own profile, or just a circle. Fill in the profile with words, images, colors and shapes that represent your feelings, thoughts, issues, concerns, interests, values, family, support system, accomplishments, strengths, skills, stressors, challenges, beliefs, etc.

QUESTIONS FOR EXPLORATION:

1. What are you presently experiencing in your life?

2. What are your challenges?

3. What are your goals?

4. How would you characterize yourself?

5. What are your strengths and skills?

CLIENT RESPONSE:

Cindy, a 21-year-old college student, created a profile filled with many conflicting images, words and phrases. Essentially, she created a profile of opposites. For instance, she included words such as happy/sad, frightened/brave, and ugly/pretty. She drew an angel and a devil, an ugly man's face and a handsome man's face, a large black X and a red heart near it. She shared that she has many conflicting feelings right now and she wasn't sure she liked the current direction of her life. Cindy complained that she doesn't like college and hates her major, which is computer science. She grumbled that she is always arguing with both her boyfriend and her parents. She remarked she is often anxious, but also has times when she feels calm and peaceful, especially when she takes nature walks alone. When asked, Cindy shared that she needs to take tiny steps forward and make small frequent changes.

I LOVE MYSELF: A TRIBUTE

We are often quick to share things about ourselves we perceive as negative and slow to share our positive characteristics. Sometimes we are so busy with challenging lifestyles, jobs, relationships, etc., that we neglect ourselves and forget to give ourselves a pat on the back when warranted. This creative exercise gives you the opportunity to take stock of your accomplishments, unique qualities, and positive traits. We need to learn to appreciate and love ourselves. A major goal is to learn to treat ourselves as well or better than we treat others. We must develop these skills so we can be our own best friend!

When you examine all the things you have done in your life, and the impact you have made on others, you will see that you will be able to come up with an extensive list of your positive qualities and the "beauty of being you."

PROCEDURE: Create a tribute to yourself. Think of all the wonderful things you do (even very small things like holding the door open for an older person or allowing someone to step ahead of you while waiting on a long line, etc.) and add your positive characteristics, talents and strengths. Please don't be modest. You may use symbols such as hearts and rainbows to symbolize unique aspects of your personality.

QUESTIONS FOR EXPLORATION:

1. What do you most admire about yourself?
2. What is your greatest achievement?
3. When was the last time you gave yourself a pat on the back?
4. Do you treat yourself as well as you treat your family and friends?
5. How can you show yourself more empathy and support on a daily basis?

CLIENT RESPONSE:

Yolanda, a 42-year-old mother of three boys, suffering from anxiety and depression, drew a personal trophy, here. She shared that it reflected her loves and strengths. Yolanda remarked that the hearts symbolize the love she gives to family and friends, especially her children. The small stick figures represent her loyalty to her family; the rainbow symbolizes her optimism and hope for a better future; the arrows pointing up represent hope and optimism; the smiling face symbolizes her healthy sense of humor ("when I'm well"). The flowers symbolize growth and her willingness to be open to new experiences, as well as her lifelong desire to learn and develop new interests and skills.

Yolanda shared that although she was able to draw these positive attributes, she has not given herself a pat on the back for a long time; she didn't feel worthy of the pat. Yolanda remarked she feels guilty and embarrassed by her "laziness and inability to function." She knows she should be more active and willing to go back to work, but she "feels immobile, like I'm glued to the couch."

MERITS OF SELF-COMPASSION

Think of how important it is to be caring and kind to yourself. You can *choose* to decide you are worthwhile and deserving of support, praise and compassion. Generally, when we show compassion towards ourselves, our self-esteem improves, our mood and motivation improve, and the quality of our relationships improves. *Our entire life improves!*

Affirmations are positive statements that usually begin with "I" (e.g., "I am worthy," "I am enough," or "I can conquer whatever comes my way"). Affirmations are inspirational, and motivate us to be healthier and happier, and improve our attitude and outlook on life.

PROCEDURE: Create an affirmation that relates to the theme of self-compassion. For example, "I will be kind to myself every day," or "I like myself for who I am." Illustrate the affirmation or part of the affirmation in any way you wish.

QUESTIONS FOR EXPLORATION:

1. How would your attitude, mood and behavior change if your thinking changed too?
2. How would it feel to forgive yourself when you make a mistake, and how would it feel to let go of past mistakes?
3. How would it feel to give yourself a pat on the back for a job well done? When you cut your finger you generally put a Band-Aid on the wound, so what about placing a Band-Aid on your emotional wounds? Do you think you'd heal quicker with a bandage and gentle, loving attention?
4. It is helpful to explore barriers to self-compassion. What are the reasons you may not forgive yourself or refuse to show warmth towards yourself when you are experiencing discomfort and difficult challenges?
5. How difficult would it be to treat yourself the way you treat others when they make mistakes or have problems?
6. When was the last time you showed compassion toward yourself? How did it feel?

CLIENT RESPONSE:

Suzanne, a 52-year-old physical therapist, chose the affirmation, "I will not let others intimidate me." She drew a cartoon-like sketch of a sizable figure pointing a finger at a smaller figure that seems to be quivering. Next, she placed a large black X through the menacing person. She stated that her boss has been demeaning and mean, threatening her with probation because she has been late to work the past few weeks due to car issues.

Suzanne had been highly stressed, fearing she will be terminated, which would be a major problem since she had been experiencing significant financial problems. She remarked she knew her boss wouldn't really fire her, but she had been obsessing about this possibility regardless of the facts. She mentioned that it is almost impossible to be fired because she worked for the state and has been in her position for 15 years. Suzanne promised she would try to ignore her boss's threats and focus on her work, and her co-workers whom she liked very much. She would be kind to herself and attempt to think about what a dedicated and successful therapist she had been for the past 15 years instead of her unrealistic fears.

FEEDING YOUR MIND

PROCEDURE: Briefly explore the following quote: "Your mind will always believe everything you tell it. Feed it faith. Feed it truth. Feed it with love."

Think about the question: "What are you feeding your mind?"

Outline a profile from a template or draw your own profile. Fill it in with things you are feeding your mind (e.g., positive or negative thoughts, love or hate, stereotypes or open-mindedness, nutritious or unhealthy food, etc.).

QUESTIONS FOR EXPLORATION:

1. What do you usually think about during the day?

2. Do your thoughts tend to be more positive or negative? Do they affect your self-esteem and motivation?

3. How does your environment affect your thoughts and mood?

4. How can you begin to control your thoughts when they become negative and/or chaotic?

CLIENT RESPONSE:

Millie, a 42-year-old woman diagnosed with depression and anxiety, admitted that she feeds her mind negative thoughts most of the time. She feels worthless and guilty for not being a good wife or mother. Millie shared that she is always anxious and fearful to go places, even with her children, who need her to drive them to after-school events and to friends' homes. She stated that sometimes her children and her husband become so disgusted with her behavior that they say very hurtful things to her and then ignore her for long periods of time. She shared that she wants to be able to be there for them, but finds herself frozen with fear and overwhelmingly tired much of the time.

A typical day, according to Millie, included lying on the couch and watching television all day except to get up and go to the bathroom or sometimes to do a little light cooking. Millie affirmed that she needed to try to think more positively and push herself to do more for her family and for herself.

WE ARE MULTIFACETED

ADDITIONAL MATERIALS: Template of a figure to outline and copy.

PROCEDURE: Using the figure template, outline a figure on a sheet of paper. You may draw your own outline if you wish. Fill in the figure with anything that is self-representative (e.g., goals, hopes, personality traits, things you like/dislike, words that describe you, problems, achievements, memories, affirmations, places you have been, people important to you, hobbies, interests, etc.).

QUESTIONS FOR EXPLORATION:

1. How do you view yourself?

2. Do you tend to label or categorize yourself? Is that helpful or unhealthy?

3. How many "hats" do you wear? How many different roles do you play in your life? (e.g., sister, friend, parent, child, worker, teacher, etc.)

4. What positive characteristics do you see in yourself?

5. What, if anything, would you like to change about yourself?

6. What is/are your proudest achievement(s)?

CLIENT RESPONSE:

Arnie, a 60-year-old man challenged with alcohol addiction, described himself as a drunk and a loser. He stated that he feels guilty about lying to his family for years and losing a lot of money due to alcohol, drugs and gambling. He questioned the fact that his wife has put up with him for 30 years. "Why did she stay with me?" he wondered. Arnie mentioned he would have left himself years ago if he had the ability.

Arnie began to acknowledge that he wore many hats; he was not just an alcoholic. Arnie eventually shared, with support, that he was a father, husband, grandfather, uncle, friend, worker and helper. He sheepishly admitted that he was a good mechanic and handy around the house. He had built cabinets in his kitchen, put down tile in his bathroom, and designed a shelf in the garage.

Arnie was encouraged to view himself as a complex and unique individual who wore many hats; his addiction was something he was challenged with, but it didn't define him.

SELF-CARE MENU

ADDITIONAL MATERIALS: Outline of a blank menu or rectangular shape that looks like a menu (if desired).

PROCEDURE: Create a self-care menu composed of things you need to meet and enhance your physical and psychological needs.

QUESTIONS FOR EXPLORATION:

1. How do you get your needs met?

2. What do you do to soothe yourself?

3. What do you say to yourself during stressful situations and when life is difficult?

4. What distractions help you cope?

5. What leisure activities help you unwind and relax?

6. Who do you surround yourself with when you need extra support?

CLIENT RESPONSE:

Sharon, a 51-year-old nurse, shared her self-care menu aimed at decreasing stress and practicing gratitude:

- Get enough sleep
- Eat more healthily
- Limit sweets
- Exercise
- Be mindful
- Put things into perspective
- Have appreciation
- Take a time-out
- Take one day at a time
- Be optimistic
- Be grateful for family
- Take small steps forward
- This is happening but _____
- "It is what it is"
- Ask the question, "Is this helping me or hurting me?"

CUP OF SELF-COMPASSION

> **"Remember to take care of yourself.
> You can't pour from an empty cup."**

ADDITIONAL MATERIALS: Outline of a large cup (if desired).

PROCEDURE: Draw your cup and fill it with ways in which you take care of yourself (e.g., journaling, exercise, nutritious eating, thinking positive thoughts, etc.).

QUESTIONS FOR EXPLORATION:

1. How can you fill your cup (e.g., keep yourself healthy and motivated)?

2. What is in your cup now?

3. What was in your cup in the past?

4. What would you like to see in your cup in the future?

CLIENT RESPONSE:

Aubrey, a creative woman who just turned 33 years old, chose to fill her cup with a combination of her interests, desires, goals, and personality characteristics below. She used the cup to celebrate her birthday with a cake, personal birthday wish, and rainbow to represent positive thinking. She also included:

- Arrows to symbolize her goal of becoming an elementary school teacher.
- A smiling man speaking, which represents her boyfriend proposing to her in the future.
- The blue wavy ocean (bottom right) to symbolize her need for peace and tranquility.
- The hearts represent the love she has for her boyfriend and her family.
- The flower symbolizes the beauty in her life.
- She added a paint brush, stating she hasn't engaged in art for years but wants to pursue it again because drawing helps her express her feelings and "calms me."
- The large purple number 1 represents an important reminder to take care of her needs and not just the needs of others.

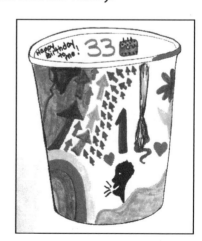

MEANINGFUL OFFERINGS

PROCEDURE: The therapist will provide the outline of a medium sized square or circle. Fill it in with gifts you have given others over the years. You may draw, write or use magazine photos and words.

QUESTIONS FOR EXPLORATION:

1. Which gift did you feel most proud of giving to someone else?
2. Share an instance where you benefited from giving someone else a gift.
3. Which do you tend to enjoy more: receiving presents or giving presents?

CLIENT RESPONSE:

A 70-year-old woman named Deidre added a number of images to her square of gifts. She included a picture of her hugging her children, (representing the gift of love and support), a sketch of a clock (representing her donating her time while volunteering at an animal rescue facility), a heart (symbolizing the love she gives to the animals she saves), a block (representing the strength she gives to her family and friends), and a group of people chatting (to represent her love of being social and helping others). She stated she receives much more benefit than the people and animals she helps. Deidre mentioned she "always feels good" after volunteering her time.

SELF-ESTEEM WALL

PROCEDURE: Create a wall that reflects your current self-esteem.[12]

QUESTIONS FOR EXPLORATION:

1. What is the size of the wall?
2. What is it made of?
3. Has it changed in size over the years?
4. Have people in your life and/or recent experiences affected the size of the wall?

CLIENT RESPONSES:

Chad, a 24-year-old man challenged with bipolar disorder and addiction issues, drew a brain on fire, and an eye ("the all-knowing eye") was placed in the middle of the brain. Chad remarked that currently he is very confused and his mood is "all over the place." He stated his self-esteem is also erratic depending on the time of day, his girlfriend's mood, the people he is with, and how he is feeling about his current circumstances. He stated he chose not to draw a wall because it is too rigid. Chad took much pride in his fluidity.

Jack, a 40-year-old man with addiction issues, drew a well thought out wall with black and white bricks placed strategically to create a hole in its center. An axe is protruding from the hole. Jack shared that until recently, his wall (heroin addiction) has been strong and unbreakable. He stated that his axe (the drug program and incentive to stay clean) started breaking it down, and now he is finally able to breathe.

4
Chapter

Connections & Relationships

Relationships are connections among people, which may include strong bonds related to friendship, marriage, partnership, family, community, and/or work, etc. Individuals may develop their own unique relationships because relationships are personal and can vary from person to person, group to group.

In the movie "Cast Away," Tom Hanks's character—stranded on an uninhabited island—creates a face on a volleyball and talks to the ball, which he names "Wilson," as if it were a person. Though funny, the gesture illustrates something very basic about us: relationships are important—so important, in fact, that our brains are hardwired to form them.[13]

We are social beings. It's in our nature to form social relationships. In fact, social relationships bring very specific rewards. The rewards they bring are emotional, material, and physical. In terms of emotional rewards, our relationships give us emotional support and encouragement in difficult times.[14]

Scientists are investigating the biological and behavioral factors that account for the health benefits of connecting with others. For example, they've found that it helps relieve harmful levels of stress, which can adversely affect coronary arteries, gut function, insulin regulation, and the immune system. Another line of research suggests that caring behaviors trigger the release of stress-reducing hormones.[15] People with good quality friendships handle stress much better. People with a supportive partner recover better from heart attacks and other illnesses. Research shows that physical affection between loving partners, parents and children, and close friends can help the brain, heart and other body systems.

Relationships not only help us cope with stress and illness, but also with a challenging environment. In poor neighborhoods of Chicago, for example, positive personal connections are associated with lower crime rates, less drug use, and fewer unwanted teen pregnancies. Perhaps relationships give us a healthy outlet for our anger and sorrow.[16]

In positive relationships partners encourage each other to grow and flourish. Friends like seeing friends succeed and achieve their goals. One of the more obvious benefits of positive relationships is that they make life more enjoyable. Positive relationships add more pleasure, purpose and fulfillment to life. Additional benefits include:

- Feeling of support and safety
- Exchange of ideas
- Excitement and enjoyment
- Empathy

- Encouragement
- Guidance
- Assistance
- Companionship
- Love
- Provides a purpose
- Helps broaden your horizons
- May lessen stress
- Encourages personal growth
- Adds meaning to our lives
- Increased self-awareness and self-esteem
- Often motivates people towards self-improvement
- Some studies show that people with strong social relationships are less likely to die prematurely[17]

The following exercises help individuals connect with others in creative and meaningful ways. Participants become aware of their role in developing healthy, productive relationships. The exercises promote connections with others and improved communication, which is crucial in the development of positive and worthwhile relationships.

FAMILY IN ACTION

PROCEDURE: Draw a family engaged in an activity (stick figures are fine).

QUESTIONS FOR EXPLORATION:

1. What is the family doing?

2. Which family members are included?

3. Who seems to be dominant in the family?

4. Are you included in the picture?

5. How would you be feeling in the scene?

6. What role do you play in your family?

7. How does your family support you?

CLIENT RESPONSE:

Mel, a young man in his twenties who was recently diagnosed with bipolar disorder, depicted his family. He included his mother, father and two brothers in the sketch. He placed himself larger than the other figures and centered in the middle of the paper. His mother is on one side of him and his father is on the other side. One brother is placed next to his mother and one brother is placed next to his father. He shared that the family is posing for a photograph and they are tired of smiling. Mel complained that his parents have been fawning over him and treating him "like a charity case." He stated, "All the focus is on me."

Mel complained that his family is suffocating him and waits on him hand and foot. He told the group that he wants to be left alone and he wants to be independent. He drew his parents with wavy arms, one longer than the other, to represent their indifference to his desires and their interference in his life. He stated that he knows they are concerned and worried but they "must leave me alone."

THE UNITED SHAPES

PROCEDURE: Draw two shapes connected in some way.

QUESTIONS FOR EXPLORATION:

1. How are the shapes connected?

2. Do the connections create an image or design?

3. How important is it for you to have connections in your life?

4. Are your connections presently strong or weak?

5. How can you create new connections and friendships?

CLIENT RESPONSES:

Bella, a 29-year-old woman with depression and anxiety, drew two amorphous shapes intertwined with each other. Bella remarked that the shapes represented her boyfriend Tony and herself. She shared that they used to have fun and were very close; "We were great friends." Her anxiety stemmed from her fear that she might have to make a decision about the relationship because he had recently changed significantly, becoming too controlling and aggressive. She had been dating him for a year, and during the past three months she had started to notice a startling disparity in his behavior and attitude. She complained that Tony wanted to know where she was at all times and whom she was visiting. Lately, "he doesn't even like when I spend time with

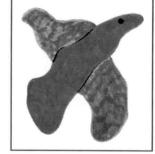

my parents." Bella remarked that he used to ask her to make at least some of the decisions about what they would do and where they would go. "But now he insists on making all of those decisions." She realized something was wrong, but didn't know how to confront him, and wondered if he would "go crazy" if she ended the relationship.

❧⋯☙

Emma, a 29-year-old woman overcoming her addiction to marijuana, drew magenta and green shapes overlapping one another, above. Emma loved the bright colors and the way the shapes connected. As she observed the picture, she noticed that the combination of shapes seemed to turn into a bird. She chose to place an eye on the pink shape to make the image even clearer. Emma stated she liked the abstract bird because it reminded her of freedom. "Flying free without worries or cares." When asked, she mentioned that connections are important to her, especially her relationship with her boyfriend of four years. She stated that although she adores her boyfriend, she still needs her independence and will probably never marry or have children.

IMPACT OF BODY LANGUAGE

PROCEDURE: Draw someone displaying nonverbal body language (e.g., someone pointing his finger at someone else, someone with a pout, someone bowing or a person winking).

QUESTIONS FOR EXPLORATION:

1. What is the importance of knowing and understanding nonverbal cues?

2. What cues do you use at times?

3. Has anyone ever said something to you verbally but their body language communicated something else?

CLIENT REACTION:

An 18-year-old teenager named Kayla designed a woman with her hands on her hips. The woman has short, straight brown hair and wears thick brown-rimmed glasses. She appears chubby, has freckles and a large nose and pronounced mouth lines. Kayla chuckled and remarked that the woman is her mother. She stated her mother is "always on my case" and is very bossy. Kayla complained that her mother wants to know everything she does— e.g., who her friends are, what happens in school, whether or not she has homework, what time she goes to sleep, what she's reading, what sites she is visiting on the computer, etc.

Kayla complained that her mother doesn't let her breathe. She mentioned that she could hardly wait to begin college next August so she could live in a dorm and be independent and free. Kayla shared that she both loves and hates her mother simultaneously. She predicted they would get along better when she is living away from home.

TUG OF WAR

PROCEDURE: Draw a tug of war between two people (i.e., two people pulling on a rope, one figure on one side of the rope and the other figure pulling from the other side).

QUESTIONS FOR EXPLORATION:

1. Which figure are you?

2. How hard are you pulling?

3. Are you going to win or lose the tug of war?

4. Do you feel in control or out of control?

5. Do you feel strong, average or weak?

6. What happens if you win? If you lose?

7. Are you in a tug of war in certain areas of your life?

8. What would you be saying if this drawing was real and you were really participating in this difficult exercise?

CLIENT RESPONSE:

Andy, a 58-year-old businessman overcoming anxiety and addiction issues, drew a tug of war between two stick figures. He drew himself as one of the figures and a potential client as the other. He drew himself larger and more detailed than the potential client. While examining the picture, Andy shared that he is engaged in a tug of war and he is pulling with all his might. He stated he is in control and will win the game. He shared that he feels strong and when he wins the challenge, he will make a lot of money. In response to the question, "Are you in a tug of war in certain areas of your life?" he answered that there's a constant struggle he considers a normal part of life. He also mentioned that his alcohol addiction has been like a tug of war, but he feels he is finally beginning to gain control over it. In addition, Andy shared that in the sketch he is focusing on the game and not thinking of much else. He shared that he likes to win. When referring to the skinny stick figure, he jokingly noted that he needs to gain weight.

INTERSECTING LINES

PROCEDURE: Draw colorful lines of varying widths that overlap repeatedly until a pleasing design is created.

QUESTIONS FOR EXPLORATION:

1. How does the pattern created relate to your current mood?

2. Does the design or part of the design remind you of anything in particular? (e.g., do you see an image in the design?)

3. Do you find the design soothing to view? If so, share what, in particular, you find calming.

CLIENT RESPONSES:

A 33-year-old man named Sam, who was diagnosed with bipolar disorder, drew a large spiral of overlapping lines in various colors. He added a grouping of wavy overlapping lines underneath the spiral. He shared that the drawing represents being "out of control." He remarked that the design was like a swirling mass of "craziness." He also added he likes to be "crazy." When asked, Sam shared that the design was soothing because creating it allowed him to vent his anxiety. He also added that the colors reminded him of a rainbow and made him feel alive.

A young woman named Pat drew small overlapping circular shapes that appeared flower-like. She shared that the design reminded her of a soft, pretty blanket. She remarked, "I'd like to snuggle up with that blanket placed over me and take a nap." Pat mentioned she had no real support in her life and she desperately needed support from others. She stated that her mother, who was 71, was hyper and always on the go. "She's never there when I need her." Pat was hoping for a stable, steady boyfriend who would be her friend as well as romantic partner. She wanted someone she could rely on, unlike her current boyfriend who is an alcoholic and her ex-husband who was selfish, irresponsible and abusive.

LOVE AND AFFECTION

PROCEDURE: Draw someone or something you love.

QUESTIONS FOR EXPLORATION:

1. Who or what do you love?

2. How does that love help you?

3. If it is a person, is the love reciprocal?

4. Why do you think love is healing?

CLIENT RESPONSE:

Reba, a 41-year-old woman diagnosed with generalized anxiety disorder, drew a sketch of nature to represent "the love of my life." She included a sun, a tree, birds in a nest, and a kitten in her sketch. Reba remarked that she loves nature and adores walking through the woods or the park. In the past, she enjoyed bicycle riding, but her red bicycle was recently stolen, much to her chagrin. She shared that being outdoors helps her cope with her anxiety because it creates stillness within her. "I feel free when I am outside."

She stated she often needs a release because she lives in a very small apartment with a roommate who is "paranoid" and angers easily. Her roommate has been holding a grudge and refused to acknowledge her for three weeks. She was occasionally destructive and recently threw dirt, rocks and twigs on Reba's favorite blanket. Reba remarked she felt like screaming when this occurred, but she took a walk instead, watching a neighbor's cat play in the field.

THE NATURE OF RELATIONSHIPS

ADDITIONAL MATERIALS: Magazines, scissors, and glue.

PROCEDURE: Find one photo from a magazine that represents a specific type of relationship.

Examples of photos to look for include: families, parents and children, animal families, people and their pets, friends, loving relationships, positive relationships, problematic relationships, unusual relationships, "ideal" relationships, relationship with self, spiritual relationships.

QUESTIONS FOR EXPLORATION:

1. Does the relationship chosen represent a personal relationship?

2. Are you engaged in a positive or problematic relationship at present?

3. Share something about the best relationship you have had or are presently experiencing.

4. What do you look for in any type of relationship?

5. Why are relationships so important?

CLIENT RESPONSE:

A 39-year-old woman named Amelia chose a photo of a family of four at the beach. She stated she wished she would find a man to marry, and have children with. She feared she was getting older and would soon be past her prime time to have a baby. She explained that she had been married for three years when she was in her twenties, but divorced because her husband was verbally and physically abusive.

She had recently been in a relationship, but her boyfriend was an alcoholic who would become verbally abusive when drunk; he couldn't hold a job and didn't want children. Amelia couldn't figure out why she always chose "such screwed up men." She stated she would pray that the right man would come along soon.

QUICK DRAWING PASS

PROCEDURE: Choose one specific color of marker or crayon, and work only with this color during the exercise. One sheet of paper will be passed to *each* individual, so everyone begins with one sheet of paper. Draw a quick sketch on your sheet of paper, and when the group leader says, "pass," give the person sitting to your right your sheet of paper. Now draw on the sheet of paper that was passed to you, and the drawing continues in this manner. This goes on until each participant has had a chance to draw on everyone's sheet of paper. The drawing pass is complete when you receive your original drawing back, complete with each participant's unique images and symbols.

*Shortened version: only *one* sheet of paper will be passed around and each person should add one image to that particular sheet, and then everyone's contributions to the picture will be explored.

QUESTIONS FOR EXPLORATION:

1. How do you feel about the additions made to your original sketch?

2. What do you think about the total picture? Do you see a theme? Are there any particular images that stand out? Feel free to ask participants which image they contributed. It is easy to know because each person used only one color of marker or crayon.

3. Did you feel a connection to others while engaging in this exercise?

4. Did engaging in this exercise change your mood or energy level?

CLIENT RESPONSE:

Group participants usually enjoy this creative experience. The exercise creates much camaraderie among group members. It is fascinating to see which pictures end up being cohesive and which ones disjointed. Sometimes the picture tells a story and sometimes it is difficult to determine any meaning at all in the drawing.

In one completed picture, a young woman noticed that someone repeatedly drew the same image of a blue superhero. The superhero artist stated he learned to draw the cartoon from his first love who had moved to another state last year. He shared that his heart still aches for her, but drawing this image makes him smile and think of the good times they had during the year they dated.

EXPECTATIONS VERSUS REALITY

PROCEDURE: Fold your paper in half. On one side of the paper draw what your life was *supposed* to be like now, and on the other half draw a representation of what your life *is* like now.

QUESTIONS FOR EXPLORATION:

1. Are you able to accept your life as it is right now (remember that acceptance doesn't mean giving up; it means you accept what is happening now, but you can still work toward goals and healthy change)?

2. What are the positives in your life now? What are you grateful for?

3. What are your expectations for the future?

CLIENT RESPONSE:

A 59-year-old woman named Bea drew a city with skyscrapers, cars, buses and a stressed looking figure on one side of the paper. On the other side of the page, she drew a woman reclining in a lounge chair on an exotic island. Bea sighed and muttered that her life plans went awry. By age 59 she was supposed to be retired, doing whatever she wanted. The plan was for her to travel, relax and enjoy the fruits of her labor. She had figured she would be able to go to movies, plays, malls, and eat at various restaurants weekly. She imagined she would have a group of friends, who would go on day trips, have fancy lunches together, and enjoy each other's company. She was going to wake up at 12:00 PM every day.

"Unfortunately," according to Bea, "that was not what happened." She shared that her husband needed to go on disability last year, so he brings home very little income each month. She complained that she has huge financial problems. Her house is in need of repair and the only places she and her husband have money to visit are the local community theatre and fast food restaurants. Bea stated her last vacation was Disney World in Florida when her youngest child was 15 years old. She said she has no choice but to keep her full-time job, which she doesn't enjoy and finds stressful. She quoted John Lennon, "Life is what happens, while you are busy making other plans."

GO WITH THE FLOW

PROCEDURE: Draw or create a collage representing the affirmation "Go with the Flow."

QUESTIONS FOR EXPLORATION:

1. What does it mean for you personally to "Go with the flow"?

2. How do you generally react to change?

3. When was the last time you needed to change?

4. How ready are you to change now?

CLIENT RESPONSE:

A young woman named Heather, who was challenged with depression and anxiety, created a collage/drawing that represented ways she tries to accept life's changes. She added a whale to represent "moving along," and nature scenes to symbolize that life is constantly changing. To symbolize change, she included a sunset, water flowing in a stream, and balloons "inflated and later deflated, flying away into the air until they are undetectable." She added a smiling face representing the peace and serenity that comes from being flexible and not fighting change. She shared that she generally accepts change and that she's ready to change now. Heather remarked that she needs to grow up and become more independent, not always relying on her parents for financial and emotional support.

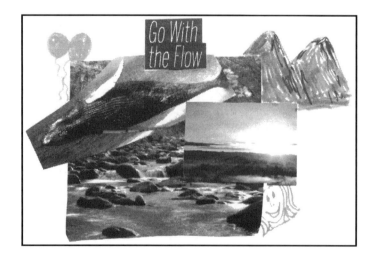

SURVIVOR

ADDITIONAL MATERIALS: Index cards.

PROCEDURE:

1. **Step One**: On an index card draw a person (preferably yourself) as a survivor; include what the person has survived (e.g., an illness, accident, surgery, relationship, storm, etc.). Stick figures and/or shapes are acceptable representations. Write your name on the bottom or back of the index card.

2. **Step Two**: The index cards are dispersed so that you will be given someone else's card.

3. **Step Three:** On the back of the card list three reasons why the survivor in the picture should continue to survive. In addition, any positive traits you notice about the survivor may be written on the index card.

4. **Step Four:** Each card will be given back to the person who originally created it for group discussion.

QUESTIONS FOR EXPLORATION:

1. What is your reaction to the artwork and what was written about it?

2. Do you consider yourself a survivor?

3. What types of things did you do to try to survive?

4. What suggestions do you have for others who may be trying to overcome great distress, life's obstacles, loss or other issues now?

CLIENT RESPONSE:

Clients appeared to enjoy this exercise because it encouraged a lot of interaction among group members and everyone supported each other. Invariably participants spoke about the ways in which they were survivors. One client shared she was a breast cancer survivor and another person shared he was a survivor of drugs and alcohol abuse. Discussion mostly focused on strength and ways to overcome problems, losses and unfortunate life circumstances.

HEALING BODY AND SOUL

ADDITIONAL MATERIALS: Outline of a Band-Aid®.

PROCEDURE: The outline of a Band-Aid®, write or draw what hurts today (physically or psychologically).

QUESTIONS FOR EXPLORATION:

1. What part of your body or mind needs the Band-Aid®?
2. How can a Band-Aid® help?
3. Does the Band-Aid® cover or hide the problem, or does it help you heal?

CLIENT RESPONSE:

Sheri, a woman in her late twenties, drew a self-portrait. She placed a large Band-Aid® on her forehead. Sheri stated that she suffers from migraines, which are often excruciating and incapacitating. She remarked she has been to neurologists, ophthalmologists, and many other professionals, but no one can determine the cause of the headaches. "Some doctors feel they are due at least partly to stress, so I decided to try psychotherapy." Sheri shared she thinks the migraines are physical, probably chemical, but she was willing to try anything to stop the pain. She shared that the headaches have made it impossible for her to attend college, work, or have meaningful relationships. Sheri stated she feels selfish, always focusing on her needs, but she doesn't know what else to do. She complained that she doesn't have the energy to deal with the needs of others at this point in her life. Sheri grumbled that her parents often criticize her because of her neediness. She shared, "They don't understand the problems and discomfort I experience on a daily basis."

COMMUNICATION BARRIER

PROCEDURE: Represent in any way you wish (image, shape, stick figure, cartoon, etc.) a person you have had problems communicating with over the years.

QUESTIONS FOR EXPLORATION:

1. In which ways are/were they difficult to deal with?
2. What have you done to try to deal with them in a positive manner?
3. Is the way you deal/dealt with them effective? If not, what could you do/have done differently?

CLIENT RESPONSE: Christy, a 47-year-old woman suffering from depression, drew a sketch of her friend Eve saying, "Me! Me! Me! Me!" Christy mentioned Eve has a good heart but all she ever talks about is herself. In addition, complained Christy, "When I begin to share anything about my experiences or my family Eve brings the discussion back to her own experiences and her own family. Christy mentioned Eve is a "one upper," meaning anything Christy has or does, *Eve has done it better or has more of it*. Christy shared that she has tried everything to deal with Eve, including trying to tune her out, changing topics, and finally mildly confronting her about her self-centeredness, but nothing had worked. Christy commented that she gave up a few months ago, and now sees Eve only occasionally, whereas she used to see her at least once or twice a week. "Avoidance has been the only things that works," she concluded.

RELATIONSHIP CIRCLE

ADDITIONAL MATERIALS: Pre-drawn handout of at least six concentric circles.

PROCEDURE: Fill in each concentric circle with names and symbols representing various people in your life. You may draw your own circles or use the pre-drawn hand-out. In the first circle, include those people you are closest with and then, working your way out towards the exterior circles, list those individuals who are more distant and/or tend to be problematic. In addition to writing names, you may represent individuals by drawing images, figures or other creative representations such as flowers and hearts to symbolize people you love.

QUESTIONS FOR EXPLORATION:

1. Who was placed in the closest circle and who was placed in the furthermost circle?
2. Is there anyone whose position in the circle has changed in recent years?
3. How do the people in your life affect your self-esteem, mood and/or behavior?
4. Which persons in your life have/had the greatest effect on what you do and how you feel?
5. How would you ideally like the people in your life to behave towards you? In reality, how do they act?
6. Who "pushes your buttons"?
7. What is your role in your relationships?
8. What does the circle say about those individuals you interact with and your relationship standards?

CLIENT RESPONSES:

A 43-year-old woman named Ella placed her children and herself in the center circle, which she colored bright yellow. She added a small heart to the circle to represent the love she has for her family. The next circle, filled in with a light green color, included her siblings and parents. The third, light blue circle included her best friends. Ella's closest co-workers were placed in the pale orange, fourth circle. Neighbors were in the fifth circle, and her ex-husband, Stan, was placed in the sixth circle. The sixth circle was dark gray with red zigzags which Ella called "lightning bolts," emanating out of it. Ella shared that Stan didn't even deserve a circle, and she called his circle "the circle of Hell." Ella said that Stan was an abusive husband who cared more for himself than anyone else. She remarked that he was an alcoholic "who valued his drink above anything else." She remarked she was glad to be free of him, and commented that her children seemed happier and less stressed since their divorce last year.

⸙

Kat, a woman in her mid-twenties dealing with major depression, placed her parents in the last circle. She stated that her parents are not supportive and view her as lazy and irresponsible. She complained that they don't understand why she is not pursuing an advanced degree in biology and why she doesn't have a job. They criticize her for her casual attire and lack of desire to socialize with her friends and ex-classmates. "They just don't understand that I am sick and feel like everything I do is extremely difficult." Kat stated she wished she could live elsewhere but knew she would have to live at home until she was able to motivate herself to be more independent.

SUPPORT WITH STICKS

ADDITIONAL MATERIALS: Popsicle sticks (thicker ones would be better).

PROCEDURE:

- On a popsicle stick, write a note of encouragement that would be suitable for anyone.
- All the sticks are placed in a box and each person chooses one of the sticks from the box and then reads the message aloud.
- After everyone shares, you may keep the popsicle stick you chose or ask to trade with another person.

QUESTIONS FOR EXPLORATION:

1. What meaning does the note have for you? How can it help motivate you?

2. Did you want to trade? Why?

3. Did you allow another group member to exchange notes with you? Why or why not?

4. Does the note have special significance because it is from a fellow group member? What might this imply about the importance of support in relationships?

5. How did it feel to show compassion to another person? How do you help yourself when you help others?

6. Are you able to show yourself the same compassion as you have shown to group members?

CLIENT RESPONSE:

Group members appeared to enjoy this exercise; most people were focused and involved. It is noteworthy that participants seemed very pleased and touched by the support given to them by their peers. Everyone asked to keep their sticks, and one person stated he would glue a magnet on the back of his and place it on his refrigerator for inspiration.

Eli, a man in his forties, remarked he felt motivated to explore affirmations and asked for a list of them to examine. He mentioned that supportive messages help him think more clearly and serve as a reminder to be more mindful.

WORKING IN PAIRS

PROCEDURE: Divide into pairs and create a 5-minute sketch together.

QUESTIONS FOR EXPLORATION:

1. How did it feel to work with another person?

2. What are your associations to the sketch?

3. Which part of the sketch attracts your attention?

CLIENT RESPONSES:

Jim and John, both young adults in their mid-twenties challenged with addiction problems, teamed up to create what they titled "The Alien." The men laughed as they described the alien as a tall, skinny, green, man-like being with slanted purple eyes and an antenna sticking out of his left ear. They shared that the alien has superpowers such as the ability to read minds, fly and swim at lightning speed. They related the alien to their desire to stand out from the crowd and overcome obstacles they are facing now. Lightheartedly, Jim added that having super powers would make it easier to find girls.

Shirley, age 75, and Olivia, age 81, created a nostalgic drawing. They designed a scene that included a movie theatre, a soda shop, and "the Automat." They used colorful reds, oranges and yellows to create the movie theatre and the Automat, and added cartoon-like stick figures with hairdos symbolic of the 1950s to symbolize themselves. The women shared that the picture represented a simpler and enjoyable time in their lives. They remarked when they were young they loved to go to the movies on Saturday night, and they enjoyed all the big stars of their era, including Lauren Bacall, Henry Fonda and Bette Davis. Shirley shared that she would sit in the theatre mesmerized, staring at the screen for the entire length of the movie.

Olivia stated that she loved the soda shop, and she would sit at the counter, sipping cherry sodas and looking at the cute young men who would walk into the shop. "Those were the days." Olivia shared that she met her husband at the soda shop. He asked if he could buy her a Coke and it was love at first sight.

The women reminisced about taking the train to New York City and visiting the Automat, a place where they could purchase a fun and filling meal for a few quarters. "It was so much fun to put the quarters in the machines and immediately a piping hot sandwich and soup appeared," Olivia recalled. "It was like magic."

When asked, the women remarked that they loved working together and found it interesting that they had so many memories in common. They even came to realize that they had attended the same elementary school in Trenton, New Jersey. They both agreed that the movie theater was the best part of the sketch because it was the most skillfully drawn image and because they had such fond memories of the wonderful productions they viewed over the years.

5

Change & Problem-Solving

"The first step toward change is awareness. The second step is acceptance."[18] Change is inevitable but accepting change can be very difficult for many people. It is in a person's best interest to learn to accept a wide variety of changes and challenges, some of which may include: aging, loss, divorce, a move, becoming an empty nester, change in ability, appearance, health, emotional wellness, ambition, motivation, financial status, etc.

The acceptance of change promotes personal growth, healing and recovery. People learn to move on by taking tiny steps forward while changing and/or challenging previous beliefs and attitudes. Sometimes individuals need to take one day at a time, one hour at a time or one moment at a time.

Transformation involves turning loss into something that an individual can cope with and accept. For instance, when an individual has to move to a smaller apartment after living in a large house for many years, they may be very upset. In order to adjust with this lifestyle transformation, the person may be encouraged to make the new home as attractive as possible and focus on its benefits, some of which might include that the apartment is easier to clean, it's bright and sunny, and all the rooms are on one level.

When people experience a loss or are not able to do what they did in the past, they can transform their skills, energy and focus. For example, someone who was a piano player and now has arthritis may be able to guide others and assist them in learning how to play the piano. An athlete who has hurt his knees to the point he can't play anymore, could coach children. When a loved one dies, the family can pay tribute to him by living a healthy, productive life and helping others, or create a scholarship in his memory. They can use his wisdom to advance in their personal and professional careers. Individuals discover that they have the choice of adjusting to new circumstances or remaining a victim and holding on to feelings such as sadness, anger, frustration and hopelessness.

Change is a continuous process of redefining and refining abilities, relationships and lifestyle. Moving on is difficult but not impossible. It takes patience, support and hope.

Individuals learn what is and what is not changeable, and what is and what is not in their control. They learn that sometimes they need to find new ways to achieve pleasure. Perhaps new experiences and meeting stimulating people can create feelings of satisfaction, similar to feelings one had in the past. Some individuals learn a new skill or volunteer to help others in order to find joy and satisfaction in their life. People frequently discover how skills, wisdom and insights gained over the years can help them cope.

Acceptance has many benefits, some of which include:
- Decreased stress
- Openness to new experiences
- Ability to move on in life
- A more positive attitude
- Increased life satisfaction and increased happiness

- Better relationships
- Less illness
- Healthier thinking patterns
- Increased desire to socialize and form new relationships
- Increased self-worth
- Better self-care
- More realistic outlook on one's life and the world

Acceptance is not the same as resignation or passivity. Acceptance means, "It is what it is." It means accepting yourself and/or your life as it is right now. An individual can still have goals, show dislike for what is presently occurring, and want to grow and develop in different ways. He may want to change his actions, thoughts, attitude and relationships but still accept what he is presently experiencing as well as unfortunate events that have happened in his life, like the death of a loved one or a physical or mental disability.

The following exercises enable participants to become more aware of how they experience change and transformation, how they can improve their attitude, mood and motivation by becoming more aware of their feelings, thoughts and patterns of behavior regarding this topic.

SCRIBBLE DESIGN

PROCEDURE: Create a scribble on the page, and then try to find an image within the scribble. Outline the image with a darker marker to make it more distinctive.

Another way to do this exercise is to design a scribble within a small square, (4" X 4" works well). Next, fill in the scribble with color, and examine the results to see if you can find an image within the design, or you may select part of the scribble you find unique. This method is similar to the first method, but sometimes drawing on a small sheet of paper elicits more of a response because the smaller size seems to be more appealing to people w/anxiety. Your group leader will determine which version of the activity you will do.

QUESTIONS FOR EXPLORATION:

1. Does the design remind you of anything or anyone?

2. Which part of the design attracts you the most?

3. What would you title it?

CLIENT RESPONSES:

Debbie, a woman in her sixties diagnosed with a severe depression, noticed a duck in her scribble design. She outlined the duck in yellow and titled the work "My Adorable Ducks." Debbie shared she was pleased with the picture because, "It made me think about my childhood." She reminisced about growing up on a farm in Pennsylvania and taking care of a variety of animals including pigs, chickens and cows. The farm included a pond, which attracted ducks and other animals such as tiny turtles and snakes. Debbie stated that growing up on the farm was fun. "That was the only time in my life I felt care-free and loved."

Debbie's current situation is very different from her past experiences; unfortunately, it is chaotic and stressful. She is in the process of moving from a large house to a small apartment, and she is divorcing her husband of 35 years for infidelity. Her children are not helping her because they are apathetic and they live across the country. She feels helpless and lonely. Reminiscing about the farm gave her some solace, even though it was only for a short while.

❦

Iris, a 57-year-old woman dealing with depression, drew a brilliantly colored scribble, and shared that she noticed two figures dancing within the design. She observed that they seemed to be doing an old disco dance step from the 1970s. She remarked the scribble reminded her of John Travolta dancing in the movie "Saturday Night Fever." Iris smiled and told group members about her teenage years, when she would spend Friday and Saturday evenings going to clubs with friends and dancing the night away. She mentioned that the clubs she visited were similar to the one shown in the movie. Iris laughed and described many of the men at the discos as smug but sexy, wearing brightly colored shirts unbuttoned almost to their belly buttons and doing all the latest dance steps. Most of the women wore short brightly colored dresses with lots of glitter and sequins. Iris mentioned she wished she were 19 years old again so she could go back in time, and have the fun she had during that period of her life.

CONTOUR LINE DRAWING

PROCEDURE: Create a figure without lifting your pencil from the paper.

QUESTIONS FOR EXPLORATION:

1. What type of image did you create?

2. How did it feel to draw in this unique manner?

3. How was the quality of the drawing affected by not lifting the pencil off the paper?

CLIENT RESPONSE:

Charlene, a young woman in her twenties with schizophrenia, drew a figure of a woman. She stated that the figure appeared lopsided, but she liked it because, "No one is perfect." She shared that people should not make fun of other people because they hallucinate or think differently. She remarked she had been teased since junior high school. Many people bullied her. They shoved her in the hallways, teased her and even pushed her to the ground a few times; she never fought back verbally or physically. She admitted she probably did not fight the bullies because she felt like she wouldn't win; there were too many of them and only one of her.

Charlene stated that her family members have called her crazy since she was young and she has always found that word very hurtful. Her parents made her feel "like I was nothing." Charlene shared that she liked the contour line drawing because nothing was expected of her. She could do whatever she wanted and it would be acceptable.

LESS DOMINANT HAND

PROCEDURE: Draw a quick sketch with your less dominant hand.

QUESTIONS FOR EXPLORATION:

1. How did it feel to draw with your less dominant hand?

2. How do you generally handle situations that become challenging?

3. How often do you try to change your routine and "take a different road or route?"

CLIENT RESPONSES: Bill, a 43-year-old male challenged with schizoaffective disorder, sketched a rendering of a mountain scene. The drawing included a spider-like image in the sky, a sun, a horse, and mountains rising high in the sky placed on top of rocky brown earth. Stars scattered on the left side of the picture symbolized mountain climbers falling off the mountain cliff. "They are falling into the abyss; they will never be seen again." Bill remarked the climbers were almost at the peak of the mountain, but there was some rumbling and a very strong gust of wind, which toppled them over.

When asked, Bill stated he was able to relate to the climbers' "downfall" because he had been doing well until he was about 22 years old. He graduated from college, cum laude, with a degree in psychology. He had a girlfriend whom he was planning to marry, and he had a job lined up at a teaching hospital. He was saving his money so he and his girlfriend could move in together and begin their new life. One day Bill was stopped for speeding and given a ticket, and after that incident he was never the same. He kept thinking the police were targeting him, searching for his phone number and private records and knew what he was doing all day long. He became panicked and even believed the police were bugging his home phone and taking personal photos of him. Eventually he had to be hospitalized and put on an array of medications, some of which helped and some of which made things worse. Bill shared that since then he has been struggling to survive.

☙•°•❧

Jane, a woman in her mid-forties, drew a shaky, small, orange flower. She shared she had a lot of difficulty creating the flower and felt very awkward during the exercise. Jane remarked she found this activity difficult because she tends to be a perfectionist and has trouble accepting imperfection. She stated she needs to do the best job possible or else she feels anxious and depressed. When asked, Jane mentioned that perfectionism has been a problem for her throughout the years, especially with her family, who becomes furious at her when she cleans up after them. She shared that her teenage son showed great annoyance when he came home from school one day and found her re-arranging his personal belongings. He yelled, "Leave me alone, I can't stand this anymore." Jane stated she felt badly but understood her son's need for privacy and independence. She remarked she is trying to be more flexible but will need to take one day at a time.

APPROACHING THE FINAL STRETCH

PROCEDURE: Draw a finish line (as in a race) and draw a figure in relation to it.

QUESTIONS FOR EXPLORATION:

1. Where is the figure in relation to the finish line?
2. How do you relate to the figure?
3. What type of race is/was it?
4. What happens at the finish line?

CLIENT RESPONSE:

William, a 24-year-old man with addiction issues, drew a small stick figure situated at the "Start" sign. He shared that the figure (himself) has not started the race yet. William shared reasons he was still at the starting line of his life. He admitted that he had been busy getting high and doing nothing else. He had a series of small jobs such as a pizza deliveryman, waiter and dishwasher, but the jobs did not last long because of his drug use and associated apathy and irresponsibility. William shared that he often overslept, took days off without notice, and took too many smoking breaks. He stated he hoped to begin the race in about six months. He thought he would be ready to take college classes and begin to take charge of his life at that time. William knew he had to take, "One day at a time, and hope for the best."

STOP SIGN

PROCEDURE: Draw a stop sign and place something/someone in front of it.

QUESTIONS FOR EXPLORATION:

1. What did you place in front of the stop sign?
2. How does it relate to your life?
3. Does the item hurt you or help you?
4. How long has it been there?
5. What are you doing to keep it there or take it away?

CLIENT RESPONSE:

Dave, a man in his mid-forties battling alcohol addiction, drew a large bottle of vodka in the center of the paper. He placed a black X through it to indicate that his drinking must stop immediately. He shared that his body and mind are deteriorating from excessive drinking, and he is about to lose his family because of his inappropriate behavior and intense anger, which he takes out on his wife and children when he is drunk.

Dave explained that he becomes a totally different person when he drinks. "Normally I am calm and easy going, but when I drink I become easily enraged." He stated that he wants to lash out at anyone he encounters, even his friends and family members. He went on to say he picks fights with other men, flirts with other women, and often spends the mortgage money on liquor, food, marijuana, and things he is not even aware of buying at the time. He shared that once he woke out of a stupor to see there was a new $2,000.00 computer on the floor by his bed. His wife "flipped" when she saw it and made him return it the next day. Dave realized that if he does not get help now he will lose everything he has worked for over the years, and he will be sick and alone.

QUESTION MARK I

PROCEDURE: Draw a question mark and place a word or image near it.

QUESTIONS FOR EXPLORATION:

1. What are you uncertain of in your life?
2. What would you like to know that you don't know yet?
3. What do you wish you knew in the past that you know now?

CLIENT RESPONSE:

An 18-year-old woman named Gina drew a question mark surrounded by brightly colored shapes and many mini question marks. The design appeared to be moving in many directions. Gina laughed, "Even my question marks have question marks." She shared that she doesn't know what she wants to do with her life, and she doesn't think she wants to attend college, even though her parents are urging her to go to the local community college. Gina stated she doesn't like school; she complained her focus is so bad that she would never be able to retain information presented by the instructor. She thought she might prefer, "To work in a department store, maybe behind the make-up counter, at least for a while." Gina knew she had to get her severe anxiety under control before she could make any specific decision about her life. She admitted that all she really wanted to do was to watch television, surf the Internet, and sleep.

ENTER AND EXIT

PROCEDURE: Draw a large, closed door and add an image representing what is behind it, near it, or what you would observe when opening it.

QUESTIONS FOR EXPLORATION:

1. What did you place in relation to the door?
2. What is the significance of the item?
3. How long has the item been there?
4. Is the item attainable?

CLIENT RESPONSE:

A 58-year-old scientist named Tony drew a bright garden filled with an assortment of colorful, blooming flowers. Tony shared that he would love having a pleasant, relaxing place to use as a sanctuary, especially when he felt stressed. He shared he would relish lying in a hammock appreciating nature and perhaps enjoying a picnic with his family in such a serene environment. Tony remarked he had been busy and frazzled at work, always anxious about deadlines and experiments going wrong. He stated that he needed a vacation or at least a mini getaway for a few days. He hoped he would eventually be able to afford a larger home with a sizable yard and an in-ground pool. Tony stated that he wanted the yard and garden more for his wife than for himself; he commented that he adored his wife, who was loving and supportive.

AIMING FOR BALANCE

PROCEDURES: Draw a balanced design. The design would ideally be harmonious, symmetrical, and pleasing to the eye. An example of a balanced design would be *Memory of a Voyage* by Renee Magritte or *Seahorse* by M.C. Escher.

QUESTIONS FOR EXPLORATION:

1. In which ways is the design balanced?

2. Is your life balanced?

3. How can you begin to balance your lifestyle if it is unbalanced?

4. What is the importance of a balanced lifestyle?

CLIENT RESPONSE:

A 35-year-old woman named Maria drew two small profiles (her and her husband) facing each other. She shared that she wishes her life was as balanced as her sketch, and that she and her husband "actually saw eye to eye." Maria shared that in reality her life is a mess, "very unbalanced." She stated her household is chaotic and disorganized. Her husband, according to Maria, doesn't help around the house and works long hours, even on the weekends.

Maria complained she is stuck with cooking, cleaning, grocery shopping and paying most of the bills. In addition, she complained she hardly sees her husband because he is so busy. "I feel lonely and forgotten at times." She stated she would have to be more assertive and demand more of her husband, even if he becomes angry and "gives me a hard time."

DESIGNING AUTONOMY

PROCEDURE: Draw "the shape of freedom." Examine what freedom means to you and sketch your visualization of it. Consider spiritual, emotional, physical and personal freedom. Examples may include an open ended shape to represent freedom to escape a situation or thought, or a circle to symbolize safety, comfort and freedom from fear or adversity.

QUESTIONS FOR EXPLORATION:

1. What does freedom look like to you?

2. Do you have the freedom you desire?

3. Have you ever felt free?

4. What would you have to do to gain a feeling of freedom?

5. Who do you know who seems free?

CLIENT RESPONSES:

Diana, a 37-year-old woman challenged with anxiety and OCD, drew a person sitting under a tree in a park, holding a red rose. She shared to her, freedom was the gift of feeling peaceful and calm. She remarked that a life without panic attacks and constant worry about checking everything repeatedly would be like heaven. Diana stated she has to check that she locked her apartment door multiple times, and she worries that she left the coffee maker on every day. The worries overwhelm her at times, and on occasion, she has left work, which is almost an hour away from her home, just to check that all the appliances and lights in her apartment were turned off.

❧

Matt, a 42-year-old man diagnosed with bipolar disorder, created a chaotic-looking design. He drew with intensity and he used many colors and shapes to create his picture. Matt remarked that his "mess" was freedom because he had the freedom to do whatever he wanted on the blank page. He was able to express himself without fear of judgment. He also emphasized that freedom was a personal word. "You can't draw or verbalize it; it is something you feel."

❧

Alex, a 50-year-old male, represented freedom by drawing himself snorkeling with dolphins and sharks. He stated he felt most free when he snorkeled in Belize, the Cayman Islands, the Bahamas, Egypt and Israel. Alex remarked he felt like he was in his own amazing underground world when he snorkeled; he only focused on what he was seeing and doing at the time. He stated he was able to let all other thoughts go out of his head while engaging in this type of activity. He also shared that music works the same way for him. He gets lost in the music and lyrics.

HAND DRAWING I

PROCEDURE: Draw with two hands at once.

QUESTIONS FOR EXPLORATION:

1. What reaction did you have while engaging in this exercise?

2. Was it easy or difficult? Strange or uncomfortable?

3. Did you create a specific image or an abstract design?

4. What theme, ideas and/or meaning do you notice in your artwork?

5. How does it feel to think out of the box?

CLIENT RESPONSE:

A 29-year-old man named David created a maze of colors and lines; he also included a variety of shapes and scribbles. When asked, David shared he had a good time engaging in this exercise. He said he didn't know what he was doing; he just experimented and played with shade and color. He didn't see an image in the art but did like that he was able to draw freely and not worry about what others thought of his work. He mentioned that it was a liberating experience.

TREADING THE WIND

PROCEDURE: Draw yourself (a stick figure is fine) walking in the wind.

QUESTIONS FOR EXPLORATION:

1. How did you portray yourself? (e.g., tall or short, strong or weak, walking with or against the wind, etc.?)

2. Is the wind strong or weak?

3. How are you handling the wind? (e.g., is it pushing you forwards; is it lifting you off your feet, etc.?)

4. How do you usually handle "stormy" situations?

CLIENT RESPONSE:

A 39-year-old woman named Marilyn drew her figure (herself) running with the wind. (See below). She noted that the wind is pushing her forward, actually helping her run. Marilyn's figure was smiling and running towards a question mark and a flower. She mentioned she doesn't know what the future will hold for her, but hopes it will be bright. She shared the flower represents love and hope. Marilyn smiled and commented that the figure looked a little bit like her, but she is "much fatter" than the figure and needs to lose weight.

MEASURING MOTIVATION

ADDITIONAL MATERIALS: Rulers.

PROCEDURE: Use a ruler as a template and outline it on a sheet of drawing paper, holding it vertically. Next, fill in your level of motivation, deciding approximately how many inches of motivation you have at the moment.

QUESTIONS FOR EXPLORATION:

1. What is your level of motivation?

2. Has it changed recently?

3. Do the colors used reflect your attitude regarding change?

4. Do you think it will be easy, difficult or somewhat challenging to change?

CLIENT RESPONSE:

Oscar, a 72-year-old man challenged with depression, stated his motivation level was very low (about one inch). He shared that his depression has made it difficult for him to get out of bed, go to work, socialize, shop or do much of anything. He stated he doesn't have energy or the desire to take a shower, get dressed or even make breakfast, lunch or dinner. He shared that frozen dinners and an occasional peanut butter sandwich are his main source of nourishment.

Oscar said he had had recurrent depressions over the years, but this one was especially devastating because he has no one to support him at home. He was divorced a few years ago and his children have moved out of the house and are leading their own lives, living in other states. They call occasionally, but are preoccupied with their own jobs and relationships.

Oscar promised he would try to be more active at home; he stated he enjoyed art therapy and would try to do a little sketching. His plan was to ask a friend to drive him to an art supply store over the weekend to purchase colored pencils and a pad; he thought if he had the supplies available he might use them at least occasionally.

BLOCKING OUT THE NEGATIVE

PROCEDURE: Draw a wall or barrier separating you from your problems, feelings, anxiety or negative thoughts.

QUESTIONS FOR EXPLORATION:

1. What are your thoughts about the size, shape and strength of the wall?

2. When was the wall erected?

3. How can you use the wall to distract yourself when stressed?

4. What are its benefits?

5. What are the problems associated with it?

6. How are you currently managing it? Are you taking steps to dismantle it?

7. How long do you think it will be a necessity in your life?

8. Do you use it as an escape? Does it significantly affect various areas of your life, such as your relationships?

CLIENT RESPONSE:

Barbie, a 48-year-old woman challenged with anxiety and depression, drew a large, brown, mountain and placed a small figure (herself) in front of it. Barbie shared she was inundated with problems such as pending bankruptcy and owing a lot of money to various companies, friends and family. She complained that she needed a break and wished she could escape from her issues and concerns. She whispered that she would like to hide behind the mountain and live peacefully away from "all the shit." Barbie remarked she would like to stay hidden forever but would be satisfied escaping for at least a few weeks. When asked, Barbie shared, "The mountain looks strong but it is unstable, because an earthquake is coming, which will demolish it." She said she knew the earthquake represented her problems, which would destroy her if she avoided them for too long. She remarked that she needed to practice relaxation and mindfulness techniques so she could better deal with her problems and not hide from them. She acknowledged that her troubles would remain no matter how long she chose to ignore them.

HEALING

PROCEDURE: Draw your response to the question, "What do you need to heal?"

QUESTIONS FOR EXPLORATION:

1. What types of items, ideas, people, etc., do you need to heal?

2. Do you currently have what you need to begin the healing process?

3. If you don't have what you need, how can you obtain these things?

4. How do you self-soothe?

CLIENT RESPONSE:

A young woman named Adriana outlined a profile and began filling it with words and phrases illustrating what she needs to heal. She added many positive thoughts and activities including: meditation, yoga, nature walks, hiking, deep breathing, gardening, staring out the window, guided imagery, movement, dance, art, painting, drawing, clay, pets, homemade cookies, baking, taking tiny steps, one day at a time, breakfast, coffee, hot chocolate, acceptance, and so on. Her immediate plan was to continue the project and eventually completely fill in the profile, and then use it for inspiration.

LIFE GARDEN

PROCEDURE: Draw a variety of weeds (problems) in a garden (your life).

QUESTIONS FOR EXPLORATION:

1. What do the weeds represent to you?
2. How many weeds are there in the garden?
3. Are the weeds easy or difficult to destroy?
4. What do the weeds do to the garden?
5. How can you get rid of them?

CLIENT RESPONSES:

Stanley, a 62-year-old man challenged with anxiety and addiction issues, completely filled a 9" X 12" paper with many large dark green and brown weeds. "The weeds are overgrown and growing wildly." Stanley remarked that his life has been full of weeds and thorns for a very long time. He shared that he has had addiction issues since he was 15 years old, and has always been troubled, angry and stressed. He stated he has had over 15 jobs in the last 20 years, most of which he hated, and almost none of which worked out because of his drinking issues.

Stanley said he feels strangled by the weeds. "Because they have grown so tall, I can't find my way out of this weed-infested life of mine." He shared that his wife is contemplating divorce, his two children dislike him and rarely visit, and he was just fired from his most recent job as a car salesman. "I have liver problems, high cholesterol, high blood pressure and a skin cancer on my ear that has to be removed next week." He remarked that one of his kidneys is failing, and he has digestive problems, including an ulcer that has been bothering him a lot lately. Alcohol consumption has been exacerbating his physical problems. Stanley said he believes he's at an all-time low and is ready to get help before it's too late.

A 65-year-old woman named Helen, diagnosed with depression, drew a skillful sketch consisting of many brown weeds growing in a field (right). The clouds overhead appear ominous. "The storm is coming," explained Helen. She shared that she is experiencing a lot of stress in her life, including a pending divorce, financial problems and relationship difficulties with her two grown children. She cried out, "My life is filled with weeds and they are suffocating me." When asked, Helen noted that she had included a few small areas of green, which represent "a drop of hope," and a few tiny pink flowers to symbolize the beginning of new growth.

One group member observed that the clouds appear threatening but there was no rain. She asked Helen if perhaps she had a bleak outlook, but in reality maybe her life wasn't as bad as she thought. Helen did agree it wasn't storming in her picture, but she feared that any minute there would be a major storm in her life. She dreaded being alone and financially strapped. She worried that her children and grandchildren would not visit and she would die alone.

QUESTION MARK II

PROCEDURE: Draw a question mark while thinking about what types of things you question in your own life.

QUESTIONS FOR EXPLORATION:

1. What size is the mark?

2. What does your question mark look like?

3. What specifically are you wondering about?

4. Are you ready to receive and/or find answers?

CLIENT RESPONSE:

Mark, a 39-year-old male with bipolar disorder, drew a huge question mark in the middle of the page. It was filled with black and gray lines that protruded out of it, and it was surrounded by clouds, and a large X. Mark said he felt completely lost at age 39. He mentioned he regretted never finishing college and ignoring his parents' wishes for him to pursue teaching. He stated he had been floundering around for 17 years. "I never married; I have no kids, and I have no steady job." He blamed his situation on his illness and his lethargy, which he attributed to lithium and bipolar disorder. Mark did ignore the fact that he had no set bedtime, he ate too much, drank too much, and he was very pessimistic.

Mark wanted things to come easily, and if he felt challenged he would shy away from people, situations and experiences that made him feel awkward. He had been dating a devoted woman for 3 years, but when she wanted to become serious, he backed away. He remarked he was not ready for a real commitment and so much responsibility.

Although Mark insisted he disliked his present situation, he did not appear willing to do the work necessary to change it. He joked that he needed that magic pill to make his problems go away.

JUST FOR TODAY II

PROCEDURE: Write the number one on the paper. Place a circle around it. Create an image or design on the rim of the circle that represents one thing you need to take care of today.

QUESTIONS FOR EXPLORATION:

1. How does focusing on one thing at a time help ward off stress?

2. What are you focusing on right now?

3. How does the practice of taking tiny steps towards a goal help you achieve it?

4. Are you able to take one day at a time, or if necessary, one hour or one minute at a time?

CLIENT RESPONSE:

Bill, a 62-year-old client diagnosed with bipolar disorder, drew a large red number one. He drew a small, yellow car on the rim of the circle. Bill shared that his car had not been working well and he needed to bring it to his mechanic. He had been procrastinating because he was afraid that the mechanic would charge him a lot of money. He shared that money was tight. "Sometimes I have enough only for a sandwich." He had not been working for months and his disability insurance was going to stop soon. He shared that financial problems were causing him stress and marital discord.

A major problem was that Bill and his wife had been arguing nonstop about whether or not to sell their home and move into an apartment. Bill wants to move and his wife wants to stay in their home. Thinking about all of these issues was giving Bill migraines and panic attacks. He stated that he would try to focus on one issue at a time. Getting his car fixed was his number one priority.

SYMBOLS OF PLEASURE

PROCEDURE: Create symbols and/or images that represent joy.

QUESTIONS FOR EXPLORATION:

1. What constitutes joy for you?

2. When was the last time you felt joyful?

3. How can you create greater happiness in your life?

CLIENT RESPONSE:

Carol, a 42-year-old woman challenged with anxiety and depression, drew a brightly colored flower to represent joy. Carol told the group she had been working hard to overcome obstacles in her life (including overcoming breast cancer and dealing with a divorce). She remarked she felt like she was, "really blossoming." She described the flower as joyful, gently moving in the breeze. Carol stated she was getting her life back, and wanted to find a job and join groups in order to structure her time and make friends. She commented she was pleased to function again, and to feel like she was part of the world. She had been isolating for almost a year, "wasting away in my bed."

TRANSFORMING CHAOS

PROCEDURE: Fold your paper in half. On one side of the paper create a disorganized design using circles, squares and triangles, and on the other side transform the shapes into an organized design.

QUESTIONS FOR DISCUSSION:

1. How did it feel to make the transformation?
2. Do you tend to be more organized or disorganized?
3. Are your thoughts currently more organized or disorganized?
4. How can you begin to organize your thoughts so that you can think in a clearer manner?
5. How do your organizational skills affect your everyday life including your relationships?
6. How can you better organize yourself so that you function more effectively?

CLIENT RESPONSE:

Carmen, a 44-year-old woman with bipolar disorder, created a chaotic design on one side of the paper, which she transformed into "more chaos" on the other side of the page. Carmen said she was full of anxiety and stress and the thoughts in her head were whirling around and around. She shared that she was completely disorganized and could only hope that when she was stabilized on lithium and learned new coping skills, she would be able to think more clearly. She remarked she could barely follow the simple directions to do this brief exercise. Carmen received support from other participants who gave her the confidence to keep trying and to think positively.

POINTING ARROWS

PROCEDURE: Draw a series of arrows representing the direction of your life.

QUESTIONS FOR EXPLORATION:

1. What are the directions of the arrows?
2. Are they going in the same direction or in varying directions?
3. Are you satisfied with their direction/s?
4. How do the arrows reflect present and future goals?

CLIENT RESPONSE:

A 51-year-old accountant named Frank added a variety of a darkly colored arrows going in different directions. He shared that his life had been full of changes recently, and he did not know what new awful thing each day would bring. He mentioned that he had just lost his house to foreclosure and his wife was considering divorce. His daughter recently moved in with her boyfriend, whom Frank disliked intensely. He complained that his company was making many changes, and he feared he would be laid off from work in the coming months. In addition, he was overweight and had just been diagnosed with diabetes. Frank shared that he was a nervous wreck and he was having trouble sleeping, so he was tired all day long. He said, "My arrows used to be straight but that was a long time ago." Frank remarked there was a time he thought life was wonderful and he had "the dream," but lately he felt like he was in a nightmare, which he hoped would end soon.

TRANSFORMING IMAGES I

ADDITIONAL MATERIALS: Magazines, scissors, and glue.

PROCEDURE: Find a large photo from one of the magazines and cut it out. Next cut the photo into three pieces and re-glue the photo on a new sheet of paper to create a new image. The image may be abstract or realistic.

QUESTIONS FOR EXPLORATION:

1. Does the new image relate to the original image in a specific way?

2. What is unique about the new image?

3. Can you relate to either the original or new image?

4. How can this exercise help us to acknowledge and accept our own transformations and changes in life?

5. Do you think people inherently change as they age and/or encounter new experiences?

6. Have you changed or transformed yourself in any way over the years?

7. How do you adjust to change?

CLIENT RESPONSE:

A young man named Bill found a large photo of an intricately decorated pumpkin. He cut the photo in a variety of ways and re-glued the pieces without a specific design or figure in mind. After he re-glued the pumpkin parts he saw what looked like a beak and a mouth, and he noticed an image of a bird. He added an eye and fangs, saying the pumpkin transformed into "Devil Bird." When asked, Bill shared that the bird reminded him of his addiction. He stated his alcohol consumption started out innocently (like the pumpkin) but changed into something that consumed him (like the devil) over the years. He also mentioned that his personality changed when he was drunk; he became aggressive, mean and hateful. He stated he is trying to transform himself back into the pumpkin by staying sober and attending meetings.

STICKY NOTE GOALS

ADDITIONAL MATERIALS: Post-it® notes and glue sticks.

PROCEDURE: Place five Post-it® (sticky) notes on your paper. You may glue them on the paper so they adhere better. Draw an image of something you would like to achieve on at least three of the notes. Examples may include: learning to swim or dive, finishing college, becoming a parent, wife, husband, etc., feeling calmer, being on time, finding friends, finding a partner, winning a race or the lottery, looking for a new job, etc. The images may be abstract, realistic, and/or a combination of drawing and writing.

You may keep the notes so you can post them at home as reminders and motivators to achieve goals.

QUESTIONS FOR EXPLORATION:

1. What are a few of your short-term and long-term goals?

2. Do you have a plan of action for achieving them?

3. Which goals have you already achieved?

CLIENT RESPONSE:

A 42-year-old woman, named Meryl, drew on all 5 sticky notes. Meryl's Post®-it notes included: a cupcake to remind her to eat fewer sweets, because she found out she has pre-diabetes; a person lifting weights to remind her to exercise; someone doing yoga to remind her to relax and be mindful; a rainbow as a symbol of positive thinking; and a laundry basket full of dirty clothes to remind her to keep her house clean and structure her time.

Meryl told the group she was attempting to do all of the things she drew on the papers, but had only been successful at tidying up her house and doing her laundry. She shared she has "a long way to go."

LADDER OF LIFE

ADDITIONAL MATERIALS: Cut paper and magazine photos.

PROCEDURE: Draw yourself walking up a ladder. Include what is on the ground and what is at the top of the ladder.

QUESTIONS FOR EXPLORATION:

1. How tall is the ladder?

2. How sturdy is it? Is it strong and steady or do you need someone to hold it steady?

3. Where are you on the ladder?

4. How do you feel on the ladder? (e.g., calm? Shaky and frightened?)

5. What is at the bottom of the ladder?

6. What is at the top of the ladder?

7. How long have you been on the ladder?

8. What can the ladder be a metaphor (symbol, image) for in your life?

9. How do your *core beliefs influence your relationship to the ladder?

Core beliefs are strongly-held beliefs, often held since childhood, which often shape your view of the world and of yourself.

CLIENT RESPONSE:

Wanda, a 57-year-old woman challenged with depression and anxiety, drew herself halfway up the ladder. She shared that she is stuck half way up because she is not sure if she wants to keep climbing. Wanda remarked she has had a difficult life and doesn't have the energy or motivation "to deal with more shit." She stated her husband is an alcoholic who is out of work and her adult children live at home, "not doing much of anything." Wanda has been the only breadwinner in the house, and the toll of being solely in charge of keeping the household afloat was too stressful. She stated her family members do not help her in any way and she has had enough. They don't clean, do the dishes, wash their clothes, or even take out the garbage unless threatened. Wanda said she was thinking of giving her children six months' notice to find jobs and start contributing to the rent or move out. In addition, she was going to give her husband an ultimatum, which would be to attend an addiction program or she would file for divorce. She was highly supported by group members.

TIME IN A BOTTLE

ADDITIONAL MATERIALS: Cut paper, acrylics, and magazine photos. If desired, provide outlines of a garbage can, which may be obtained from Google.com.

PROCEDURE: Place the ways you "waste" time in the garbage can provided (or draw your own). You may fill the receptacle with words, phrases, and images. Magazine photos may be used.

QUESTIONS FOR EXPLORATION:

1. How are you wasting your time now?

2. What types of thoughts and behaviors waste your time?

3. How can you make the things you must do a little more pleasant?

4. How would you like to change the way you structure your day and/or time?

5. What types of activities and thinking patterns enhance the quality of your life?

CLIENT RESPONSE:

Mara, a 41-year-old woman with severe anxiety, placed a variety of items in her garbage can. She included the word *envy* and stated she tends to be jealous and envious of most of her friends. She remarked she wishes she had more money, a bigger house, and more clothes, took more vacations, and had a nicer car. She added that she worries a lot over things she has no control over such as the safety of her adult children, the weather, the state of the world, terrorism and crime. She said she worries whether or not she is doing a good job at work and whether people think she is smart, a good friend, etc. Mara also added the word *anger*, stating she is highly sensitive, gets insulted easily, and has a short fuse. She shared she can become irate at someone for even minor remarks such as, "She is taking a long time to work on that project" or asking why she was late for work.

Mara added a face to the garbage can and mentioned she sometimes feels people are staring at her and criticizing her appearance, what she is doing, saying, etc. She stated she would try to make better use of her energy, and let go of unfounded and silly concerns.

ACCEPTANCE AND FREEDOM

ADDITIONAL MATERIALS: Cut paper, acrylics, magazine photos.

PROCEDURE: Draw three things in your life you need to accept in order of importance.

QUESTIONS FOR EXPLORATION:

1. What are the benefits of acceptance?

2. What are the problems associated with non-acceptance?

3. What is the one thing you must accept in order to feel less stressed and freer?

4. What have you accepted in the past that helped you move on?

5. How would life change for you if you accepted one or more items on your list?

CLIENT RESPONSE:

A 54-year-old woman named Hannah drew three distinct symbols. The first one, a small black shape, represented her need to accept that she is "an empty nester" and must move on with her life. She remarked that her youngest child just started college and lives out of state. Hannah shared she feels lost and lonely without her daughter at home. She complained that she has no one to laugh with, and no one to shop with on the weekend.

The second symbol, a chaotic swirl of lines and shapes, represented her need to accept her new diagnosis of bipolar disorder, which has been difficult for her to deal with and acknowledge as her new reality. Hannah mentioned she feared her family and friends wouldn't respect her any more, and would "look down on me." Hannah stated she didn't want to take medication and she didn't want to be a burden to anyone in her family.

The third symbol consisted of two broken hearts, representing the strained relationship between Hannah and her husband. She shared they do not get along, but he helps her in a variety of ways and earns a good living. She remarked that she is, "Not going anywhere, so I might as well make the best of it."

KEY TO HAPPINESS

PROCEDURE: Draw your own unique key. What you will see behind the door once you find your key to happiness?

QUESTIONS FOR EXPLORATION:

1. What is behind the door?

2. How long has it been there?

3. How long have you wanted it?

4. Is it within your reach now?

5. Is it realistic; is it possible?

6. What are the steps you need to take to find the key and open the door?

7. How will what you find change your life?

8. Is your key now in someone else's pocket? If so, how can you retrieve it?

CLIENT RESPONSE:

Blake, a 33-year-old man diagnosed with schizoaffective disorder, drew a variety of keys "that you need to open the door." He added a large eye and a person's face to the picture ("Me undergoing electroconvulsive therapy"). He shared there are many types of keys including deadbolts. He stated he doesn't know what is behind the door but the door is made of solid steel and very difficult to penetrate.

Blake shared he wished he could "solve the puzzle," but he would have to keep searching for the right key. He thought the correct one would be made of silver or gold, and very special. Then he remarked, "Maybe it is the key to my heart."

RIP CURRENT

PROCEDURE: Draw yourself in a rip current (extremely difficult life experience).

QUESTIONS FOR EXPLORATION:

1. How are you handling the situation? (e.g., are you swimming against the current or with it? Are you just floating, waiting to see what happens? Are you drowning, etc.?).

2. How are you feeling at the time? (e.g., are you afraid, fearless, motivated to save yourself, on the verge of giving up, etc.?).

3. Have you experienced, or are you experiencing, a life rip tide? If so, how did/are you dealing with it? Have you ever been in a real rip tide before? How did you manage it during that time?

CLIENT RESPONSE:

A 38-year-old woman named Kanti drew herself as a tiny figure "caught in a vortex of fear, frustration, failure, anger and helplessness." She appears overwhelmed and on the verge of being sucked into the whirlpool; Kanti stated she is frozen with terror. Outside of the rip current are the words "peace and happiness." Kanti shared she would like to escape from the vortex but she doesn't have the skills or motivation to do anything right now. She stated she feels stuck and drowning in disgrace. Kanti mentioned that one of her problems is that she expects too much of herself: "Being anything other than perfect is not acceptable."

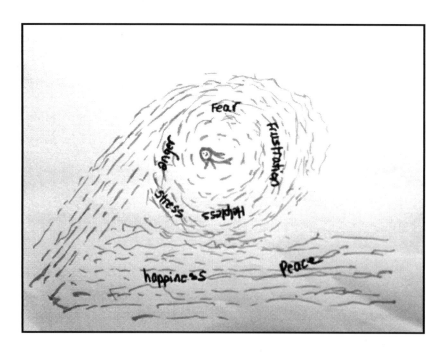

QUESTIONING HAND

ADDITIONAL MATERIALS: Paper, markers, colored pencils, black markers.

PROCEDURE: Outline one or both hands and fill in the hand/s with questions you have about your goals, relationships, everyday life, your future, etc. The questions may be written using a design format (e.g., using various fonts and colors, and adding small images like flowers or hearts).

QUESTIONS FOR EXPLORATION:

1. Which question is most pressing?

2. How do your questions reflect your strengths and/or perceived weaknesses?

3. How do your questions reflect your satisfaction and/or dissatisfaction with your current lifestyle and relationships?

4. Do your questions seem overwhelming? Do they seem puzzling, troubling or perplexing?

5. Do your questions appear intriguing and introspective?

CLIENT RESPONSE:

Dave, a 51-year-old man recovering from addiction issues, had a variety of questions, each written in a different color. He also added small symbols such as a whiskey bottle, skulls, lightning bolts, and a fist. A few of Dave's questions included: "When will my wife and children forgive me? Will my wife stay with me? Will I be able to stay sober? Will I be able to help myself? Will my health improve? Will I be able to get a job? Will I lose my home? Will I ever be able to get my license back again?"

Dave shared that his questions made him nervous, but he was trying to stick with the AA motto to "Take one day at a time," and focus on the things that were in his control.

6

Anxiety & Stress

Stress reduction techniques help individuals relax, reduce anxiety, lessen the degree and frequency of anxiety attacks and learn how to be mindful. People learn skills to cope with illness, fear, frustration, loss and relationship problems. They discover the importance of positive thinking, self-processing, and healthy self-talk. Individuals become skilled in identifying and changing erroneous thinking such as catastrophizing, over-generalizing, and labeling. They learn methods to stop worrying such as thought-stopping, positive self-talk and identifying realistic and unrealistic fears. They practice meditation techniques such as deep breathing and guided imagery. Meditation helps individuals find a sense of calm, inner peace and balance. Some research shows that meditation techniques may improve immune system functioning, allergies, asthma, cancer, depression, fatigue, heart disease, sleep problems, and high blood pressure. People are taught the importance of being mindful. Mindfulness increases self-esteem, self-awareness and self-acceptance. It improves concentration and creativity. When individuals are in the "here and now" they have increased physical stamina, they are more confident, and their moods are more stable. They have better ability to concentrate and memory improves.

Additionally, stress reduction techniques help individuals become increasingly aware of harmful roles they may take on, such as being the victim or scapegoat in the family. They identify negative relationship and life patterns, and try to change and/or improve them. People learn coping techniques such as choosing one's battles and focusing on the positive aspects of their life instead of the negative. They discover how to be patient by taking one day at a time, taking tiny steps forward, and not allowing themselves to be overwhelmed by adversity. Clients learn how to identify and avoid anxiety triggers. They focus on support systems and asking for help when needed. Individuals come to understand the importance that attitude and motivation play in reducing stress, and they learn self-soothing techniques such as taking long walks, celebrating achievements and exercising. Individuals learn to take care of themselves physically and psychologically, and to focus on their strengths and attributes.

THOUGHT IN A BOX

PROCEDURE: Draw a box and place a thought you want to free yourself of in it.

QUESTIONS FOR EXPLORATION:

1. What thought did you place in the box?

2. How does the thought hurt you?

3. How can you free yourself from the thought?

4. How long have you had the thought?

CLIENT RESPONSES:

Roy, a client in his early forties suffering from depression, anxiety and bipolar disorder, drew a box that contained a broken heart, a dollar sign with an X drawn over it, a house with an X drawn over it, and a bomb, lit and "ready to explode." Roy shared that his wife had had an affair with his longtime friend and then left him to live with the friend. Roy was shocked, horrified and greatly saddened. In addition to this terrible event, he was laid off from his job of ten years and had to sell his home, pay alimony and try to find a new job. He stated he feels like the world is closing in on him and he's ready to give up.

During the processing of his artwork, Roy shared that he's very guarded and suspicious of women because he was so hurt and stunned by his wife's behavior. He stated that he knows he must learn to trust again, "But it is very hard to do so." He also acknowledged he needs to let go of the past and look toward the future. He stated he would try to socialize more and go out with friends; he had been isolating for months.

⟨✤⟩

Leon, a man in his mid-thirties challenged with depression and anxiety, drew himself inside a prison cell. He clothed himself in a prison uniform that might have been worn by a convict in the 1940s or 50s. It had black and white stripes and a matching hat. He even placed a ball and chain around his ankle. He told the group that he feels like he is in prison because of his deep depression, lack of motivation and financial problems. Leon shared that he used to paint, sculpt, socialize with friends and engage in sports such as basketball. For the past six months, he has given up all of his activities and slept or watched television most of the day. He remarked that he stays in the house, peers out the window on occasion and envies others who are jogging, bicycle riding and seemingly enjoying life. He stated that he just focuses on money and how he can control an uncontrollable situation. He nodded his head in agreement when other group members encouraged him to divert his attention to leisure activities and try to get out of the house as much as possible. He was encouraged to be mindful and concentrate on what is in his control instead of what is out of his control.

132

PINPOINTING ANXIETY

ADDITIONAL MATERIALS: Outlines of the human body.

PROCEDURE: Fill in the part/s of the body that "feels" anxiety.

QUESTIONS FOR EXPLORATION:

1. Do parts of your body that feel the anxiety change from time to time?

2. How does self-awareness play a role in decreasing stress?

3. How can you decrease anxiety?

4. When is your stress its highest and when is it lowest?

CLIENT RESPONSE:

A 40-year-old man named Jeff filled in the entire figure with anxiety. He remarked he has a lot of nervous energy and feels stressed from the top of his head to his toes. He made a point of focusing on his brain, which, "is filled with bizarre thoughts right now." He described thoughts of the end of the world and of politicians destroying the world. He shared that he is not thinking clearly and he is having trouble focusing. Jeff added a yellow outline to emphasize that some of his energy is actually positive energy. "It's not all bad." He told the group that he hopes he will feel more positive in the future.

Jeff said he tries to relax by drawing, painting, gardening and taking care of his house. He was hoping to set up a small studio in his house so it would be easier to spontaneously create works of art. He shared that his goal was to better structure his time so he wouldn't dwell on the past and on his financial and social problems.

IDENTIFYING STRESS

PROCEDURE: Draw something that is stressful. Examples may include a visit to the doctor, a new job, a confrontation with your boss, giving a speech, experiencing a loss, moving to a new home, a marriage or a divorce.,etc. You may draw the stressful situation or depict how the stress feels, using line, color, and shape. (e.g. a bright red blaze of color may represent a very stressful encounter with an adversary or a page full of dark swirls of color may symbolize anxiety about financial problems.)

QUESTIONS FOR EXPLORATION:

1. How intense is your stress?

2. What is the size and shape of your stress?

3. How are you handling the stressful situation?

4. How long have you been stressed?

CLIENT RESPONSE:

Marlene, a woman in her early forties, drew a caricature of her boss. She portrayed him as a short, rotund, bald man with large, thick glasses, a small, pointy nose, and thin, pencil-like mouth. She dressed him in a brown suit, gray shirt, and an olive-green bowtie. She added horns growing out of his head to symbolize "his horrible, devil-like qualities." Marlene explained that she enjoys her work as an administrative assistant for a large advertising company, but her boss is demanding, "mean and sometimes cruel." Marlene complained that her boss demands perfection and seems robot-like at times. "I don't believe he has feelings."

She shared that if she is five minutes late for work he goes into a tirade. She remarked that sometimes when she's working he looks over her shoulder to make sure she's producing fast enough. "If he is dissatisfied with what he sees he loudly criticizes me in front of my co-workers. His criticisms are demeaning," and "not even reality-based." Marlene shared that she has had enough, and is considering quitting her job because the thought of going back to work elicits panic attacks.

SAFE HAVEN

PROCEDURE: Draw the feeling/s you experience when you are in your *safe place* and/or thinking about your *safe place* – use color and design.

QUESTIONS FOR EXPLORATION:

1. What are the feelings elicited by being in your safe place?

2. How do the feelings help you feel relaxed, accepted and/or content?

3. How can you use those feelings and associated images to help you relax in other environments?

CLIENT RESPONSE:

Celeste, a 35-year-old woman challenged with anxiety and depression, drew herself on a small island, sunbathing in a garden of exotic flowers. She shared that she could imagine herself breathing in the fresh air and delightful island fragrances.

Celeste commented that she would nap peacefully in this habitat because her worries would only encompass which delicious fruit she should eat next and what time of day to take a swim and go for a walk in the surrounding lush forest. Celeste shared that she does think of the island when she's stressed, and sometimes, if she puts her mind to it, she will feel less anxious and more hopeful.

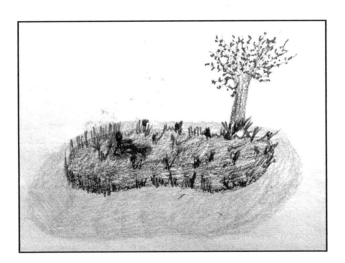

MANIFESTATION OF FRUSTRATION

PROCEDURE: Draw what frustration looks like and/or feels like.

QUESTIONS FOR EXPLORATION:

1. How does the image reflect your feelings of frustration?

2. When is your frustration the highest?

3. What experiences tend to upset you?

4. How do you try to calm your irritation at others and yourself?

CLIENT RESPONSE:

A 50-year-old, highly stressed man named Raymond, drew himself feeling weak and frustrated because, "I am not able to climb the large, ominous-looking brick wall." He shared that the wall represents his ineffectiveness in helping his elderly mother who is very ill. Raymond explained that his mother is in the hospital and all he can give her is his love and support. He stated he wished he could do more, but "She is ill with heart problems and very weak. Her condition is not good; she is very frail and unable to eat." He had been caring for his mother the past two years and they have been very close. Raymond noted that she was an excellent, caring mother, helping him through alcohol addiction, divorce and financial problems.

When asked what was on the other side of the wall, Raymond stated that it would be impossible to know because of the clouds (bleakness) and lightning, which "Might strike me if I even approach the top of it." He commented that he hoped the other side of the wall would be less menacing than the current side. He prayed that he would eventually find a little bit of sunshine and peace.

MEASURING ANXIETY

PROCEDURE: Draw your anxiety level (use a straight line as your base). An option would be to use a ruler to draw a straight line about 10 - 12 inches across, and create a graph or image in relation to that line, which depicts how stressed you feel. For example a tall, narrow triangular shape placed on top of the base line may depict high anxiety while a small semi-circle almost on par with the line may represent low stress.

QUESTIONS FOR EXPLORATION:

1. How high is your anxiety level?

2. What colors and shapes represent your anxiety?

3. Does your anxiety level change during the day?

4. When is it highest? When is it lowest?

5. What measures are you taking to keep it as low as possible?

CLIENT RESPONSE:

Marie, a 44-year-old client challenged with schizophrenia, drew a phallic-looking design using red and blue marker. The tip of the "anxiety shape" was bright red. Within the design, she wrote, "I am exhausted and beaten." She added, "Help, get me back up before I crash and burn!" While processing her picture, she shared that her ex-partner had almost raped her the previous day. She had bruises on her legs and arms, and her hand was swollen. She complained that her ex-partner currently has custody of her son. When she visited her son at her ex's home, he was clearly drunk and very aggressive. Marie remarked that she usually visits with a friend, but this time no one was able to accompany her.

When asked how she could begin to feel safe, Marie stated, "Nothing works; my ex-partner breaks into my house all the time, takes my things, and breaks into my computer." She added that her mother is conspiring with him and discounted Marie's claims (although Marie appeared severely paranoid, the attack did occur). Marie stated that she hated her mother and felt no one was honest.

With a lot of support, Marie began trusting some of the clients in group therapy. Her mood appeared a little calmer as she vented her anger and frustration, and spoke about the details of the assault. She stated she would try to get a restraining order and mentioned she had contacted the police. She acknowledged that she needed to accept help from others in order to prosecute her ex-partner and find a safer home for her son.

SURVIVING THE STORM

PROCEDURE: Draw a tornado. Think about your current attitude and mood.

QUESTIONS FOR EXPLORATION:

1. How does the tornado reflect your emotions?

2. Does it reflect anger and/or anxiety?

3. How strong/intense is it?

4. Does it cause destruction?

5. Will it continue to grow or begin to diminish in strength?

6. Does it appear suddenly or is there a gradual onset? (e.g., first darkening clouds, wind, and then rain, etc.)

7. Are there places or ways to take refuge from it?

8. How do you endure it when its winds are at full force?

CLIENT RESPONSE:

A 20-year-old woman named Kara drew a spiraling tornado. She shared that she was just diagnosed with bipolar disorder, which explained her occasional explosive outbursts and recent spending sprees. She remarked that her friends always wondered where she got her excessive energy, and her family wondered why she was so moody. She said she could be laughing one moment and then a little while later feel very depressed. Kara felt pleased to know there was a specific reason for her unstable mood and strange behavior. She, unlike many other individuals, wanted to start taking medication to help keep her in balance. She mentioned she wanted to be a psychologist and needed to be on an even keel to go to college and focus on her studies.

THE SCREAM

ADDITIONAL MATERIALS: Printouts or a photo of Edvard Munch's painting, "The Scream" (1895).

PROCEDURE: View Edvard Munch's painting. Next draw your own image of stress and anxiety.

QUESTIONS FOR EXPLORATION:

1. How do you look and feel when you are stressed?

2. What are your stress triggers?

3. What do you do and/or what would you like to do to decrease stress?

4. If you are currently anxious, how long have you felt this way?

5. What is the main source of your stress?

CLIENT RESPONSES:

A 22-year-old woman named Belinda, challenged with severe anxiety and bipolar disorder, tried to draw the original painting. She stated the painting depicts the terror and intense fear she experiences during a panic attack. She shared that she feels terrified and immobile during these attacks, "Like I am going to die any moment." She told the group that her heart races, she can't think, she becomes dizzy, nauseous, and sometimes can't move. She stated she becomes frozen in time. Belinda believed Edvard Munch captured that feeling excellently. She mentioned she loves the painting and has a copy of it framed in her bedroom. Belinda commented that the painting scares her and at the same time comforts her. It reminds her she's not alone, that other people have similar feelings and experiences.

A 28-year-old lawyer named Donna created a type of floating disconnected face that actually resembled her own face. She shared she has horrific nightmares every night, and when she wakes up, she immediately experiences a panic attack "of immense proportions." As soon as Donna hears the alarm ring, her heart beats fast, she feels nauseous, and she feels like she is going to die. Donna stated she believes the sound of the alarm causes the attack. She said she feels like she is "coming apart," like she is in a dream, not in touch with reality. When asked, she stated the volume or type of alarm didn't matter, even the sound of birds chirping or flowing water caused the panic.

SUIT OF ARMOR

PROCEDURE: Draw your suit of armor (e.g., your protection from stress, anger, anxiety, or hurt feelings, etc.).

QUESTIONS FOR EXPLORATION:

1. What type of armor did you create?

2. Is it strong or fragile, penetrable or impenetrable, etc.?

3. How long have you been wearing it?

4. Has it helped you or hurt you?

CLIENT RESPONSES:

A 58-year-old woman named Jana drew a person holding a pile of sticks, surrounded by small stones, grass and beautiful flowers. Jana recited the childhood saying: "Sticks and stones may break my bones but words will never hurt me." She shared that she knows words can hurt but has learned to ignore people who are unkind or "stupid." In her sketch, she is holding a pile of sticks to represent her ability to intercept the sticks (insults) before they touch her. She stated that she has the power to react or not react to what other people say and do. She commented that as a teenager she was bullied unmercifully and she developed a hard outer shell in order to survive. Her suit of amour is her ability to let cruel words bounce off of her. She does not hold on to them; she does not let others dictate her self-esteem.

❧

A young man named Bill shared that his suit of armor is his brain. He stated he could "turn off my thinking" and not allow anyone to penetrate his mind. He explained that he doesn't trust easily and usually avoids people. His armor keeps him at a safe distance and prevents him from being disappointed and hurt by others. Previously Bill shared that his girlfriend of five years left him for no apparent reason. "She just took off one day and that was that." He complained he had no idea why she left, and then he exclaimed, "She didn't even leave a note!"

GUARDING THE MIND

PROCEDURE: Draw a symbol, image or sketch that represents how you can "protect your mind." Examples may include avoiding negative energy and "toxic" people, utilizing mindfulness, keeping mentally active, and positive self-talk.

QUESTIONS FOR EXPLORATION:

1. In what ways can you protect your mind?

2. Have you started this process yet?

3. What are the benefits?

CLIENT RESPONSES:

Lindsey, a 33-year-old woman challenged with depression and anxiety, drew red squiggles of anxiety surrounding an open mouth that had blue lines emanating from it. Lindsey shared that she has learned to breathe deeply when she is stressed. Focusing on her breath helps her relax and better cope with difficult situations.

A 29-year-old man named Max drew a helmet and stated he tries not to let negative thoughts or others' insults penetrate his head.

A 53-year-old man named Grady shared that he uses positive self-talk and focuses on his children in order to be positive.

A 39-year-old woman named Mara shared that she plays slideshows in her head of beautiful memories such as vacations at the shore and trips to Europe with her husband.

HEALTHY DISTRACTIONS

PROCEDURE: Draw ways in which you can distract yourself when you are feeling stressed, bored, frightened, lonely, angry, etc. You may include words and phrases.

QUESTIONS FOR EXPLORATION:

1. How does distraction help lessen stress?

2. Which distractions do you find most useful?

3. When was the last time you used distractions to lessen stress/emotional pain?

4. How can you remind yourself to engage in the activities/exercises/leisure skills you included in your artwork? (e.g., keep a list of activities on your refrigerator or on your nightstand or keep certain items such as a pad and markers in full view.)

CLIENT RESPONSE:

A 46-year-old woman named Ruthie created a number of sketches that represented her leisure activities, some of which included: listening to music, attending yoga class, exercising, reading, journaling, surfing the internet and talking to family and friends on the phone. The images she drew were tiny and difficult to decipher. It was apparent she drew them with an unsteady hand. When asked, she shared that she has many interests but hasn't been engaging in them for a long time. Ruthie remarked she often feels lazy and apathetic and has many challenges which include: great difficulty waking up in the morning, trouble sleeping throughout the night, lack of motivation to take a shower or get dressed, inability to concentrate, lack of desire to cook nutritious meals, consuming large quantities of ice-cream, pizza, cheeseburgers and fries, which have led to a significant weight gain, problems taking her medications on time, and avoiding errands and chores, which include washing her clothes and cleaning her house.

She mentioned that she finds sleeping during the day is a great distraction for her because she has virtually no energy. Ruthie said she knows it is not healthy to sleep so much. She declared she would try to start exercising again and was planning to join the local gym.

CONTAINING NEGATIVE THOUGHTS

PROCEDURE: Draw a negative feeling, thought or image and then draw it being contained in some way (e.g., within a container, surrounded by a fence, a wall, a moat, etc.).

QUESTIONS FOR EXPLORATION:

1. How was your negative thought contained?

2. Is the container strong or weak?

3. Does the container actually work?

4. How long has the container been in use?

5. How can you lessen anxiety in your life? What are your coping techniques?

CLIENT RESPONSES:

Wendy, a 38-year-old woman with anxiety and OCD, drew a circle of friends and family surrounding a large red burst of anxiety. She shared that she often feels nervous, tense and frightened, and experiences frequent severe anxiety attacks. When she has the attacks, she feels faint, dizzy, nauseous and out of reality. Medications are sometimes effective, but knowing she has the support of loving friends and family helps her get through each day without completely falling apart. Wendy remarked, "If I didn't have my wonderful support system, my anxiety would burst, and I would either be hospitalized or much worse." She whispered uneasily, "You know what I mean."

<center>◌৹৹৹৩</center>

May, a 45-year-old woman with depression, drew a thick green square surrounding a sketch of an office environment. May shared that she would like to contain the office in which she works and not let her boss and co-workers "make her crazy." She remarked that her epression stems from "a very nasty boss and horrible co-workers." She complained that everyone in her office is dysfunctional.

May stated she has to keep working because she is a single mother and doesn't have the luxury of a lengthy job search. In addition, she felt she would not be able to handle going on interviews and meeting new people. Her goal was to learn the coping skills she desperately needed to work effectively in her unpleasant and extremely hostile setting.

MINI STRESS MANDALA

ADDITIONAL MATERIALS: Template of a 3 ½" circle.

PROCEDURE: Outline the circle on a sheet of paper and fill it in with things that you find stressful. Examples may include stressful events like weddings, divorces, moves, a new job, an interview, financial problems, relationship problems, losses, etc.

QUESTIONS FOR EXPLORATION:

1. What is your reaction to your artwork? How did it feel to share your stress?

2. What types of things do you find most stressful?

3. Do you notice a pattern in the types of things that cause you anxiety?

4. Do you have coping skills to deal with some of the stressors? What are they?

CLIENT RESPONSE:

Gene, a 68-year-old man challenged with alcohol addiction, filled his mandala with words and symbols related to his history of addiction. He added "a bottle of booze," a sad woman's face, a small house, the words and phrases: "Help, shit, sorry, guilt, wife, children, missing, crazy man, and out of control." Gene shared that he feels guilty about his past and is fearful his wife will divorce him. "I think she has finally had enough." He remarked, when asked, that he has self-soothed through alcohol most of his life.

He shared that it helped him at first but then he lost control and the alcohol took over his personality, behavior and his life. He remarked he used to be like Dr. Jekyll and Mr. Hyde. "My wife and children never knew which one I would be when I got home." He shared that his present coping skills include going to meetings, exercising, keeping busy and trying to think positively.

STRESS METER

PROCEDURE: Draw or provide an outline of a thick test tube or a similar shape that takes up most of the page. Divide it vertically into 6 segments. Label the segments:

1. Relaxed (Bottom-most segment)

2. Coping

3. Stressed

4. Anxious

5. Panicked

Fill in the test tube up to the line that best represents how you feel at the moment.

QUESTIONS FOR EXPLORATION:

1. What are the reason/s for feeling the way you do?

2. Have you felt this way for a while or just recently?

3. How are you trying to cope with this feeling/s?

CLIENT RESPONSE:

Tony, in his late seventies, drew a shaky-looking test tube filled to capacity. He stated that he is in panic mode. Tony explained that he is in financial trouble, partly due to gambling. In addition, his internist recently informed him that he has diabetes and heart problems. He shared he has always been a "big guy" and now his smoking and weight (250 pounds) are finally catching up with him.

Tony said that he may have to sell his house in a senior community and would have to move to a small apartment in a less desirable neighborhood. He feared when his wife is informed of their situation her anger might spiral out of control and she might divorce him after 35 years of marriage. He wasn't sure how to cope, but knew he needed to learn to decrease his anxiety or else his heart issues would worsen and his marriage would fall apart completely.

CALM CENTER

PROCEDURE: Draw the calmness you feel or would ideally like to feel at your core.

QUESTIONS FOR EXPLORATION:

1. Do you have the ability to envision your calm center?
2. What does the calmness look like and feel like?
3. How long has it been part of you?
4. How can you develop and/or maintain serenity?
5. How can a calm center help you face adversity and change in your life?

CLIENT RESPONSE:

In response to this exercise, a creative, intelligent woman in her late fifties wrote this beautiful poem in 10 to 12 minutes. Everyone in the room was in awe of her talent.

Centered is the Calm

I am the ocean,
the depth
lies in my belly.
I reflect
the colors above,
old as the first words
young as the
teardrops now
descending from the sky
When the winds
blow harsh,
integrating cynicism
and decadence,
I am at the core calm still.
Mindful of brilliant
colored schools of fish
shimmering by,
I house the ocean's life.
I am the ocean,
the depth
lies in my belly.
J.A. 2016

TOOL BOX

PROCEDURE: Write or draw at least three items you have in your coping skills toolbox, (e.g., exercise, meditation, yoga, art, journaling, therapy, poetry, cooking, gardening).[19]

QUESTIONS FOR EXPLORATION:

1. How do the skills you included help you handle stress?

2. What skills would you like to develop and/or implement in the future?

3. Which techniques have you used in the past, but may not be utilizing now?

4. Give an example of a time a particular coping skill helped you reduce anxiety.

5. Which is your "go- to" coping skill?

CLIENT RESPONSE:

Fred, a 38-year-old individual with major depression, added his wife and children, his church, a prayer book, and his dog Max to his toolbox. Fred remarked that his family is very supportive and gives him the impetus to "go on." He stated that his dog is also very helpful because he is a great distraction, very loving and very smart. "He doesn't ask me to do anything, which is a relief." Fred mentioned he goes to church each Sunday and prays daily. His belief in a higher power gives him hope that he will eventually feel better. Fred shared, when asked, that deep breathing has also been helping, and he is trying to begin doing a little guided imagery at home using a relaxing meditation CD.

COPE CAKES

ADDITIONAL MATERIALS: If desired, an outline of a large cupcake (which can be obtained from Google images).

PROCEDURE: Draw your own unique "Cope cake" and fill it in with three or more coping techniques. You may use the outline provided or create your own design.

QUESTIONS FOR EXPLORATION:

1. What is your "go to" coping skill?

2. Which coping skill would you like to try in the future?

3. Which coping skill have you used in the past?

CLIENT RESPONSE:

Francine, a woman in her mid-twenties, drew a large, bright, chocolate cope cake with sprinkles. She giggled, and proclaimed, "My favorite flavor is chocolate, and I feel like eating the cope cake now." Francine added skills such as: exercise, eating healthy food, music, positive thinking, humor, socializing and getting enough sleep to her cope cake filling. She shared that at present her only coping skill is taking care of her four cats, but she intended to practice her DBT skills ("mindfulness, using my wise mind, and emotion regulation") more often. She also mentioned she was planning to take a yoga and a dance class in the near future.

This exercise was pleasurable for group participants, and led to a lot of conversation. Group members liked the name "Cope cake" and enjoyed relating the cope cakes to cupcakes, which they all enjoyed eating and baking. The clients seemed relaxed and ready to share at least one ingredient that went into their therapeutic treat.

MANAGING ANXIETY

PROCEDURE: "I will not allow myself to get tangled up in my thoughts."

Think about this affirmation and then create a design in any way you wish, using any materials you desire, to represent your thoughts when they begin to spiral.[20]

QUESTIONS FOR EXPLORATION:

1. What are your anxiety triggers?

2. What does it feel like when you become tangled in your thoughts?

3. What types of thoughts tend to dominate?

4. How do you detangle yourself?

CLIENT RESPONSE:

A 38-year-old woman named Meg, challenged with depression, partly due to a brain injury caused by an automobile accident, found red wool, which she wrapped in a variety of ways and then glued to a sheet of black construction paper. She shared that the wool represented her confusion and fear that she wouldn't recover from her depression. She remarked she had been depressed for many months without any noticeable improvement.

Meg mentioned that yoga temporarily improved her mood and seemed to reduce leg pain, which she experienced daily due to the automobile accident. Drawing also relaxed her. She stated that she hoped to improve her concentration so she could read, which was her favorite leisure activity. Meg commented that the therapy groups and being with people in general helped her "get out of her head," become more focused and better in touch with everyday reality.

STRESS MONSTER

PROCEDURE: Draw your stress monster and/or draw yourself defeating it. You may use magazine photos, cut paper, etc., if you like.

QUESTIONS FOR EXPLORATION:

1. What does your stress monster look like (size, weight, color, shape, etc.)?

2. How long has it been around?

3. How does it affect your mood, relationships and behavior?

4. Is it easy, so-so, or difficult to defeat?

5. Have you been successful at beginning to conquer it?

6. How have you been trying to defeat it?

7. What are your greatest challenges in trying to conquer it?

8. What would life be like for you if you defeat it?

CLIENT RESPONSE:

Max, a 29-year-old man fighting heroin addiction, designed a complex anxiety monster. He added a man (himself) surrounded by a variety of problems including: a hypodermic needle (addiction), squiggly lines (anxiety), a clock representing "a waste of my time," the eyes of a wolf, (representing Max's paranoid behavior when he is high), and the word "Worry" (representing his fear that he will destroy himself and his family). He added a heart to the figure, which represented his fear that he will have a heart attack and die before his thirtieth birthday.

Max shared he has been an addict for three years and can't seem to overcome this addiction. He stated that he has been in and out of rehabs for a long time. When asked, Max shared that if he was able to overcome his addiction he would go back to college and study to become a physical therapist. He added that he wanted to have a serious relationship and eventually marry and have children.

THE OSTRICH

"I will not allow myself to get tangled up in my thoughts"[21]

PROCEDURE: Draw what you are in denial of or afraid to deal with right now.

QUESTIONS FOR EXPLORATION:

1. What stands in the way of your accepting life as it really is?

2. How does denying your current situation help you?

3. What happens if you accept your current situation?

4. How would you react physically and emotionally?

5. Would your behavior change?

6. What coping skills can you use to accept reality?

CLIENT RESPONSE:

Jenny, a 35-year-old woman challenged with heroin addiction, drew a large black needle surrounded by black, red, and gray swirls of color. She shared that she had buried her head in the sand for many years, never wanting to deal with her addiction or acknowledge how it hurt herself and those around her. She told the group that she thought she was in control and could function effectively because she worked every day and kept her house spotless. She viewed the heroin as a leisure activity and not as an addiction that was actually ruining her life and destroying her relationships, with family and friends. Her husband of five years divorced her, because he "hated who she had become," and Jenny admitted she didn't even recognize herself after a while.

Her relationship with her siblings and parents also became estranged. She said that it wasn't until she had a major car accident that nearly killed her and put her in a coma for two weeks, that she opened her eyes and realized she had no choice but to change her lifestyle and work toward staying clean.

MIND DRAIN

PROCEDURE: Mind Drain contributes to a person feeling emotionally depleted, exhausted and burned out. It describes the way individuals increase stress and anxiety in their life. This is created by worrying and focusing on negative and stressful thoughts and events, and engaging in erroneous thinking by focusing on the past and the "what if's," "I can't," "always, never," "I'm not good enough," fear, jealousy, comparisons, envy, "woulda, shoulda, coulda, can't," etc.

Create a sketch of how you engage in mind drain using images and/or words.

QUESTIONS FOR EXPLORATION:

1. Which negative thoughts can you attempt to lessen or stop now?

2. How can you transform your negative thoughts into more positive ones?

3. Are there any benefits to mind drain? What are the negatives?

4. How can you begin to limit your mind drain? (e.g., with distraction and positive thinking.)

CLIENT RESPONSE:

A 38-year-old man named Seth drew a profile of a man (himself) with a cracked skull. Emanating from the skull is a large bottle of vodka. Seth shared that for the past 20 years he has been drinking and smoking marijuana daily. He stated: "My mind is turning into a sieve; things go in it and then right back out of it." Seth remarked that his body has also been affected by his drinking; he complained that he has liver problems and diabetes.

He shared he has gained 20 pounds in the past few months because of anxiety and lack of caring what he ate or drank. He added that in addition to drinking vodka on a daily basis he usually drank at least four or five beers after dinner. He commented that he wished he had not "screwed myself up over the years."

CIRCLE OF SECURITY

PROCEDURE: Place yourself in a bubble. You may represent yourself as a shape, stick figure, etc. Next, draw someone or something near the bubble that represents a threat.

QUESTIONS FOR EXPLORATION:

1. Who or what is threatening you?

2. How long has this situation been occurring?

3. How strong is the bubble? Is it safe?

4. How long do you want to stay in it?

5. Is it helpful? Is it healthy for you to take refuge in it?

6. Are there any alternatives to the bubble?

CLIENT RESPONSE:

Sydney, a 36-year-old woman challenged with severe anxiety and social phobia, drew a tiny figure in a heavily outlined bubble, surrounded by a light gray haze. On top of the bubble was a bright red clock. Sydney feared that time was "ticking away" and she had not done anything with her life as of yet. She complained that she was currently unemployed after being laid off from her job as a hair stylist. She remarked she didn't have a boyfriend, which saddened and frustrated her. Sydney shared that her goal was to be married with at least two children by now, but instead she lived alone in a small, old apartment in an area that she disdained.

She said she would like to find a way out of her bubble but wasn't sure how to break free from it. When asked, she mentioned she was planning to volunteer at a local hospital, hoping to find her purpose and perhaps meet a new friend or partner.

ANGER MANAGEMENT

Sometimes when we are angry, we temporarily lose control and don't always think as clearly as we would like. Our thoughts become foggy and tangled in a web of anxiety and confusion. We may say things we later regret, and we may act in ways that are unhealthy and sometimes even dangerous to others and ourselves (e.g., aggressive driving or punching your fist through a wall). At times, we may say things we really don't mean; these words may end up haunting us for a long time and can do permanent damage. We might accidentally hurt the self-esteem of a loved one and/or make threats or ultimatums that can destroy relationships of all kinds, including a work or marital relationship.

Stress reduction techniques help us relax and provide the opportunity to take time to process concerns that are stressful and disturbing. Taking a time out when you feel angry is a healthy way to deal with challenging situations.

Remember the acronym: **SPA**: Stop, Pause/Process, and Assess/Act (wisely).

Stopping gives you the opportunity to mentally leave a heated situation before it gets too hot and uncontrollable.

Processing allows you to think about what occurred, including your role and the other person's role in the debate or argument, and the healthiest way to handle the situation.

Assess/Act affords you the opportunity to behave in a calm, mature manner, and reasonably and assertively discuss the situation, and the best way to proceed so that both parties are satisfied.[22]

Creating mandalas is an excellent way to decrease anxiety, increase focus, and become more mindful of oneself and one's surroundings. Mandalas are easy to design; all you need is drawing paper, a paper plate to use as a template, and markers or crayons. The goal is to create a spontaneous design in a serene environment where you can cool down, and then explore challenging problems. Expressing one's anger on paper allows the anger to flow outward instead of inward. You don't "own" the intense feelings as much, and thereby you gain better control of them. In addition, engaging in creative pursuits such as mandala art, is healthy for the body (better immune system, slower heart rate, lower blood pressure, etc.), and helps with abstract thinking and memory. The benefits of designing mandalas also include assistance with emotional regulation, which helps individuals handle anger in a healthier and more appropriate manner.

ANGER MANDALA

ADDITIONAL MATERIALS: Small circular template such as the top of an oatmeal container.

PROCEDURE: Using a small circular template (approximately 5 inches in diameter), outline a circle onto white drawing paper. Fill in the mini mandala with words, phrases, affirmations, photos, symbols, sketches, etc., that relate to the theme of anger. You may use the mandala to express anger and/or to symbolize ways to handle anger effectively.

QUESTIONS FOR EXPLORATION:

1. How does the mandala reflect the ways you generally deal with anger?

2. How can mindfulness help with anger concerns and symptoms associated with anger?

3. What effective strategies do you use, or would you like to use in the future for more effective anger management?

CLIENT RESPONSES:

Bill, a 58-year-old man suffering with alcohol addiction, added cartoon sketches of a stick figure exercising, running, swimming and holding his hands over his ears. Bill stated that he has difficulty containing his anger and knows he needs to immediately leave the room when his heart starts pounding. He said he attempts to speak rationally, but his anger rises quickly, and all rational thought disappears when he becomes angry. He planned to continue to practice coping techniques in order to communicate more effectively with his children and his fiancée.

Wanda, a 62-year-old woman diagnosed with bipolar disorder and depression, shared that her "blood boils," when she becomes angry. She mentioned she loses control and has been in many fistfights over the years. Wanda stated that a few years back a neighbor insulted her, and Wanda reacted immediately and aggressively. She pulled the woman's hair and punched her in the eye; a fistfight ensued, and Wanda remarked, "It was not pretty." She chuckled and commented, "We were going at it; both our halter tops actually came off and we were fighting almost naked."

The madness stopped when the police arrived and threatened to arrest Wanda and the other woman. Wanda shared she hopes never to be involved in an altercation like that again, and is trying to take deep breaths and think before she allows her anger to "explode."

7
Chapter

CBT-Based: Thought, Emotion, Behavior

Cognitive behavioral therapy (CBT) focuses on the relationship between thoughts, emotions and behaviors and how each influences the other: "Individuals learn that they can better control their anxiety through self-awareness and monitoring their thoughts."[23]

Clients learn that their thoughts yield emotions, which give rise to specific behaviors. They find out that by changing their thoughts, anxiety and stress can be reduced and self-esteem can be increased. Individuals examine and work to change negative thinking patterns that lower motivation and self-worth. They practice how to transform negative thinking into more positive thinking and reframe displeasing situations so that they are more manageable.

The first step in raising self-esteem is self-awareness: becoming aware of destructive thinking and then learning techniques to lessen or eliminate it. "Cognitive behavioral therapy is based on the idea that our thoughts cause our feelings and behaviors, not external things, like people, situations, and events."[24] The idea is to change one's reaction to situations and life events, even if the situation or event can't be changed. This type of thinking empowers individuals, giving them increased control over their life and everyday interactions with others.

CBT can be used to treat many disorders including phobias, depression, anxiety, chronic pain, PTSD, mood swings, eating disorders and anger management. It helps individuals feel better about themselves while they learn how to cope with daily stressors and responsibilities. "The goal of cognitive behavioral therapy is to help people learn to recognize negative patterns of thought, evaluate their validity, and replace them with healthier ways of thinking."[25] CBT focuses on specific problems; it is goal oriented and educational. The therapy has a here and now focus. It is time limited and clients are expected to take an active role in the therapy.

Exploring core beliefs is an integral part of CBT. Core beliefs are strongly held beliefs that people may hold onto for many years; they often form from childhood experiences and events. When the core beliefs are positive, self-esteem is raised, but when they are negative, self-esteem diminishes. During therapy, individuals learn to identify and then change negative and irrational beliefs. They do this by questioning them and examining evidence for and against them. Some questions include:

- Is there evidence for this belief?
- Has anything happened recently that might lower your self-esteem, and/or contribute to your present feelings?

Clients learn specific skills such as identifying distorted thinking patterns, examining core beliefs and finding evidence to prove or disprove core beliefs and erroneous thoughts. Clients learn that they can change the way they perceive situations and therefore help to change unsettling feelings and resulting behaviors. Clients use affirmations, positive self-talk, and self-awareness to improve their attitudes and reactions to events, experiences and people they encounter. Finding new coping strategies leads to lasting change and improved behavior and self-esteem. Clients realize they can control their thoughts instead of having their thoughts control them. Clients learn to solve problems that have been long-standing.

Art therapy enhances much of the CBT process by providing individuals with the opportunity to creatively express core beliefs, as well as reality-based, and distorted thinking patterns. This helps create greater self-awareness since clients are easily able to clarify and share emotions through color, line, collage, design, image, and shape. Art creates a clear and less threatening means to identify and process emotions and patterns of thinking and behavior. It serves as a steadfast canvas to observe, analyze, and refer to as needed.

ATTITUDE AND POWER

PROCEDURE: Creatively symbolize, and/or list, one or more ways keep you can alter your attitude today.

QUESTIONS FOR EXPLORATION:

1. How does your attitude affect specific areas of your life, such as your relationships and job satisfaction?

2. Does your attitude tend to be more positive, negative or moderate?

3. What steps can you take to change your attitude when it is harmful to your motivation, quality of life, and/or self-esteem?

CLIENT RESPONSE:

Amy, a woman in her thirties challenged with extreme anxiety, drew a thunderstorm. She shared that the storm symbolized her negativity and hopelessness. A yellow lightning bolt symbolized her fear that catastrophe could occur at any moment. Amy remarked that she is constantly stressed and focuses on terrible scenarios, visualizing them in detail, especially during the evening hours. She stated that she wants to try to be upbeat and more realistic about her life. Amy was aware that a brighter outlook would change her relationship with others as well as her view of herself and her abilities.

IMAGE AND ITS OPPOSITE

PROCEDURE: Draw an image and then draw what you perceive to be its opposite.

QUESTIONS FOR EXPLORATION:

1. How can "opposite action" help individuals work through issues, confront situations, deal with distressing emotions, and engage in activities that they might otherwise avoid?

2. Share a time you chose to react differently than you usually do to a specific person and/or situation.

CLIENT RESPONSE:

Scott, age 45, drew a sketch of a lion and a mouse. He shared that he used to work on Wall Street and had a very high-powered career which he was able to maintain and actually "thrive on." He stated he would get up at 6:00AM each day and not get home until 8:30PM or 9:00PM. He often worked evenings and weekends. He had a beautiful wife and two small children, and thought he was living the perfect life until his "perfect life" caught up to him. He began feeling vague anxiety symptoms such as stomachaches, headaches and minor panic attacks. Gradually his anxiety increased and he self-medicated with alcohol and cocaine on occasion. Eventually he felt he could not attend any type of meeting or gathering without first consuming alcohol. He needed increased amounts of alcohol to self-soothe and he became addicted to it, to the point he needed a drink when he first woke up in the morning. He felt he couldn't start his day without it. Alcohol became his passion and major focus. He began to neglect his family and his career. He was often late to work and had many absences due to terrible hangovers and apathy.

Scott's previous laid back mood transformed; he became angry, moody and unpredictable in his behavior. One evening he got so drunk, he had sex with a co-worker. In a drunken rage, he told his wife and his wife was shocked and furious. "That was the last straw – she wanted a divorce." Scott was devastated. That was his "bottom." He started attending AA and entered into a recovery program. He stated he felt motivated to change, but he knew it would be a difficult road ahead.

Scott related to his artwork because he used to be "the lion" and now he characterized himself as "the mouse – actually the rat." He stated he feels weak and ineffective as a human being. His goal was to change back to the lion in the future. When asked, he remarked that his "opposite action" would be to practice relaxation skills instead of drinking when he's stressed. He shared he would also try to act calm instead of angry when posed with problems.

MOOD SPIRAL

PROCEDURE: Create a spiral that reflects a mood. For example, a large, heavily drawn spiral may express anxiety or excitement, while a smaller, sketchier spiral may reflect indecisiveness, lightheadedness or uncertainty.

QUESTIONS FOR EXPLORATION:

1. What mood was symbolized in the spiral?

2. Is the spiral simple or complicated, seemingly in control or out of control?

3. Does the spiral seem to be spreading or contained?

4. How does this presentation relate to your mood and behavior?

CLIENT RESPONSE:

Zack, a 26-year-old client with bipolar disorder, designed an intense, black and yellow mood spiral. He began the spiral in the center of the page, worked his way out, and then added squiggle designs and straight yellow lines emanating from the center. Zack shared that the spiral was "crazy." It represented his bipolar disorder and his inability to gain control over his life. Zack stated, "It has a mind of its own."

Zack had been suffering from poor impulse control, even jumping, in the middle of winter, into a large body of freezing water without thinking. He had a tendency to stay out all night, sleep on the streets and not let his parents or friends know where he was or what he was doing. Once he lent a homeless man $100.00 for "food." That was all the money he had.

Zack stated the spiral was alive and constantly moving, much like him. "It looks like it is shooting off the page." He shared it reflected his anxiety and confusion, and his problems associated with decision-making and being responsible.

FOLLOWING YOUR MOOD I

PROCEDURE: Represent your mood using lines, shapes, colors, and/or images.

QUESTIONS FOR EXPLORATION:

1. What do the colors, shapes and lines represent?

2. How is your mood affected by your thoughts and behavior?

3. When is your mood most positive?

CLIENT RESPONSE:

Edward, a young man in his twenties challenged with bipolar disorder and drug addiction, drew a black and white, maze-like design to represent his mood. He began in the middle of the page and worked his way outwards. He shared that he was going to add color but he felt "black and white – blah." He said the design represented him feeling lost and trapped. He complained that his parents didn't trust him and watched over him constantly. "I have to tell them when I am leaving the house and what time I will return; I even have a curfew of 11:00 PM most nights."

When asked, Edward stated that he feels brighter when he is in the program, because he has friends and people he can talk to without being judged. He shared he could eat in peace and take a brief walk without being followed. He especially enjoyed art therapy where he could express himself without fear of being criticized or judged.

FOLLOWING YOUR MOOD II

ADDITIONAL MATERIALS: Magazines.

PROCEDURE: Choose one photo from a magazine that best represents how you are feeling at that moment.

QUESTIONS FOR EXPLORATION:

1. How does the photo represent your mood?

2. What aspect of the photo attracted your attention?

CLIENT RESPONSES:

Luis, a 46-year-old man, stabilized on medication for his bipolar disorder, requested to use two photos. He chose a photo of playing cards and the black outline of a man. He stated that everyone is dealt a hand of cards and "We have to handle our deck to the best of our ability; we choose what we are going to do with our hand." He explained that the black outlined figure represented his father who constantly demeaned him as he was growing up. "He still says very nasty things to me, even as an adult." Most recently, his father had been outraged because Luis was getting divorced from his wife of 20 years. His father characterized him as a loser and a bum, blaming Luis for the divorce. Luis remarked that his father found fault in everything he did. He stated he learned that his most effective coping skill was to ignore his father and focus on doing his best.

❧

Millie, a 49-year-old woman challenged with a clinical depression and anxiety, found a photo of a chameleon. She said that she is like the chameleon because her moods are very changeable. She stated that one day she is bright and hopeful and the next day she feels down in the dumps. Millie shared that she disguises herself according to whom she's with. She gave the example of acting refined and even haughty with one group of women and then acting "street-like" with another group of people. She remarked she would even change her opinions regarding politics, fashion, religion, and health depending on whom she is with at the time.

Millie shared that not being true to herself lowers her self-respect and makes it difficult for her to form her own opinions and values. She stated that she is rarely comfortable with her own thoughts and attitudes, and fearful to share them with others. She becomes anxious that other people will think she's "dumb and/or wrong." Millie stated she knows she's a people pleaser and is working on this issue.

FIGURE FULL OF FEELINGS

ADDITIONAL MATERIALS: The outline of a figure.

PROCEDURE: Fill in part of the figure outline with color/shapes to represent feelings.

QUESTIONS FOR EXPLORATION:

1. What feelings are represented?
2. Which part of the figure did you emphasize (e.g., the heart, brain, stomach, etc.)?
3. How do your feelings affect your mood and behavior?

CLIENT RESPONSE:

Dawn, a young woman in her twenties who was overcoming a severe depression, stated she was feeling better and wanted to create an upbeat figure. She decided to surround the figure with photos of things that made her feel cheerful. She emphasized a large, pink flower and a red hammock, stating she loved gardening, and felt content and relaxed, reclining in her hammock, situated between two shade trees in her "backyard garden of beautiful flowers." Dawn also added positive photos and words to the figure, some of which included, "coffee, Paris, beauty and art." She shared that she loves to paint and art helps her relax. The only part of the figure that disturbed her was a small green shape in the center of the figure (where her stomach would be located). Dawn stated the amorphous flower-like shape represented gastrointestinal problems, probably associated with anxiety and stress. Dawn was very focused and involved in this exercise, and said she would like to complete the figure at a later date.

CORE BELIEF

Core beliefs are strongly-held beliefs, often held since childhood, that shape your view of the world and of yourself.

PROCEDURE: Draw a symbol representing a core belief.

QUESTIONS FOR EXPLORATION:

1. What is your core belief?
2. How long have you had this belief?
3. Does it help you or hurt you?
4. How can you change it, if it is negative?

CLIENT RESPONSE:

Pamela, a 22-year-old woman challenged with depression, drew a witch to represent her core belief. She shared she always felt ugly, with her stringy dark hair, small brown eyes, and long nose. She remarked when she was in elementary school the other children would tease her and actually call her "The Wicked Witch of the West." They would shout out, "Where is Dorothy and Toto?" Pamela, an attractive woman, who doesn't look anything like a witch, viewed herself as the same little girl who was teased so long ago. Her negative thinking and poor self-image have kept her from pursuing healthy interests and loving relationships. She was asked to look for evidence to demonstrate that she's not ugly now, as an adult. She was supported to look within for her beauty, and not to focus on her outward appearance.

EXPRESSIVE EMOTIONS I

PROCEDURE: Draw an emotion such as happiness, excitement or anger.

QUESTIONS FOR EXPLORATION:

1. What emotion did you draw and how does the emotion help you or hurt you?

2. Do your emotions change during the course of the day?

3. How does understanding your emotions help you become self-aware and function more effectively?

CLIENT RESPONSE:

Fern, a vivacious woman in her thirties, drew a tornado-like spiral to represent her anxiety. She shared that she felt very anxious because she was in her mid-thirties, living with her parents, unmarried, childless, and without a job or profession. Fern wasn't sure what to do with her life. She believed she was too old to start school again and worried she would do poorly in college because it was difficult for her to concentrate on tasks. She was afraid of beginning a new relationship because she "always picked losers."

Her previous boyfriend verbally abused her, dated other women, and stole money from her. She remarked she stayed with him because she thought she couldn't do any better. Fern compared herself with other people her age and felt she was way behind. She labeled herself a loser.

MOOD FORECAST

PROCEDURE: Draw a weather symbol to reflect your current mood (e.g., sun, clouds, lightening, etc.).

QUESTIONS FOR EXPLORATION:

1. Which weather symbol did you choose and why?

2. What types of things generally affect your mood? (e.g., the weather, food, sleep, your environment, friends, family, achievements, mistakes, etc.)

3. How can you choose to improve your mood when you are feeling frustrated, angry, depressed, and anxious, etc.?

CLIENT RESPONSE:

Carol, a 55-year-old woman overcoming clinical depression, drew a sunrise over a dark, murky ocean. The sun was bright yellow with a pale orange glow that lit up a light blue sky. Carol shared she had been in a deep state of despair for months; she was eating poorly and she was not sleeping. She stated that she was living in a nightmare, but recently she had started to "see the light." In addition to her medication change and participation in group therapy, she believed her improved relationship with her daughter affected her the most.

She described the heated arguments they previously had had, which added to her depression, stress and sense of hopelessness. Carol finally acknowledged her role in the arguments, and this realization helped her learn new communication skills which were instrumental in lessening the arguments. She stated practicing coping skills such as being assertive, positive self-talk, taking one day at a time, choosing her battles, and finding distractions, helped her cope with problems that had seemed overwhelming. "I can only do what I can, and I have to leave everything else alone."

TORN PAPER COLLAGE

ADDITIONAL MATERIALS: Various types of colored papers, glue and scissors.

PROCEDURE: Consider your current mood. Then choose different colored papers that reflect your mood. Tear them into pieces, and glue the pieces on another sheet of paper until a unique design is formed. Title the design.

QUESTIONS FOR EXPLORATION:

1. Describe your mood and the pieces of paper you chose to represent it.

2. Does your mood tend to vary during the course of the day or does it generally stay stable?

3. What types of things improve your mood and what types of things negatively affect it?

4. Which part of the collage strikes your eye?

CLIENT RESPONSE:

Anna, a 32-year-old woman challenged with anxiety and depression, remarked she enjoyed working on this project very much because "no thinking was involved."

She commented that she didn't have to worry about her drawing ability; she just let herself have fun. When the exercise was completed, Anna laughed and stated that the colors and shapes reminded her of a tropical fish. She added the small square blue eye towards the end of the session to make the design look even more "fishy."

Anna's mood transformed quickly when she shared that the design brought up memories of a recent vacation to Bermuda. She told the group that she went there with her boyfriend, never imagining that's where their two-year relationship would end. She thought her boyfriend would propose on the trip, but he broke up with her instead, saying she was too high-maintenance. Anna shared she had a wonderful time during the first few days of the trip, and would never have imagined two months later she would be alone, sitting in a therapy group, getting much needed psychological help.

TRANSFORMING IMAGES II

PROCEDURE: Draw an object and then transform it into another form or image.[26]

QUESTIONS FOR EXPLORATION:

1. How did you change the original shape?

2. Did you prefer the shape as it was or transformed?

3. How can you begin to transform your lifestyle and relationships if you are dissatisfied with them?

4. How can you transform negative thinking into more positive thinking?

CLIENT RESPONSE:

Selma, an 81-year-old woman challenged with depression and mild memory impairment, drew an "Orb of agitation" and then transformed it into a peaceful lake. She shared she is trying to learn skills so that she can lessen her stress and relax once in a while. She stated she is always on high alert and feels her heart beating fast in her chest a good deal of the time. Selma mentioned that she is very sensitive and startles easily.

She gave an example that happened the previous week. Her daughter called to say she would be at her house in a few minutes. While Selma was waiting for her daughter to arrive, she went outside to take out the trash. When her daughter did arrive, Selma was still busy with the trash. Her daughter walked up to her and said, "Hi Mom," and Selma said she "jumped eight feet into the air." Selma commented she needs to become calmer or she will explode.

MOOD GRAPH

PROCEDURE: Draw a graph representing how your mood changes throughout the day.

QUESTIONS FOR EXPLORATION:

1. When is your mood brightest? Darkest?

2. Does your mood seem stable or does it fluctuate a lot throughout the day?

3. What measures can you take to improve your mood when you feel depressed and/or anxious?

CLIENT RESPONSE:

Helene, a 50-year-old woman challenged with extreme anxiety, drew a graph that looked like a road going uphill and then back down again. It was composed of various colors. The road began with a light blue shape situated on thick, brown stilts ("for support"). A bed was sketched on top of the light blue shape ("Difficulty getting out of bed in the morning").

The light blue shape transformed into a purple shape (energy from her morning coffee); a car is driving on top of the purple shape, (represents her desire to travel more often). The purple shape blended into a light green shape that contained a person walking uphill (getting tired already in the early afternoon). The green shape blended into a lighter purple shape that had another cup of coffee situated on top of it. The light purple shape merged into a pink and red shape that had a person dancing within it (client shared that she perks up again during early evening for a short while), and then the shapes began to slope downhill. Another thick stilt is holding up a light gray shape at the bottom of the graph (tired during the evening hours).

Essentially, what Helene designed was a replica of her typical day. She shared that she needs extra help getting out of bed in the morning, because she feels so tired and depressed. Driving to work is a chore for her, but when she finally arrives at work, she feels a little better, especially after her coffee. Midday is when she feels her best, but late in the afternoon, she becomes depressed again, and then she needs extra help and support to get through the rest of her day and evening. Helene shared the evening is the worst time of day for her because she becomes highly anxious, has difficulty sleeping and often experiences nightmares.

IMMEDIATE FEELING

ADDITIONAL MATERIALS: Magazines, glue, and scissors.[27]

PROCEDURE: Choose a word found in a magazine that describes how you are feeling at present. You may add a picture (photo or sketch) if desired.

QUESTIONS FOR EXPLORATION:

1. How does the way you are feeling affect your mood and behavior?

2. What experiences throughout the day led you to feel the way you do right now?

3. What time of the day do you tend to feel your best? At your worst?

4. How do your thoughts affect your feelings?

CLIENT RESPONSE:

A 20-year-old woman named Kelly chose the word "expect." She added a question mark to the word, and shared that she was feeling confused and didn't know what she wanted to do with her life. Kelly remarked she was not sure whether she wanted to finish college, and she didn't know if she wanted to pursue her original goal, which was to become a nurse.

She stated she felt pressured by her friends, but wasn't sure she felt ready to live by herself in a dorm or an apartment. In addition, she was considering ending her two-year relationship with her demanding, high maintenance boyfriend who added a lot of drama to her life. Kelly stated her anxiety has been debilitating and has given her pause about pursuing any profession that might increase stress. She thought she needed to take a break and consider what she wanted to do with her life.

EXPRESSIVE EMOTIONS II

ADDITIONAL MATERIALS: A 20-square grid (5 boxes per row) with the outline of diverse shaped heads in each square.

PROCEDURE: Fill in as many heads (faces) on the grid as you please with the various emotions you feel throughout the day. Star the face that represents your current emotion.

QUESTIONS FOR DISCUSSION:

1. How does your mood change throughout the day?

2. Are your mood changes mild, moderate or severe?

3. When do you feel the best? Are you able to share the reasons for feeling well?

4. When do you feel the worst? Are you able to share the reasons for feeling poorly?

5. What can you do to help to control your emotions?

CLIENT RESPONSE:

Aidan, a 23-year-old man with bipolar disorder, filled in all the faces, mostly with silly or monster like expressions. He explained that his mood changes frequently; sometimes he can become very angry, and sometimes he becomes frustrated and sad. He shared that he plays many video games, and tried to re-create the faces of some of the characters in the games. Aidan remarked he can usually control his emotions, but has difficulty when his parents annoy him and when his girlfriend "acts like an idiot."

He mentioned that he had hurt his hand while punching the wall in his girlfriend's apartment, and he also created a small hole in his own bedroom wall. He casually remarked that he broke a lamp and vase during a recent argument with his father. When asked, Aidan remarked that his worst time of day is the morning because he likes to sleep late and hates waking up early to go to work or program. He stated no one better get in his way first thing in the morning, especially not before he drinks his giant cup of black coffee. Aidan shared that a medication adjustment was needed, and his doctor was exploring options.

MIND RESET

PROCEDURE: Draw your "mind reset button." (How can you change problematic thinking?)

QUESTIONS FOR EXPLORATION:

1. What type of button did you draw (e.g., large, small, unusual, etc.)?

2. What specifically happens when you push it?

3. Have you ever pushed it? Do you want to push it?

CLIENT RESPONSE:

Ira, a man in his mid-forties with anxiety and addiction issues, drew his reset button as a flying spiral blocked by a black wall. Ira shared that beyond the wall was color and a new beginning, but the wall, though not very thick, was preventing him from getting to the other side. He stated that even if he presses the reset button not much would happen. Ira shared that he might try to work on his addiction issues, but he wasn't hopeful that he would be successful. He confessed that he didn't know if he was ready to change his life and lifestyle. Ira stated he loved his friends and he loved partying.

If he gave up drugs, he would have to leave his girlfriend of two years because she was a heroin addict. His addiction has been a major problem, causing him work, financial, physical and psychological problems, but he clearly wasn't going to stop smoking marijuana and taking barbiturates at this point in his life.

SPLAT OF FEELING

PROCEDURE: Create a splat of color that represents your current feelings or emotions.

QUESTIONS FOR EXPLORATION:

1. What emotion is represented?
2. How does the shape of the splat reflect how you are feeling?
3. How does the size and intensity of the splat reflect your current emotions?
4. How did it feel to create the splat?

CLIENT RESPONSE:

Irene, a 20-year-old woman challenged with bipolar disorder and addictions issues, created a large, blue, gray and red splat in the center of the paper. She added diagonal dark blue lines and a gray blob in the middle of the splat. Irene shared that her design represented her relationship with her mother, which had been very poor for the past year. She remarked her mother (the gray area) was very critical and controlling (the diagonal lines). According to Irene, her mother was highly anxious and created a lot of chaos in the home.

She was dramatic and angered easily. Irene mentioned that she was supposed to have minor surgery and didn't mind until her mother "Made me anxious because she obsessively discussed how dangerous it was to undergo anesthesia." Irene added an amorphous red shape floating near the gray area. This represented her anger at her mother and her desire to get away from her. She titled her shape, "Ghostly," (the splat did have a ghost-like form).

MORNING REFLECTION

PROCEDURE: Draw the first thing you saw when you looked in the mirror this morning. Be specific (e.g., your eyes, hair, tired face, a blemish, your smile, etc.).

QUESTIONS FOR EXPLORATION:

1. What effect did your reflection have on your mood?
2. Were you satisfied with your reflection? If not, how would you like to change it?
3. Was it the same reflection you usually see, or was something different today? (e.g., smiling today instead of frowning, appearing brighter or more tired than usual, etc.).

CLIENT RESPONSE:

Dennis, a 61-year-old man with alcohol addiction, drew a tired-looking man with a lot of straggly hair. He shared that he flinches when he sees his reflection and thinks he looks "like shit." Dennis remarked that he wonders how he got so old and so ugly. He said he used to look much better, "All the women chased after me then." When asked, he stated he would like to change his reflection; he would like to look the way he did when he was 30 years old.

Dennis stated he thinks he would look better if it wasn't for his "Very bad lifestyle and years of messing around with my body." When asked if today's reflection was typical, he shared that his reflection looked about the same as usual; he joked, stating, "I desperately need a shave and haircut."

COGNITIVE DISTORTIONS

Cognitive distortions are distorted, erroneous, biased and or exaggerated thinking patterns that create anxiety and stress. The distortions may inhibit us from leading relaxed, satisfying and healthy lives. They may ruin relationships, promote depression, decrease self-esteem, and make daily life increasingly difficult. Many of the distortions such as *personalization* are not reality-based.

Examples of cognitive distortions include:

Labeling (An extreme form of generalization – attaching a negative label to yourself or others)

Filtering (Dwelling on a single negative detail and sifting out all the positives)

All or Nothing Thinking (Black and white thinking: you see things as good or bad, no middle ground)

Mind-reading (You think you know what people are thinking or feeling without asking them)

Personalization (You take responsibility for things that are not in your power and/or things you haven't done and are not responsible for)

Magnification (Making mountains out of molehills, giving things more value than they are worth)

PROCEDURE: Choose one or more distortions that you have used in the past or presently use and create a drawing, sketch or doodle that illustrates the distortion/s.

QUESTIONS FOR EXPLORATION:

1. Which distortion did you illustrate? How has it helped you or hurt you in the past?

2. How can erroneous thinking patterns harm one's self-esteem, attitude, behavior and possibly relationships?

3. Describe healthier ways to view problems and concerns.

CLIENT RESPONSE:

A 61-year-old woman named Celia drew a thin, sad-looking stick figure woman holding up what she described as "the circle of life." Celia remarked that she tries to control many things in her life, which can't be controlled. She stated she knows she has to accept change, and to *accept what she can't change*, but she finds this extremely challenging. Her present issue is accepting the circle of life. She is holding the circle in an attempt to hold on to life, but she realizes how heavy the circle is, and that her shoulders are not large or strong enough to hold it up for too long. Celia stated she fears that if she puts the circle down, she will have to accept the recent death of her father, which is unbearable. She is currently in disbelief that her beloved father, such a creative, sharp, strong, vital man is gone forever.

CORE BELIEF WRITTEN
WORD COLLAGE

Core beliefs are strongly-held beliefs often developed from an early age. They reflect our attitudes about the way we view others, the world and ourselves. They are the very essence of how we see ourselves. When our beliefs are positive, they can affect our self-esteem, relationships, behavior and mood in a healthy manner, but when they are negative, they can prove harmful to our confidence, relationships, motivation and overall mood.

PROCEDURE: Write your name in a distinctive manner somewhere on the paper and surround it with words and phrases that represent how you view yourself, other people, your community, country and the world. You may add small extras such as symbols, doodles, and designs to the word collage.

QUESTIONS FOR EXPLORATION:

1. How have your core beliefs affected your self-esteem, mood and behavior?

2. Who or what do you believe has been instrumental in the development of your core beliefs?

3. Which core beliefs would you like to change, and which ones do you want to keep?

4. How can you begin to change some of your negative beliefs?

CLIENT RESPONSE:

A 54-year-old woman named Fern surrounded her brightly colored name with a variety of sketches, phrases and words including: the word "Halloween," because Halloween is her favorite holiday. The phrase, "In good taste," was added because she believes she is an excellent dresser and prides herself on her unique and colorful style; an eye symbolizes her acuity. A sketch of two figures hugging symbolizes the love she has for her boyfriend Saul, and a sketch of two buildings was added to symbolize her strength and the strength of her relationship with Saul. She also included a small cloud to represent "reality."

Fern shared that her life is going well now; therapy helped her a lot. The cloud was included to remind her to stay vigilant, and to understand that she might feel depressed again, and that "shit happens."

WORD WAR

PROCEDURE: Think about the thoughts that go through your head during the course of the day. Are they positive, negative, conflicting, contradictory?

Next outline a profile and fill it in with both positive and negative thoughts that "fill your head" on a regular basis.

QUESTIONS FOR EXPLORATION:

1. Which words are motivating and which keep you stuck?

2. Did you include a balance in the number of positive and negative words, or do the negative or positive dominate?

3. How long have you had these thoughts? (e.g., a short time, long time, etc.)

4. How do the words that come into your mind affect your emotions, mood and behavior?

5. How do they affect your self-esteem?

6. Have they changed recently? If so, is there a specific reason for the change?

CLIENT RESPONSE:

Janet, a 38-year-old mother of twin boys, designed a collage profile. She included the words and phrases "Don't worry, eat, sleep, mediate," and "It is what it is." She also included a photo of a watch and a figure dancing in a bed of roses. Janet shared that she tries to think positively, and when negative words pop into her head, she tries to counteract them with positive and calming words and thoughts.

She remarked that she attempts to be mindful and upbeat by thinking of lovely images such as the figure dancing in the roses and wonderful vacations she has experienced with her family. Janet shared that she tries not to think of the passing of time too much (a major stressor represented by a sketch of a watch) and stated that bringing her thoughts back to the present moment helps her significantly. Janet commented that until she learned to be more aware of her thinking patterns, negative thoughts were the only thoughts that filled her head, causing her a great deal of stress and unhappiness.

8

Stimulating & Thought-Provoking

The following exercises provide individuals with creative methods to explore a variety of thoughts, ideas, concerns, interests, and goals. Self-esteem and self-awareness, along with the increased ability to focus and think in the abstract are primary goals. Experiencing an assortment of exercises increases one's capacity to think outside of the box and communicate more effectively with a wide range of individuals.

Connections are enhanced as group members learn new methods to relate to one another and to the world at large. Healthy risks are taken as individuals explore innovative ways to examine their issues and share thoughts with others. The exercises introduce clients to numerous ways of expressing issues, thoughts and emotions. Clients learn and expand upon their cognitive skills as they decide how to approach the warm-ups and then analyze their responses to them.

CREATING SECURITY

PROCEDURE: Draw one person, place or thing that makes you feel safe.

QUESTIONS FOR EXPLORATION:

 1. In what way does the person, place or thing make you feel safe?

 2. What do you need, in general, to feel safe?

 3. How do you create a safe environment for yourself?

CLIENT RESPONSE:

Ellen, a woman in her late thirties, represented her husband George as a tall, imposing, heavyset man "with large muscles." Ellen added a mustache, beard and a lot of auburn hair, remarking that George's beautiful, full head of hair was what attracted her to him when they met at a friend's party ten years ago. She shared, "He is smart, funny and assertive. Ellen proudly remarked, "He is a police officer and isn't afraid of anyone or anything." She shared an instance where he stopped two men from holding up a grocery store in New Brunswick, New Jersey. He did not flinch even when threatened.

Ellen stated, "You can see why I always feels safe with him." In addition, Ellen shared that he is supportive and always puts her interests first. She explained that because he is good-natured and easy-going, she drew him with a smile on his face.

UTOPIAN FANTASY

PROCEDURE: Draw one item you would find in your version of Utopia.

QUESTIONS FOR EXPLORATION:

1. What would your Utopia look like? What would the environment be like?

2. What is the significance of the item you chose to draw?

3. How would it make life better?

4. How can you achieve your own version of Utopia in your everyday life?

CLIENT RESPONSES:

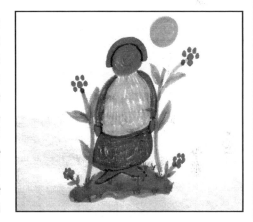

Charlene, a 50-year-old woman challenged with depression, drew a multicolored person standing on a bed of green grass surrounded by flowers and a bright orange sun. Charlene shared that her version of Utopia would be living in a peaceful world where everyone accepts each other as equals. A person's race, religion, color, financial status, education level, and sexual orientation wouldn't matter. She shared that she wishes people were multicolored so everyone would be respected and considered beautiful. Charlene confided that she worries about her son who is African American. She stated she tells him to be polite to everyone, for fear that a prejudiced individual might do him harm.

೧⸱ೢ•°෨

Marcy, a 49-year-old lawyer, drew herself relaxing on a tropical island, reclining in the grass under a palm tree, surrounded by clear blue water. The bright yellow sun is shining down on her. Marcy shared that she is tired of her job, which is very annoying and stressful. She frequently works 60-hour weeks and is often in the office until 11:00PM. She complained that she receives work-related calls at all times of day, even on weekends, and sometimes in the middle of the night. Her commute tends to be almost two hours each way and sometimes she feels exhausted even before the day begins. She stated that she would love to be alone on an island where she could just read, nap and enjoy nature. Marcy wished her worries and cares would be thrown away, then she could focus on herself and her needs. Marcy shared that even if this lifestyle is not feasible now, she is saving so that her retirement might be similar to this version of Utopia.

GROWTH AND SELF-AWARENESS

PROCEDURE: Draw something growing. Consider themes such as responsibility, positive emotions, and independence. Additional ideas may include motivation and emotional resilience. Examples of more tangible items may consist of flowers or trees. Sometimes positive and/or negative emotions such as happiness, and hope, or stress, anger and fear may be artistically represented.

QUESTIONS FOR EXPLORATION:

1. What is growing?

2. How long has it been growing?

3. Is it positive or negative?

4. Is it growing quickly or slowly?

5. Will it stop soon or will it continue to grow?

6. If it is positive, how will you nurture it?

7. If it is negative, how can you minimize or stop the growth?

8. How does the entity that is growing affect you?

CLIENT RESPONSE:

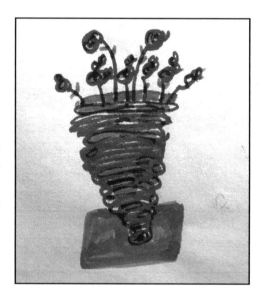

A 40-year-old woman named Priscilla drew her anxiety spiraling upwards. She shared she is presently worried and anxious, but hopeful she will be able to control her stress in the future. Priscilla stated that she is learning many coping skills, such as mindfulness, to help her focus and relax. She noted that she included flowers blooming on top of her anxiety to represent a better life and healthy growth.

WHAT IS HATCHING?

PROCEDURE: Draw something hatching. Hatching relates to birth, new growth, bringing forth and/or creating. Examples of something hatching may include a baby bird, beginning a new job, achieving confidence, freedom, self-awareness, love, independence, or artistic creativity.

QUESTIONS FOR EXPLORATION:

1. What is hatching?

2. Is it something necessary, fun or interesting?

3. Will you need to care for it?

4. Is it an item, person, animal, thing or concept?

5. Have you been waiting a short time or long time for it to hatch?

CLIENT RESPONSE:

A 34-year-old man named Ray drew a cartoon figure of a type of "bird-penguin." He shared that the animal is smiling but leery of the prickly cactus situated next to it. Ray remarked that the bird-penguin is a baby, and has not yet learned to avoid danger. "He is naïve to the ways of the world and not safe at all." When asked, Ray shared he used to be like the bird-penguin and he got into a lot of trouble.

Ray remarked that as an adult he is smarter, more aware and much more careful. He mentioned he only trusts those people whom he has known for a long time and who have proven their loyalty and honesty. He told group members he hardly socializes; he stays home and reads, watches movies, and plays video games.

UNIQUE NEST

PROCEDURE: Draw a nest and place something in it. A nest relates to security, safety and warmth. Consider the various types of nests and who or what may benefit from it's comfort. Examples may include: Babies, birds, depressed or fearful adults, animals, reptiles, insects, etc.

QUESTIONS FOR EXPLORATION:

1. What type of nest did you create?

2. What is in the nest?

3. Is the nest sturdy? Is it safe?

4. Can the nest withstand strong weather conditions such as thunderstorms?

5. Would you like to be in the nest?

6. Who would be with you?

7. What is the purpose of the nest?

8. How is your home like a nest?

CLIENT RESPONSE:

Jessica, an 18-year-old woman challenged with depression and anxiety, drew herself snuggled in the nest. She shared that she doesn't want to leave home; she just wants to stay in her room and sleep. She shared that her parents have implored her to go to college, but the thought of college promotes intense anxiety attacks. Jessica stated she can't even work part-time because her focus is poor and almost everything and everyone makes her nervous and upset.

She told the group she can't function and has social phobia. When asked, she remarked that she wants to be alone in the nest, under the covers and undisturbed. It was interesting to note that Jessica paid a lot of attention to her blanket, which was pink and red, and filled with small flowers.

COFFEE WARM-UP EXERCISE

ADDITIONAL MATERIALS: Sketchbook, pencil, cup of coffee, spoon or stirrer or finger, paper towel (place under paper).

PROCEDURE: Splash/dribble a few drops of coffee on the paper and let dry. Find shapes in it and outline.

QUESTIONS FOR EXPLORATION:

1. What shapes and images did you see in the coffee drops?
2. Are the shapes self-reflective in any way?
3. Do the shapes remind you of someone or something significant to you?

CLIENT RESPONSE:

Brittany, a young woman in her twenties, was able to observe the hazy outline of a dog in the splotches on her paper. She shared that her dog, Posy, was her pride and joy, and a much-loved companion. Brittany shared an instance in the past when she felt very depressed and lonely. One evening she drank too much and took too many pills. Brittany said she did not want to harm herself; she just wanted to relax and sleep. Posy sensed something was wrong when Brittany remained asleep long after her alarm started ringing at 7:30AM. Posy began barking loudly, and then started licking Brittany's face. Finally, Brittany woke up feeling very sick; she called her sister, who called an ambulance. Brittany's condition wasn't life threatening but Posy was the hero for the day and managed to get Brittany the attention she needed in order to begin her path towards better mental and physical health.

CLOUDY THOUGHTS

PROCEDURE: Draw a cloud and place something in it or under it.

QUESTIONS FOR EXPLORATION:

1. What did you place in/under the cloud?
2. What significance does the placement have for you?
3. Do you want to keep the object/thought there or remove it?
4. If you want to remove it, how can you begin to do so now?

CLIENT RESPONSE:

A 22-year-old man named Dale drew a blue car under a large, black and gray cloud. Dale stated that he had just received his third DUI and his license has been revoked indefinitely. He didn't appear to understand the severe consequence of his behavior even as he informed group members his parents hired a lawyer because of possible jail time and a very large fine. He complained that he had no way to go to work and school, and had no transportation to visit friends. He stated he could not date, and felt like a total loser. Dale grumbled that his independence had been "obliterated." His parents reprimanded him and took away many of his electronics for an unknown period. Dale stated that he felt defeated and angry, and remarked he would do what he had to do to get his privileges back.

IMMEDIATE SMILE

PROCEDURE: Draw the first person or thing you saw today that brought a smile to your face.

QUESTIONS FOR EXPLORATION:

1. If you saw a person, was it a stranger or someone you know?

2. What specifically about them touched you in a positive way? Was it their personality; did they smile at you? Tell you a joke, etc.?

3. Did you notice something from nature (such as a flower or tree) or an item (such as a painting, antique, etc.)? Was it something to eat or drink, such as a cup of coffee, hot chocolate, tea or a doughnut, etc.?

4. What type of environment and/or people can you surround yourself with in order to improve your mood?

5. How can food and eating in a nutritious manner improve your attitude?

CLIENT RESPONSES:

A 39-year-old woman named Joelle decided to create a "quickie collage." She shared a few things that make her smile. She added her cat, Antonia, a cartoon photo of a small family gathering, a vacation in the Adirondacks, macaroons from Paris, a photo of smoothies (which she drinks twice a day), Elmo (her nephew's favorite Sesame Street character), and the title of an essay, "Food and Gatherings." Joelle remarked she smiles when she thinks of all these things, but "It is my cat that elicits the widest smile." She shared that when she opens her eyes in the morning, Antonia is watching her, waiting patiently for her to wake up and play. She stated her cat is very special to her and has lived with her for nearly twelve years. Joelle remarked her cat is like her baby and she adores her.

$\infty\!\!\sim\!\!\infty$

A 52-year-old woman named Morgan combined sketches with magazine photos to represent a variety of things that make her smile. She shared that her grandson is number one, but there are other things that also make her smile first thing in the morning. A large container of coffee was included in her art to represent the importance of caffeine in her life. She added that she is starving when she wakes up and thinks about her coffee and breakfast immediately. She remarked that she couldn't start the day without her beloved beverage and a treat such as a doughnut, cookie, Danish or brownie. Morgan sighed, and said she knows she doesn't eat in a healthy manner, but her special breakfast makes her very cheerful.

A photo of a hand adorned with bracelets, and a lovely watch represented Morgan's love of jewelry and flowers. Morgan noted that she usually starts the day with a smile but, unfortunately, the smile often starts waning as the day progresses. She also said that she doesn't like her co-workers or her work as a waitress and hopes to find a different type of job soon.

THE BUDDING BOX

PROCEDURE: Draw a box and create something growing or emerging out of it.

QUESTIONS FOR EXPLORATION:

1. What is emerging from the box?

2. What is the item's significance?

3. Were you comfortable or uncomfortable drawing something outside of the box?

4. Do you usually think outside of the box or do you prefer structure in your life? When was the last time you thought in a nonconventional or creative manner?

5. What are the benefits and possible negatives to thinking outside of the box?

CLIENT RESPONSE:

Marta, a 48-year-old mother of four children, drew a contained box. She remarked she didn't want anything to grow out of the box; she wanted it to be secure, and she wanted to remain in the box with her family. Marta shared that the spirals within the box represented family illness and other upsetting issues that have plagued her for some time.

She loudly wished all her problems would go away, and she and her children could stay in a safe place, not bothered by the world and the unpleasant things that happen in life. She focused a lot on the light black frame, saying it relaxed her to fill it in with the dark crayon. It provided the barrier for her safe haven.

FOOD AND MOOD

PROCEDURE: Draw a food item that represents a mood, feeling or emotion you experience periodically. For example:

Confusion – Mashed potatoes ("mushed mind") **Anger** – Hot sausage
Excitement – Hot tamales **Envy** – A pickle
Depression – Bland soup **Relaxed** – Strawberries and smooth yogurt
Happiness – Ice-cream sundae

QUESTIONS FOR EXPLORATION:

1. In what way does the chosen food item represent your mood?

2. Is your feeling/mood positive, negative or neutral?

3. How often do you feel this way?

4. What are your mood triggers? (e.g., work, relatives, overeating, not getting enough sleep, etc.)

5. What time of the day do you feel your best? Your worst?

6. What is your comfort food?

CLIENT RESPONSES:

Marla, a woman in her fifties, drew a melting ice-cream sundae. She shared that life used to be wonderful. She had a loving husband and two sweet children. During the past three years, her life took a turn for the worst. Her husband died last year of a sudden heart attack; her children "grew up" and left home, and she developed arthritis and a clinical depression. Marla shared she feels sad all the time and sleeps a lot. She mentioned that sleeping is the only way to escape her unpleasant reality. "Times were good and now all the good times have melted away." She remarked that she purposely drew the melting ice-cream to look like tears.

Damien, a 33-year-old man diagnosed with bipolar disorder, drew a pizza with one slice separated from the pie. He shared that the separated slice was for another person, and represented his kindness, generous spirit and "sharing mood."

Suzanne, a 34-year-old woman challenged with schizophrenia, drew mashed potatoes. She shared that the mashed potatoes represented her "mushed mind." "I am mentally slower than I was years ago. I have struggled with my varying moods every day. Sometimes I get confused very easily and feel embarrassed. I used to be so smart and have a graduate degree in history. Lack of sleep is definitely a trigger." She continued to say that walking her dog in the park helped her relax.

HEART BEAT

PROCEDURE: Draw your heart beating.

QUESTIONS FOR EXPLORATION:

1. How fast is it beating?

2. How large or small is it?

3. Is your heart strong, weak or neutral?

4. What speeds up your heart rate?

5. What slows it down?

CLIENT RESPONSE:

An 85-year-old woman named Jean drew a large red heart "With a series of lines in front of it that remind me of an EKG graph." The lines vary in height; the ones that are raised, according to Jean, represent the adoration she has for her grandchildren. Jean related the heart to her feelings about her family, which are very strong. She stated that her heart beats fast when she thinks about all the wonderful experiences and fond memories she has had over the years, especially those of her late husband Carl. She mentioned that Carl was a kind and wonderful man who always had a smile on his face. According to Jean, he was loving and romantic until the day he died. Jean also spent a few minutes bragging about her grandson who recently had graduated from medical school and was continuing training to become a surgeon.

OBSERVING LIFE

PROCEDURE: Draw a pair of eyes (think about your own eyes). Consider size, shape, clarity or fuzziness of your vision, as well as the significance of the sights you observe.

QUESTIONS FOR EXPLORATION:

1. How were the eyes represented (e.g., large/small, looking forward or sideways, open or closed)?
2. What do you see when you open your eyes?
3. What do you see in your mind's eye when you close your eyes?
4. What do you wish you wouldn't see?
5. What was the most wonderful sight you ever saw?

CLIENT RESPONSE:

Esther, a woman in her eighties challenged with depression, drew two crossed eyes. She murmured that she is not seeing things clearly right now. Esther shared that she had been feeling very stressed about recent memory problems, emphasizing that she had always been sharp, organized and an avid reader. She was frustrated because she was becoming increasingly forgetful, and had been having difficulty recalling the names of the books she read, as well as the characters' names and details of the stories.

Esther was concerned she might have Alzheimer's disease, since her sister and her aunt both suffered from it. She shared that she wished she could be the way she was: "Not having to worry about memory problems." When asked one of the questions from the list above: "What do you see in your mind's eye?" She remarked she sees, "A younger Esther, caring for my children and enjoying my family and my home."

EXPRESSIVE FORMS

PROCEDURE: Draw an amorphous shape and title it. Possible examples may include a ghost-like shape to represent fear, or an outline of a mammal such as a dolphin to represent freedom.

QUESTIONS FOR EXPLORATION:

1. What type of shape did you draw? Think about color, size, complexity and/or simplicity of the shape.
2. Look at it closely. What can it represent?
3. How does the title you chose for the shape reflect your reaction and/or feelings?

CLIENT RESPONSE:

Todd, a man in his mid-sixties fighting alcohol addiction, drew a large circular shape with a tiny circle in the center of it. Todd remarked that the shape represents his belly, "Which is too large and unhealthy." Todd shared that he has gained 20 pounds in 6 months and now has high blood pressure and high cholesterol. He is borderline diabetic, and his knees are beginning to feel painful when he walks. Todd noted that eating helps him cope and is presently a substitute for alcohol. He said he eats fast food daily and enjoys a half dozen doughnuts and a couple of cups of strong coffee for breakfast. His goals were to begin going to the gym and to eat in a healthier manner as soon as he completed the psychiatric/ addictions program he was attending.

PEERING THROUGH GLASS

PROCEDURE: Draw a window and draw or write what you see when you gaze out of it.

QUESTIONS FOR EXPLORATION:

1. What do you see when you look out the window?
2. What are your thoughts and feelings?
3. Is the sight pleasant, neutral or unpleasant?
4. Are you viewing the past, present or future?
5. Is there anything you would want to change about what you see?
6. If you are displeased with the sight, how can you change it?

CLIENT RESPONSES:

Barbie, a single mother in her mid-forties, drew a long, dark road leading to the unknown. A lovely autumn scene, complete with gold and orange foliage on the trees, a grassy pasture, and a narrow wooden fence, surrounds the road. Barbie shared she presently feels stressed and depressed because of job issues, financial issues, feelings of loneliness, and the overwhelming concern that she is a bad mother who is not paying enough attention to her 12-year-old son. She shared that she hopes the road eventually leads to more feelings that are positive and a happier and more productive life. Barbie added she prays the road will be brighter for her son.

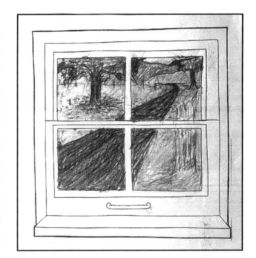

Linda, a 54-year-old woman with anxiety and depression, drew four figures being pushed by "an unknown force." The spirals represent confusion and the feeling of unreality. Linda shared that when she looks out the window she sees time slipping away. She remarked that sometimes she feels like she's in a whirlwind, and becomes so anxious thinking about the passage of time that she can't breathe. Linda admitted she needs to accept change, but stated acceptance is difficult for her since she feels that she has not been a success in life, wasting precious time doing nothing except marrying a "nothing man" whom she divorced years ago. In addition, she expressed great dissatisfaction with her job, which she found boring and stifling. "I'm doing a tedious job with no point." Another client whispered that she should "Take a break and close the shades."

REFLECTING UPON "UPSIDE DOWN"

PROCEDURE: Draw an upside-down sketch of something or someone.

QUESTIONS FOR EXPLORATION:

1. What did you choose to draw?
2. How does the upside-down presentation of the drawing change the meaning of it and/or your reaction to it?
3. Do you ever feel like parts of your life or your thinking is upside down?
4. What self-help measures can you take if you feel this way?

CLIENT RESPONSE:

A 35-year-old woman named Eva drew herself upside down. She shared she feels like she is upside down a lot of the time. Eva remarked she has been confused lately, especially about whether or not to keep her job. She shared that she hates her boss, who is thoughtless, demanding and annoying. In addition, "She is a Republican who is very vocal about her political views!" Eva mentioned she believes her boss is at the source of many of her issues. She anxiously described her dilemma. "I have been at my job for 10 years and I know the work inside and out." Eva expressed fear that if she leaves her current job, she would have to get used to a new job and a new work environment all over again. She was scared she might be going from the frying pan into the fire. Eva wasn't sure if she was willing to take the risk even though her mental health was greatly affected by her current work situation.

CONTRAST IN BLACK AND WHITE

PROCEDURE: Draw a quick sketch using black and white crayons or black marker on a white background.

QUESTIONS FOR EXPLORATION:

1. Were you satisfied using black and white, or did you feel the need to add more colors?
2. If you added more color, how do you think the design would change, and would you change your feelings about it?
3. How does thinking in black and white (no gray area) harm us and narrow our choices in life?

CLIENT RESPONSE:

Olivia, a young woman in her early twenties, created a small Yin-Yang. She explained that she is currently viewing her life in black and white. She shared that she loves her boyfriend, but also dislikes him. She loves her parents, but also resents their interference. She likes her new profession as an editor, but also finds it boring, and she loves to eat, but also feels strongly that she needs to eat less in order to lose weight. Olivia remarked that life is difficult; she knows she has to work harder to be flexible and go with the flow, but she's having difficulty following this way of thinking and behaving.

INSPIRATIONAL OBSERVATION

ADDITIONAL MATERIALS: Magazines, scissors, and glue.

PROCEDURE: Find a magazine photo that is uplifting. Glue the photo on another sheet of paper if desired.

QUESTIONS FOR EXPLORATION:

1. What is it about the photo that is uplifting?
2. What does it represent to you?
3. Does it reflect your life or personality?
4. What other things tend to make you feel cheerful?

CLIENT RESPONSE:

A 50-year-old woman named Harper found a photo of a woman lying in the sand, making sand angels and looking joyous. Harper shared that she and her children used to make angels in the snow and had so much fun laughing and playing. She remembered making snowmen and forts with them, and then warming them up with hot chocolate, grilled cheese sandwiches, and tomato soup when they came in from the cold. She remarked her children would love it when she placed marshmallows and candy canes in the hot chocolate. "They thought it was heaven." The memories were bittersweet, because Harper was experiencing stress and depression partly due to being a recent empty nester. Her youngest child had just begun college, and was living in a dorm on campus. Harper stated that she devoted all her time to her children and didn't know what to do without them. She remarked she missed being a mom, and really didn't want to do anything else. One group member suggested she either volunteer to work with children, perhaps in a hospital, or get a job at a daycare facility.

BOUQUET OF FLOWERS

PROCEDURE: Draw your own unique bouquet of flowers. The flowers may be realistic or abstract, or a combination of both.

QUESTIONS FOR EXPLORATION:

1. Is the bouquet for you or for someone else?
2. Is the bouquet simple or full of color and movement?
3. How does this presentation reflect your feelings at the moment?
4. Do you deserve the bouquet?
5. How can flowers brighten your mood?
6. Do you tend to do nice things for yourself?

CLIENT RESPONSE:

Myra, a 79-year-old woman recovering from a severe depression, drew a colorful bouquet of flowers floating on a cloud. She shared that her beloved husband, "in heaven," used to bring home flowers for her every Friday. She shared that he had been doing this for years. "It was his way of letting me know how much he loved me." Myra smiled and sighed, "Each week the bouquet would be different and always amazing." Myra remarked she continued the tradition by buying herself flowers each week. She added, "In this way I am reminded of him in a positive way and now smile, instead of just crying, when I think of him. He was my best friend."

EXPLORING SLUMBER

PROCEDURE: Draw an image or design representing how you sleep. Think about whether you sleep soundly or toss and turn. Do you snore, scream out, or mumble in your sleep?

QUESTIONS FOR EXPLORATION:

1. What does your picture say about the quality of your sleep?

2. How does the quality of your sleep affect your mood and behavior during the day?

3. Do you tend to dream? Do you remember any particular dream?

4. What is your bedtime routine like?

5. What do you do to try to increase the likelihood that you will fall asleep and stay asleep?

CLIENT RESPONSE:

A 45-year-old woman named Marla drew a primitive sketch of a person with messy hair and a miserable looking expression, lying diagonally on a bed with one skinny leg placed in an awkward position. Marla remarked she sleeps poorly and has horrific dreams. She shared that she keeps asking her doctor to provide a medication to stop the endless nightmares. She told the group she has no difficulty falling asleep, but she wakes up many times during the night, often sweating with her heart beating rapidly.

Marla stated that she has tried relaxation techniques, yoga, and hypnosis, but nothing has worked so far. She yawned as she shared that she feels very groggy almost all day long. She smiled and stated she was thankful for coffee, "Without it I wouldn't be able to function at all."

BRAIN ACTIVITY

PROCEDURE: Draw what is presently happening in your brain (you may add designs, images, words, etc.). The group leader may provide the outline of a head/profile (to be filled in with the images) if desired.

QUESTIONS FOR EXPLORATION:

1. What does your brain activity look like?

2. Is the activity erratic, static, calm, organized, disorganized, chaotic, etc.?

3. How does your brain activity help you or harm you?

4. How can you begin to change the activity if it is undesirable?

5. How can you enhance the positive activity?

CLIENT RESPONSE:

A 63-year-old woman named Kate drew a whale, which she labeled "Wise Mind," and a disorganized, colorful, sun-like shape in the upper right hand corner of the page, which she labeled "Stress Mess." She shared that she is constantly trying to negotiate between the calm, sensible part of her mind and the anxious, stressed part, which can spiral out of control easily. During this exercise, she felt her peaceful mind was dominant, but a ball of anxiety was lingering, and ready to explode at any moment.

Kate liked that the whale was drawn spontaneously; it was not a preconceived image. She wanted to create a calm scene, and then she noticed that the blue hills looked like a whale, which seemed to be swimming calmly in the sea. Kate added an eye and spout to the whale's head, and shared she would like to be serene and strong like the whale because when her brain "gets overloaded" she feels dizzy, weak, sad, unmotivated, and sometimes nauseous. Kate stated that she uses various coping skills and keeps trying to re-direct herself to what is happening in the moment to try to maintain balance and control.

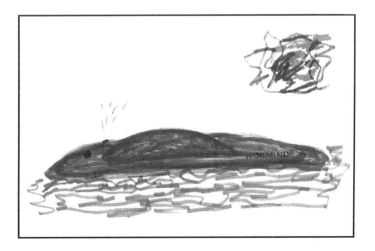

OBJECT RELATIONS

PROCEDURE: Draw an inanimate object that relates to you in some way (e.g., drawing a bed may indicate lethargy, or drawing a computer might represent you being technical or rigid. Other examples of objects that may be drawn include: a fly swatter, remote, phone, photo albums, grandfather clock, egg timer, rocking chair, etc).

QUESTIONS FOR EXPLORATION:

1. In which way/s does the object relate to you? For instance, think about specific personality characteristics.
2. Which personality characteristics are you most proud of? Which ones do you consider unique?
3. Are there any traits you would like to change or "tweak"?

CLIENT RESPONSE:

A 32-year-old woman named Jan drew an old-fashioned television set complete with bunny ears (antennae). She shared that this television set from the early sixties represented her persona "Because I am an old-fashioned person who tends to focus on the past." Jan stated that she should have been born in the fifties or early sixties; "I would have fit in much better at that time, when people were friendlier and life was simpler." Jan mused that, "A television set can transport you to the past and bring back various memories depending on the shows you watch." She shared that "Peggy Sue got Married," one of her favorite movies, represented the idea of using media to go back in time.

CONTRASTING EMOTIONS

PROCEDURE: Draw the opposite feeling that you are presently experiencing.

QUESTIONS FOR EXPLORATION:

1. Are you satisfied or dissatisfied with the opposite feeling?
2. How can examining the opposite feeling help you address your issues and gain greater self-awareness?
3. How can exploring the opposite feeling help you brainstorm ways to improve your mood and problem-solve?

CLIENT RESPONSE:

Marvin, who was just fired from his job as manager of a major department store, drew a smiling face. Marvin shared that he felt terrible and didn't know how he would pay his mortgage or where he would get another job, or if anyone would hire him at age 59. He stated his wife was angry because she thought it was his fault that he was fired; she told him if they lost their home, she would leave him. She told him she had put up with a lot of "crap" from him over the years and this was the last straw. Marvin stated he hadn't been sleeping or eating much and had minimal energy. He remarked he felt like his world was caving in and his anxiety was out of control. He did say, though, that he was open to hearing suggestions by others and he would continue to explore coping skills.

EVERYDAY MIRACLES

PROCEDURE: Draw a common, everyday experience that you find amazing (e.g., a sunrise, a baby's smile, etc.).

QUESTIONS FOR EXPLORATION:

1. What is amazing about yourself or your life? Share at least one thing that impresses you.
2. How does focusing on everyday experiences enhance life satisfaction?
3. What types of things and experiences do we tend to take for granted?

CLIENT RESPONSE:

A 79-year-old man named Frank joked that he is amazed when he wakes up in the morning. He shared that he has many physical problems including diabetes, heart problems, arthritis, and colitis. He was also experiencing mild memory loss and other cognitive impairment. He stated he tries to be mindful and doesn't take anything for granted. He remarked that he was stupid when he was younger and abused his body with drugs and alcohol. Frank said he didn't realize that one day the drugs would take their toll on him, and one day he would grow old and regretful about being so ignorant and uncaring about everyone except for himself. His biggest regret was not sobering up before his wife of 50 years died of lung cancer. He sighed, whispering that he loved her very much and rarely showed it because he was so focused on himself.

CULTIVATING CHANGE

PROCEDURE: Draw a seed and something growing out of it. Examples may include a plant, fruit tree, idea, or something else imaginary.

QUESTIONS FOR EXPLORATION:

1. What is emanating from the seed?
2. How long will it take to grow?
3. Is it something worth waiting for?

CLIENT RESPONSE:

Jack, a man in his twenties challenged with schizophrenia, drew an alien growing from the seed. The alien was green and blue with antennae on top of his head; he had one large eye. Jack shared that the alien was a baby, but would grow into a man within a short period. He would have many amazing powers, including X-ray vision and being able to fly. Jack remarked that the alien would rid the world of war and solve many mysteries, and most importantly, cure diseases. The first disease it would cure is schizophrenia. "The alien would have a wand and wave it over your head, and then you would feel normal."

UTILIZING ENERGY

PROCEDURE: Draw a sketch incorporating both positive and negative energy.

QUESTIONS FOR EXPLORATION:

1. How do the two energies relate to one another?
2. Does one of the energies seem more pervasive or stronger?
3. Which type of energy are you currently experiencing?

CLIENT RESPONSE:

Rue, a 67-year-old woman challenged with memory issues and extreme moodiness associated with a recent stroke, folded her paper in half and represented her positive energy as mindfulness. She stated she tries to be in the moment and relax whenever possible. Rue explained that when she uses her energy to meditate, she feels safer, more secure and comfortable. Her self-esteem and motivation improve.

The other side of the paper demonstrates her negative energy, "A ball of anger and stress." Rue remarked she knows she angers easily and becomes anxious whenever something doesn't go as planned. She shared that she is trying to control her stress in order to heal and feel at ease more often. When asked, she commented that she felt somewhat anxious (a 6 on a 1-10 scale where 10 was the most anxious). She shared that her mood can change quickly, so she would have to observe her mood during the course of the day. Rue mentioned that even a small slip-up like stumbling or spilling her coffee could cause great stress and put her in a foul mood.

ALONE/LONELY

PROCEDURE: Draw an image, shape, or design symbolizing feelings associated with both being alone, and being lonely. It may help to fold your paper in half, or draw a line through the center of the page, so the distinction is clear.

QUESTIONS FOR EXPLORATION:

1. In what ways are the designs similar and/or different?
2. What are the differences between being alone and being lonely?
3. How often are you alone? How often are you lonely?
4. Are there benefits to being alone?
5. What can you do when you are feeling lonely?

CLIENT RESPONSE:

Charlotte, a 20-year-old woman with depression and anxiety, drew a small gray figure sitting in a dark corner to represent loneliness, and a bright red figure sitting at a desk reading a book to represent being alone. She shared that she often experiences loneliness, even when she is with a group of people. She mentioned that she has temporarily left college, partly because she has few friends and feels isolated from the other students. She complained that she has never been invited to parties or asked out on a date. Charlotte explained that she feels depressed and sad when experiencing feelings of loneliness, but actually enjoys being alone at times, so she can think, read, and study in peace.

YIN-YANG

ADDITIONAL MATERIAL: Pre-drawn yin-yang circular outlines.

PROCEDURE: Draw one image representing calmness on one side of the circle and one image representing stress on the other side. Words may be included.

QUESTIONS FOR EXPLORATION:

1. Which side did you draw first?

2. Which side, if any, appears to be your primary focus?

3. What type of things cause stress in your life?

4. What do you do to lessen anxiety and feel serene?

5. What role does balance play in a healthy lifestyle?

CLIENT RESPONSE:

A young woman in her early twenties named Marin designed an attractive, eye-catching Yin-Yang. She told group participants that she filled in the light blue and green area first because she viewed those colors as soothing. The colors represent her attempt to stay calm and mindful; unfortunately, her anxiety often gets the best of her. The red, purple, blue and pink wavy shapes represent her stress, which she attempts to contain. Much to Marin's chagrin, she has been having great difficulty keeping her stress from affecting her mood, behavior and functioning level. She has been missing a lot of work and not keeping up with her laundry, household chores, bills and other responsibilities. The bottom of the yin-yang appears fiery, and what looks like a hand, is reaching out in a menacing manner. Marin stated that recent personal losses have led to her experiencing panic attacks as well as nightmares and poor sleep. She stated she is trying to exercise and do yoga to try to stay balanced and more relaxed, although today she felt very fearful and in tenuous control.

PERSONAL STORY

PROCEDURE: Write a story using between five and 20 words. Alternatively, you may use symbols and images to represent your story.[28]

QUESTIONS FOR EXPLORATION:

1. Does the theme of the story relate to current matters in your life?
2. What is the mood of your story?
3. Are friends, family, and/or other significant people in your life represented in your story?
4. How challenging was it to write/to draw?

CLIENT RESPONSE:

Some clients were perplexed at first, but then found the exercise to be a challenge worth taking. Themes such as loss, addiction and adventure were most common.

A young man named Sergio wrote a brief story about a man who could not quit drinking whiskey and had to be hospitalized for liver issues. The man was eventually stabilized and decided to lead a healthier life, but relapsed two days later. Sergio stated that he chose to write his own story because "That is all I know and it is real."

ISLAND SURVIVAL

PROCEDURE: Draw and/or list three items you would choose if you needed to survive on a deserted island for a month.

QUESTIONS FOR EXPLORATION:

1. Describe what items you chose and why.
2. How would you survive physically?
3. How would you survive emotionally?
4. What would you do to lessen boredom?
5. What coping techniques would you utilize?

CLIENT RESPONSE:

Tania, a 29-year-old woman with anxiety and addiction issues, drew an island that included the three necessities she would desire. She included matches so she could make a fire for warmth and to cook food. She chose a fishing pole so she could catch fish to eat, and she included a hacksaw so she could cut wood for the fire, and make a small shelter where she could keep cool and/or warm, and hide from wild animals that might inhabit the island.

Tania shared she would probably be bored, but she would swim a lot and try to get a good tan. She would take one day at a time and pray for someone to rescue her. She thought she would be frightened, especially at night, so she would work hard to create a shelter that was safe and secure. Tania stated that she would stay close to the shore so passing boats could readily spot her and she could spot them. She joked that she would look for something that she could make into a head with a face, "Like that movie with Tom Hanks," and talk to it as if it were a person. "I would name it Mr. Getmeouttahere."

ABSTRACT ART

ADDITIONAL MATERIALS: Cut paper, acrylics, magazine photos.

PROCEDURE: Create a design that is not recognizable upon first glance. Use line, shape and color to create your masterpiece (think Picasso, Miro, Kandinsky, etc.). Abstract art allows you to express yourself in a non-traditional manner. The interplay of lines, shapes, color and images work together to create a unique piece of work. The artist decides the significance and the meaning of the artwork.

The finished creation may or may not produce an image that is perceptible. It does not matter, but the exercise is enjoyable and looking for an image that might appear in the work often gives insights into the subconscious. Remember to have fun with your art and "Go with the flow."

QUESTIONS FOR EXPLORATION:

1. Did your work elicit specific thoughts or feelings? Did it remind you of anything or anyone?

2. Was it easy or challenging to work in such a conceptual manner?

3. Were you able to "let go" and just see how your art would evolve?

4. Does the way you approach art relate in any way to the way you approach life?

CLIENT RESPONSE:

A man in his forties named Dan drew a colorful design, and upon observing it carefully, he noticed the shape of a snake. He added an eye and *shoots* emanating from its mouth with question marks at the ends. Dan liked the drawing and related the question marks to the many problems he is currently trying to solve, such as whether or not to sell his home, and whether or not to divorce his wife who has been unfaithful. He shared that he drew in a haphazard manner at first, not caring how the work turned out, but thought it was fascinating when the snake appeared, remarking that the snake reminds him of his wife, " a slimy cheater."

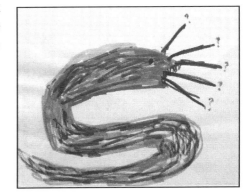

PERSONAL BOUNDARIES

PROCEDURE: Draw a figure (it can be a shape or design) that represents you in some way and create a boundary around it.

QUESTIONS FOR EXPLORATION:

1. Describe the type of boundary you drew.

2. Is the boundary large or small, thick or thin?

3. Has the boundary been up for a short time or a long time?

4. Is it easy or difficult to penetrate?

5. Has it been a help or a hindrance?

6. Would you like to keep it up or begin to tear it down?

CLIENT RESPONSE:

A 47-year-old woman named Marla drew herself in a safe bubble-like shape, which she described as, "Opening up to stress and anger." Marla shared that she stays safe by keeping her feelings inside, "Because if I let them out I think I may explode." Marla said she attempts to contain her stress by being agreeable, staying away from conflict, exercising and playing the guitar. She shared that those approaches help a little, but her anger ends up expressing itself via incapacitating migraine headaches. When asked, Marla stated that her bubble has been up since childhood and it would be extremely difficult to burst it. She remarked it has been a problem because she stays safe, but feels ill all the time and "Has no life." She mentioned that she "Never takes risks, always playing it safe."

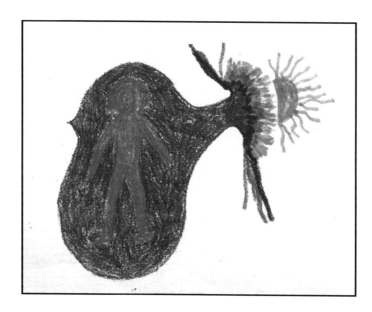

SPONTANEOUS THOUGHTS

PROCEDURE: Draw a circle and divide it into four parts (a paper plate may serve as a template). In each section, write the first word that pops into your head. Next, illustrate one of the words.

QUESTIONS FOR EXPLORATION:

1. How do the words represent your current mood and/or experiences?
2. Which word is most significant to you now?
3. Which word did you choose to illustrate? How does the illustration relate to the selected word?

CLIENT RESPONSE:

Kyle, a 29-year-old man challenged with heroin addiction and anxiety, included the words: Drugs, Depression, Nowhere, and Joy. He illustrated "Joy," which is his girlfriend's name. Kyle drew a large woman's face with a wide smile and crossed eyes. He added curly red hair and freckles. Kyle shared that he is trying to stay clean, but his girlfriend refuses to get help for her own addiction issues. Kyle recognized that she was an enabler, and he knew that was why he was highly encouraged from many sources to end their year-long relationship. Kyle told the group he was sad and frustrated that Joy refused to stop using. He said he knew he had to break up with her, but he was keenly aware that the strong connection they had would make this breakup heart-breaking and terribly difficult for him. He feared the extreme stress he would undoubtedly experience might make him want to start using again.

MIRAGE OF HOPE

PROCEDURE: Imagine you are deprived of all necessities while wandering in the desert for two days. You are walking sluggishly through the vast wasteland when suddenly you see a mirage.

Draw what that mirage would be; what would it look like?

QUESTIONS FOR EXPLORATION:

1. What would your reaction be upon viewing the mirage?
2. Would it be of help?
3. Would it motivate you to move forward or demoralize you?

CLIENT RESPONSE:

A 39-year-old woman named Rebecca drew what she called "an oasis." It consisted of a large rectangular table with a bright orange tablecloth, and an attractive awning that provided shade. On the table were some of her favorite treats, including hamburgers, fries, a vanilla shake, soda, a banana split, an ice-cream sundae, cupcakes and a blueberry pie. Surrounding the oasis was a small, grassy field filled with swaying roses growing wildly. Rebecca shared she would be thrilled to view this mirage. She remarked that it would be disappointing to find out the haven was not genuine, but it would motivate her to keep moving until she could find "real" food and shelter. She stated she has a strong will to live and called herself "The Survivor."

THE "GENUINE YOU"

ADDITIONAL MATERIALS: Glue, magazine photos.

PROCEDURE: Create a drawing or collage of the "genuine" you. Think about your likes, dislikes, aspirations, needs, quirks, strengths, ideals, dreams and goals. Explore core beliefs.

QUESTIONS FOR EXPLORATION:

1. What characteristics do you admire most about yourself?

2. Which characteristics need tweaking?

3. What were you like in the past, and what are you like now?

4. Are you living your "authentic life"? If not, how can you begin to live the life you most desire?

CLIENT RESPONSE:

A woman in her forties named Gloria created a colorful sketch that turned into a giant hamburger. Gloria remarked that she had had no intention of drawing a hamburger. "It just happened." She shared that the hamburger might represent her inability to control her hunger, and her frustration about being 35 pounds overweight. She remarked that cheeseburgers and fries are her favorite meal, and she indulges almost every day. She attributed her eating issues to her frustration regarding her job, relationships and life in general.

Gloria mused that as a teenager she wanted to be an actress. She had acted in school plays and was considered the high school superstar. She had hopes of pursuing acting in college, but her parents insisted she take courses that would help her prepare for "The real world." They encouraged her to study science and medicine, focusing on biology. Gloria remarked that she attended medical school for two years, but hated it, and eventually became an occupational therapist. She sighed and shared that she wished she had pursued her original dream, but "Now it is too late."

Notes & Credits

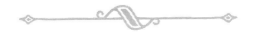

CHAPTER 1

1 Kabat-Zinn, J., (2006). *Mindfulness for Beginners* (Audio CD), Sounds True.
2 *Mindfulness: Finding Peace in a Frantic World.* Retrieved from http://franticworld.com/what-is-mindfulness/
3 *ACT: Acceptance and Commitment Therapy.* Retrieved from http://getselfhelp.co.uk/act.htm.
4 Germer, C. K., (2013). *Mindfulness and Psychotherapy.* London, U.K.: The Guildford Press.
5 Buchalter, S., Retrieved from http://www.mandaloodle.com.
6 Term coined by author.
7 Hay, L. *I Choose to Make the Rest of My Life the Best of My Life.* Retrieved from http://www.theseeds4life.com/i-choose-to-make-the-rest-of-my-life-the-best-of-my-life-louise-hay-2.
8 Marston, R. *Online Counselling College.* Retrieved from http://onlinecounsellingcollege.tumblr.com/post/20114427805/happiness-is-a-choice-not-a-result-nothing-will.

CHAPTER 3

9 UC Davis Health. *Self-Esteem.* Retrieved from http://www.ucdmc.ucdavis.edu/hr/hrdepts/asap/Documents/Self_esteem.pdf.
10 Branden, N. *On Self-Esteem.* Retrieved from http://nathanielbranden.com/on-self-esteem.
11 Neff, K. *Self-Compassion.* Retrieved from http://self-compassion.org/the-three-elements-of-self-compassion-2/.
12 Modified by an idea by Nimura, T. *A Smart Way to Boost Your Child's Confidence.* Retrieved from http://www.parents.com/parenting/better-parenting/positive/a-smart-way-to-boost-kids-confidence/ *I presented a similar idea to clients, which was presented as "Adding to your Building Blocks of Self-Esteem."*

CHAPTER 4

13 Universal Class. *The Benefits of Social Relationships.* Retrieved from https://www.universalclass.com/articles/business/communication-studies/the-benefits-of-social-relationships.htm
14 http://thenationshealth.aphapublications.org/content/41/2/20.full
15 Johnson, T.D. *Healthy Relationships Lead to Better Lives.* Retrieved from http://www.health.harvard.edu/newsletter_article/the-health-benefits-of-strong-relationships
16 *The Benefits of Happy Relationships.* Retrieved from https://positivepsychlopedia.com/year-of-happy/the-benefits-of-relationships/
17 *Why Personal Relationships are Important.* Retrieved from https://www.takingcharge.csh.umn.edu/enhance-your-wellbeing/relationships/why-personal-relationships-are-important

CHAPTER 5

18 Branden, N. Retrieved from https://www.brainyquote.com/quotes/quotes/n/nathanielb163773.html.

CHAPTER 6

19 "Mental Toolbox of Coping Skills" is a phrase coined by author and used in many therapy groups.
20 "I will not allow myself to get tangled up in my thoughts," Affirmation coined by author, Buchalter, S.
21 "Burying your head in the sand does not make the situation go away; it just prolongs the stress and delays the healing process." Phrase coined by author, Buchalter, S.
22 The acronym: **SPA**: Stop, Pause/Process, and Assess/Act (wisely) was coined by author, Buchalter, S.

CHAPTER 7

23 *What is Cognitive Behavior Therapy (CBT)?* Retrieved from www.beckinstitute.org/cognitive-behavioral-therapy/.
24 *What is Cognitive Behavior Therapy (CBT)?* Retrieved from http://www.nacbt.org/whatiscbt-htm/.
25 Martin, B. *In-Depth: Cognitive Behavioral Therapy*. Retrieved from http://psychcentral.com/lib/in-depth-cognitive-behavioral-therapy/000907.
26 Another option is to have participants draw a negative shape, image, statement, etc. and then transform it into something more positive.
27 Providing pre-cutout magazine photos may be a desirable option during a brief warm-up exercise.

CHAPTER 8

28 Four words are usually used during this exercise, but I think clients need more flexibility in the number of words allowed, in order to use the exercise for increased self-expression and insight.

Made in the USA
Middletown, DE
01 July 2018